FEMMES FATALES
1 8 6 0 - 1 9 1 0

Essays by

Henk van Os

Jacqueline Bel
Kristien Hemmerechts
Marianne Kleibrink
Eddy de Klerk
Sijbolt Noorda
Christien Oele

KONINKLIJK MUSEUM VOOR SCHONE KUNSTEN ANTWERPEN | **GRONINGER MUSEUM**

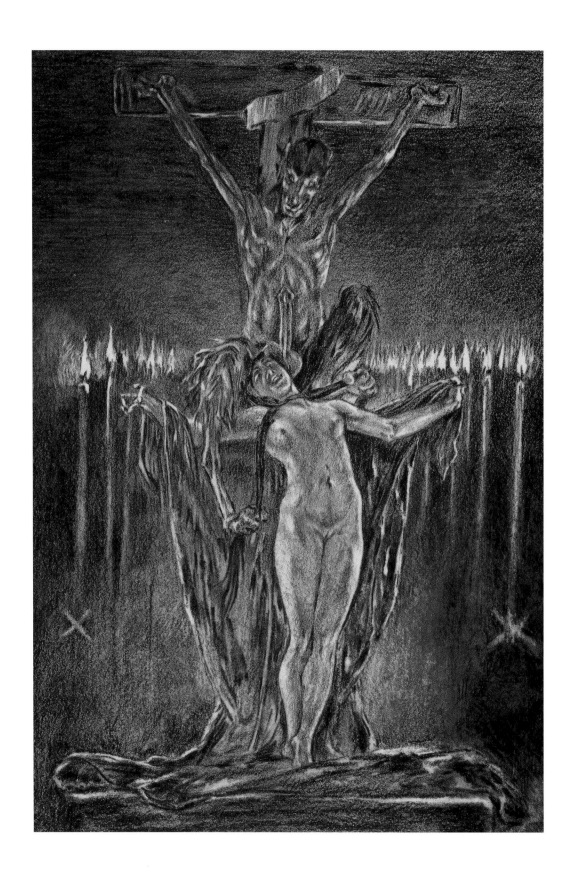

*Félicien Rops. **Les Sataniques**. 1882, gouache and mixed media on paper. 20.7 x 14.5 cm. Private Collection, Belgium*

TABLE OF CONTENTS

6

FOREWORD

The seductress and the *femme fatale* are two essentially different species. At first glance it may seem that these two types of woman resemble each other – but look more closely and you'll find a fundamental distinction. For the seductress, her sexuality and voluptuousness are ends in themselves. Not so the *femme fatale* – she uses her feminine attractions to lure men to their destruction. The extent to which a woman may be described as 'fatal' depends on her function in the myth, the biblical story or the literature where she figures. One thing is certain: in all cases the *femme fatale* destroys the men with whom she comes in contact. Using her physical attractions and voluptuousness, the *femme fatale* seduces men and causes their ruin. Her power lies in her physical beauty which men find overwhelmingly irresistible. This superlative beauty enraptures men and drives them to distraction; ultimately it leads to their death.

In preparing the exhibition and catalogue texts, the distinction between the seductress and the *femme fatale* has been faithfully observed. Catalogue and exhibition consider the *femme fatale* and thus inevitably, her victim the man.

When selecting the art to illustrate the theme of the *femme fatale*, we limited ourselves to a consideration of works from the second half of the nineteenth century with a little overlap into the early twentieth. During this period the seductive woman emerged as a highly popular subject both in literature and the fine arts as well as in opera and theatre.

The exhibition was the initiative of Henk van Os, one-time professor at Groningen University and former director of Amsterdam's Rijksmuseum, presently professor at the University of Amsterdam. With it, he picks up a topic first broached in 1972, when he curated the show *Het Geheim* (The Secret) here in Groningen. That exhibition, it should be added, caused quite a commotion in the Netherlands. Furthermore, the present exhibition fits into the policy of the Groninger Museum to make an annual presentation on a topic related to art history of the nineteenth century.

The Groninger Museum's ongoing interest in nineteenth-century art easily explains the connection with Antwerp's Koninklijk Museum voor Schone Kunsten (Royal Museum of Fine Arts). The Antwerp museum has a superb collection of nineteenth-century art and a wealth of expertise about this period. Furthermore, the Belgian museum had long cherished the wish to complement four large works in its collection, by Alma-Tadema, Cabanel, Stevens and Tissot, with paintings of *femmes fatales* brought from other collections. It was felt that other works of this nature would enrich and enliven the four famous masterpieces in the Antwerp collection.

The notion of the *femme fatale* developed in the second half of the nineteenth century against a backdrop of profound social change. For a start, the place of the artist in society was rapidly altering and this, together with a burgeoning middle class, led men and women to look for new forms of entertainment.

They longed to escape from the dull daily routine into a fantasy world filled with high tragedy and stirring symbolism. What could have proved more satisfying in such a period than the *femme fatale*? She made life spicy, aroused and excited her viewers yet at the same time served as a warning. So the old stories were unpacked – tales from mythology or the Bible, the adventures of Medea, Circe, the Sirens, Judith, and Salome were told anew. But this time the women weren't heroines nor models of female chastity and piety. Artists such as Gustave Moreau, John William Waterhouse, Frederic Sandys, Max Klinger, Franz von Stuck, Alexandre Cabanel and Edvard Munch were to give the women a new role: they became seductive vamps plotting the downfall of the male.

So violent and exuberant was their portrayal of these women that – especially in the more sober days of the twentieth century – these works have gained such labels as 'kitsch', 'affected' or 'melodramatic'. Interestingly, the same words were used to criticize the 1972 exhibition in the Groninger Museum titled *Het Geheim (The Secret)*. Not until the 1980s did this attitude begin to change. Then nineteenth-century art was rediscovered and in Britain, France and Germany in particular important exhibitions were held, among which *Kampf der Geschlechte*, *The Last Romantics* and *Symbolism in Britain*. The nature of the nineteenth-century Romantic experience and its use of symbolism was thoroughly researched and presented to the public.

Considering that presently pictures representing *femmes fatales* occupy a major place in museum collections and permanent exhibitions, we feel extremely lucky that we have been able to gather at least fifty important works illustrating this topic for our exhibition. We are proud to announce that on show will be well-known pictures painted by John William Waterhouse, Franz von Stuck and Fernand Khnopff. There will also be lesser-known pieces on display by such artists as Herbert Draper, Arthur Hacker, John Collier, Carlos Schwabe, Frederic Sandys and Georges Desvallières.

The exhibition dedicates a special section to the Norwegian artist Edvard Munch. Fifteen of his graphic works appear, all on the topic of the *femme fatale*, all of them strongly autobiographical, in which he portrays himself as the victim of the devouring female. For men especially, these works are highly confrontational.

More than an ordinary catalogue, this book brings an added dimension to the exhibition. In five essays, experts in five different fields contribute their angle on the phenomenon of the *femme fatale*. Authors are Jacqueline Bel, with literary details about *fin de siècle* writing; Marianne Kleibrink on the fatal women of classical times; Eddy de Klerk with a psychoanalyst's understanding of these women's make-up; Sijbolt Noorda as theologian looking at the femmes in the Bible; and Henk van Os, considering the phenomenon as an art historian.

In their different ways these essays explore that tantalizing topic, the *femme fatale,* offering a wide range of insights. Finally, Belgian author Kristien Hemmerechts adds a further dimension to the discussion with a literary contribution.

The descriptions of the works on display were written by art historian Christien Oele. She introduces the pictures, describing in a direct and accessible manner their general aspects and their details. The final editing of the catalogue lay in the capable and conscientious hands of art historian Thijs Tromp.

We should like to thank all those who in various ways have made this exhibition possible. Special mention should be made of the museums and galleries in Australia, Belgium, Britain, the Czech Republic, France, Germany, Hungary, Italy, the Netherlands and Norway, and to our private lenders Victor and Gretha Arwas, Mrs Lucile Audouy, Mr. Philip Serck, Alessandra and Simon Wilson, The Triton Foundation and those who wish to remain anonymous. To all those who have generously lent out works for a lengthy period of time we extend our warmest thanks.

We should also like to thank our translators, Wendie Shaffer, Kate Williams and Stephen Smith, who rendered the Dutch texts into English, with a pleasing mixture of accuracy and imagination.

Neither the exhibition nor this book would have materialized without the enthusiasm and dedication of the staff at the Groninger Museum and the Koninklijk Museum voor Schone Kunsten in Antwerp. We mention in particular the energetic commitment of the curators Patty Wageman and Leen de Jong.

In conclusion we thank most warmly our guest curator, Henk van Os, who proved an untiring inspiration both for the production of the exhibition *Femmes Fatales*, and for the accompanying catalogue.

Paul Huvenne

Director, Koninklijk Museum voor Schone Kunsten Antwerp

Kees van Twist

Director, Groninger Museum

Henk van Os

A FRAMING FOR THE FEMME FATALE

In 1799 the Spanish painter Francisco de Goya made a series of etchings titled *Los Caprichos*. One of the best-known of them bears the caption *The Sleep of Reason Produces Monsters* (ill.1), words which could very well serve as the motto for this exhibition. For they are more than the title of an etching: they enclose the secret of the picture. But what does the emotional content of the text suggest? Is it a warning, or perhaps a moral teaching? Should reason never relax? Or was Goya making a statement about human life? Did he mean that reason cannot always be on the alert and that every form of enlightenment or illumination will always cast its shadow somewhere? If we approach the nineteenth century with Goya's etching as a banner, we encounter both interpretations. The belief in reason, in the ideals of the Enlightenment, goes hand in hand with the certainty that a watchful person will be able to suppress the monsters of the dark. But beside this you find the conviction that all the brave ideals are no more than a thin varnish. Beneath the surface of bourgeois complacency there lurk uncontrollable forces that determine people's lives. Side by side with the lofty conviction that civilization is always moving forwards is the certainty that all this progress leads nowhere. As the Dutch writer Gerard Reve might have put it, 'Onward, full of hope and courage – but where to?'

A faith in reason combined with a sceptical attitude towards rationality is, of course, contradictory. The nineteenth century thus observed the conflict between the Rationalists and the Romantics. In art-historical writings about this period two opposing camps have been defined: classicists and romantics.

In fact it is not so simple, since the one group could not exist without the other. That is what makes Goya's etching so intriguing. Take the case of a prominent industrialist from the *fin de siècle* period, one of the major art buyers of the time. Every day he works at his job with astonishing efficiency, sure of his rational *raison d'être* and bursting with bourgeois self-confidence. In the evening he goes to the opera or the theatre. There he wallows in the tragic fate of proud knights and seductive females, he is bombarded with feelings which he is only too glad to ignore in the daytime. Salome dances to obtain the head of John the Baptist and Helen demonstrates that in the world of men peace can at most be a temporary truce in an eternal war. For the businessman, life really begins when the curtain rises, or perhaps he finds it within the richly-carved frame of a splendid painting. Thus for the nineteenth-century burgher, artists would fashion a world where life was more exciting and glorious than in his wildest dreams.

In the course of the nineteenth century, with the growing power and wealth of the bourgeoisie, came an increasing demand for illustrations of 'living dangerously', *vivere pericolosamente*. There can have been few moments in history when so many well-to-do people simultaneously craved excitement. There are many monuments in the major European cities today bearing witness to the magnificent gesture that people made in those days through art and architecture. Be impressed, these buildings seem to cry, look at us: pillars and pediments, statues with Baroque *Schwung*, richly Rococo interiors. The past was plundered to create a world where you could rise above your

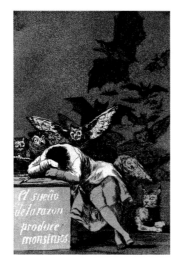

1. *Francisco de Goya,* **The Sleep of Reason Produces Monsters** *(from the series Los Caprichos), 1799 etching and aquatint, 21.5 x 15 cm. Prentenkabinet (Printroom), Rijksmuseum, Amsterdam*

2. *Franz von Stuck,* **Angel Guard***, 1889, oil on canvas, 250 x 167 cm. Museum Villa Stuck, Munich*

everyday dimensions. In these years too, the artist gained a new position in society. No longer simply a person with particular talents, now it was the artist and he (almost always male) alone who had the ability to broaden your perception, to show you an undreamed-of reality. Towards the close of the eighteenth century the artist had come to occupy a marginal position in society. No longer able to count on church, court or nobility for commissions, the artist turned his attention to a world-wide market. And it was the position as outsider that provided him with an essential role in the bourgeois life of the second half of the nineteenth century. The German painter Franz von Stuck (1863-1928) portrayed himself as a guardian angel at the entrance to a world of fiery light (ill.2). You could only enter that world – or indeed know about it – with his guidance. His fellow-citizens of Munich were perfectly aware of this. When the artist celebrated his fiftieth birthday with an elaborate meal, thousands marched through the streets in a torchlight procession to pay him their respects. They wended their way towards his neo-classical mansion where they sang him a hymn of praise. For just one moment the artist appeared on his balcony, acknowledging the crowd, a black silhouette against the brightness within. And of course Von Stuck developed the scene into a painting (ill.3)! Of all the artist-princes of his day he is the only one who took the concept of his own exceptional gifts and qualities and made it the subject of his art.

Von Stuck's self-appreciation stands in striking contrast to that of the previous generation of artists such as Gustave Courbet.

He too felt himself to be an outsider and painted himself in the role of artist. One of his pictures shows him meeting a prominent client while out for a walk in the countryside. The client greets him respectfully with the words *Bonjour, Monsieur Courbet* (the painting's title) (ill.4). Here we see the artist who is a respected person because his work reveals the nature of reality, or – put more pungently – because his work shows the essence of reality. In contrast, Von Stuck represents the world of mystery that lurks behind reality. To summon up these secrets, he and his contemporaries used tales from the past. They were not interested in those narratives as such; what intrigued them were the feelings that the stories evoked. Thus in their pictures they isolated certain significant figures from their narrative context. Instead of pictorial narratives, which viewers were used to from the current genre of history paintings showing biblical and mythological scenes, artists summoned up evocative shapes, appealing to the imagination.

The scene which the British artist John William Waterhouse (1849-1917) painted in 1891 showing the mythological enchantress Circe is a striking example of the way in which the new generation of artists particularized image motifs (ill. 5). In the myth, the sorceress Circe offers a cup containing an enchanted potion to Ulysses; in the painting, however, I the viewer behold her in all her delicious womanhood. I find myself somewhere at her feet, looking up at this empress of love. For me she reveals her magic arts; she enchants me. Ulysses, seen only as a reflection in the round mirror behind her throne, is reduced to one of her attributes. It is not through him, rather, the viewer is confronted head-on with Circe's irresistible powers

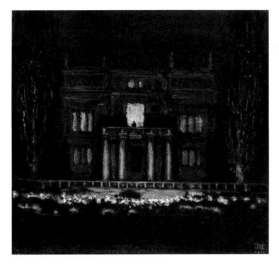

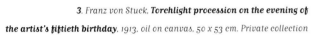

*3. Franz von Stuck, **Torchlight procession on the evening of** **the artist's fiftieth birthday**, 1913, oil on canvas, 50 x 53 cm. Private collection*

*4. Gustave Courbet, **Bonjour, Monsieur Courbet**, 1854, oil on canvas, 132 x 150.5 cm. Musée Fabre, Montpellier*

of attraction. And soon she will change me, together with the companions of Ulysses, into a snorting pig who will forever after lie at her feet in visible witness to her sensual powers. The painter has opened out the story, as it were, for the feelings of the viewer.

The year before he painted the Circe scene, Waterhouse depicted the confrontation between Ulysses and the Sirens (ill.6). These beautiful sea nymphs could sing so delectably that anyone who heard them fell under their spell. So the Greek hero, wishing to preserve himself and his crew, ordered his men to plug their ears with wax. However, he was curious to hear the madrigals himself, so he made the crew bind him firmly to the boat's mast as a measure against possible addictive behaviour. Undoubtedly, Waterhouse based his composition on depictions from Greek vases. Consequently this work looks more like traditional history painting than the Circe picture, but this doesn't mean its effect on the viewer is any less powerful. This is because of the way the artist has presented the boat and the figure of Ulysses. We see the Greek king partly with his back to us and so share the tension he is experiencing. We too are threatened by the seductive nymphs.

So painters manipulated the narratives by adapting the *mise-en-scène* to make the viewer feel part of the scene. This was a ploy already used by artists in the late Middle Ages. Taking the story of Christ's Passion, they distilled a highly emotive figure from it – the Man of Sorrows. The instruments of the Passion, such as nails and crown of thorns, are woven into the picture as the attributes of a tortured Saviour. The painter John William Waterhouse uses a comparable method of im-

age building in his Circe picture, and twenty years earlier the British artist Frederick Sandys (1832-1904) had done the same in his picture of *Medea* (ill.7). Towards the end of the nineteenth century, artists demonstrated their genius at developing their own image motifs to represent the mysteries of life. Thus the English artist Edward Burne-Jones (1833-1898) has constructed his painting *The Wheel of Fortune* using various mythological motifs (ill.8). The figure of Fortuna, actually no more than the personification of an abstract concept, is seen turning a wheel to which naked men are fastened; her eyes are firmly shut. The men undergo the same fate as Ixion in the Greek myth, who was bound to a perpetually revolving wheel as punishment for having attempted to rape the goddess Hera.

A sophisticated arrangement of fore- and back-ground is another method of lending a figure from a history painting a central position. An outstanding example of this is the painting of Cleopatra by the Frenchman Alexandre Cabanel (1823-1889) from 1887 (ill.9). The ravishing queen of Egypt is shown together with a panther and a semi-nude maidservant on a kind of stage where she reclines languishingly upon a chaise longue over which a tiger's skin has been draped. She glances in the direction of a dying man who is being carried away, and the viewer follows her gaze. Cognoscenti will recall that Cleopatra would offer prisoners condemned to death a sip of poison to speed them on their way. The artist wished chiefly to portray a beautiful woman who nevertheless calmly and coolly made men her victims.

Before long, those in search of shapes that embody human appetites and desires come across the strange hybrids, half

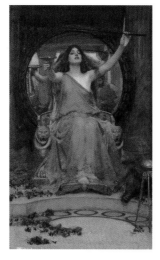

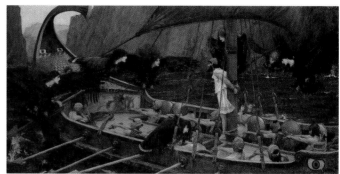

5. *John William Waterhouse, **Circe offering the Cup to Ulysses**, 1891, oil on canvas, 146.5 x 91 cm. Gallery Oldham, Charles Lees Collection, Lancashire*

6. *John William Waterhouse, **Ulysses and the Sirens**, 1891, oil on canvas, 100 x 201.7 cm. National Gallery of Victoria, Melbourne, purchased 1891*

human, half beast: creatures such as griffins, Sirens, sphinxes, mermaids and centaurs. Besides these inventions of classical mythology there are also the creations of self-invented scenes such as we see in a large painting by the German Max Klinger (1857-1920) from 1895 (ill.10). It is an extraordinary picture telling of the unbounded sea that brought forth a pair of lovers, but the mermaid will soon drag the man to the ocean's depths in her passionate embrace. It is a remarkable feature of *fin de siècle* art that intricate narratives, which were purely the invention of the artist, were presented as realistically as possible. The artists of the period used great ingenuity in conceiving pictures that represented the emotions rioting beneath the surface of the dignified bourgeois existence. A rich iconography was created to represent a spectacular and passionate life.

Naturally, it was not only the visual arts that busied themselves with classical themes. In literature, too, old myths were revived. There is the re-telling by the French writer Gustave Flaubert (1821-1880) of the temptations of St Anthony, which first appeared in weekly episodes but was not published in book form until 1874. In Flaubert's version Anthony is no longer seen as the impregnable ascetic who could resist the temptations of seductive females; he has become a fearful nervous man filled with frustrations, which prevent him from ever savouring the delights of life. This radical reinterpretation of traditional narratives characterizes the way in which visual artists applied the iconographic tradition of biblical scenes. For example, Bathsheba and Susannah, traditionally models of chastity whom lustful men desire for their own salacious pastimes, turn up at the end of the nineteenth century as the se-

ductress triumphant. And now it is the men who are subdued. Long before Freud introduced the idea, it was customary in literature and the visual arts to take saints and figures from mythological narratives in order to symbolize forces and feelings that simmer beneath the surface of everyday life. Maybe that's what Goya's monsters are, engendered when reason sleeps? In Flaubert's case, the re-telling of the temptations of St Anthony has, apart from this, a special significance. At the end of the book he discloses: *Antoine, c'était moi*. And similarly, what Waterhouse intends with his composition of *Ulysses and the Sirens* is that the viewer will realize, 'Ulysses, that's me'. This dramatic appeal to the public is an essential aspect of late-nineteenth century art and as a result has led many to dismiss it with scornful qualifications such as 'melodramatic' and 'affected'. It's certainly true that the quantities of variations on the temptations of St Anthony inspired by Flaubert's writing, painted by artists as different as Paul Cézanne and Félicien Rops (p.115), seem rather to have got it in the neck from the viewers.

Because visual representations of significant figures were clearly connected with literary sources, paintings of this type could unhesitatingly be dismissed as 'literary art'. Many critics felt this to be the most devastating judgement imaginable. Art that was truly innovative could not, after all, have its roots in a literary tradition. So said the preachers of the art-for-art's-sake school. Impressionism appeared on the scene and the norms and values of modernism were defined. And so it was that the conceptual quality and the visual power of certain symbolic representations failed to be noticed. A fine example of what I

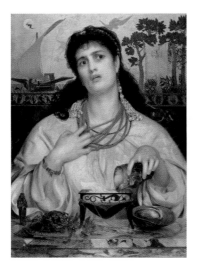 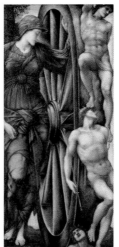

7. *Frederick Sandys*, **Medea**, 1868.

oil on canvas, 62.2 x 46.3 cm. Birmingham City Museum and Art Gallery, Birmingham

8. *Edward Burne-Jones*, **Wheel of Fortune**, 1871-1877.

oil on canvas, 151 x 72.8 cm. The National Gallery of Victoria, Melbourne

mean is the painting titled *La Belle Dame sans Merci* made by John William Waterhouse in 1893, inspired by Keats's poem of the same title, from 1819 (ill.11). Reproductions of this picture decorated the bedroom walls of innocent schoolgirls for a great many years. Indeed, I have known modern-minded parents who politely asked their daughters to remove the picture, on the grounds that it was mere kitsch. This released them (the parents, that is) from the obligation of asking what was so appealing about the representation that for over a century it had the power to entrance the imagination of women like their daughters.

Waterhouse's painting of *La Belle Dame sans Merci* illustrates that the relationship between this type of art and literature is no simple matter. The painting is not simply the illustration of a story. All those little girls were doubtless quite unaware of who exactly *La Belle Dame sans Merci* was. Indeed, had they actually known that the lady of Keats's poem was a heartless harridan (forgive the term) it seems most unlikely that they would have hung her picture on the bedroom wall. The narrative poem is no more than the means towards an unforgettable image with a fascinating poetry of its own. What these artists aimed to do was create scenes that would excite the imagination, and in this they were often successful. Literature, poetry, music and visual art should combine to call into being a world where imagination reigned and everyday reality was left behind.

This is not the first exhibition to be held in the Groninger Museum showing art that presents what I am calling significant, or meaningful, figures. In autumn 1972 the exhibition titled *Het Geheim* (The Secret) was opened here. It showed German art from the period 1870-1900, work rejoicing in allegory and symbolism by such artists as Arnold Böcklin, Max Klinger, Hans Makart, Franz von Stuck and Hans Thoma. It was no trouble for us to borrow major works by these painters, because at that time German museums kept almost all this work in their depots. The reason for this was not only that people found such paintings ugly, they also condemned it as morally reprehensible. If you liked Von Stuck not only did you show poor artistic taste you were also not PC. Those were the years when Dutch culture-vultures only dared to go to the Wagner Festival in Bayreuth without letting anyone know. My colleagues and friends Horst Gerson and Wim Beeren actually refused to attend the opening of *The Secret*. In 1973 the exhibition was chosen as topic of study by a workgroup of the Netherlands Press Foundation because it had been the most heatedly-debated cultural phenomenon of the previous year. And one Dutch weekly pilloried me for being the instigator and organizer of the exhibition, labelling me 'the pervert of Groningen'. Never a dull moment.

In thirty years much has changed. For one thing, the paintings that were brought out of the museum depots for my exhibition, now hang prominently on those very museum walls. They fetch phenomenal prices and are among the most frequently loaned-out works of the museums that own them. So I should like to take the opportunity of thanking the directors of the Groninger Museum and the Museum voor Schone Kunsten in Antwerp. All honour to them for acquiring top works to display in the present exhibition even though nowadays this is a far more

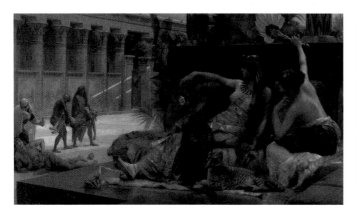

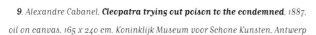

9. *Alexandre Cabanel,* **Cleopatra trying out poison to the condemned**, *1887,*
oil on canvas, 165 x 240 cm. Koninklijk Museum voor Schone Kunsten, Antwerp

10. *Max Klinger,* **Siren**, *1895,*
oil on canvas, 100 x 185 cm. Villa Romana Florenz, Florence

difficult achievement than thirty years ago. Kees van Twist and Paul Huvenne were prepared to bring works from as far away as Australia, so that we could have first-class art on show. In the past few decades, experts have published extensively on the artists who were formerly despised and rejected. There are oeuvre overviews, monographs and, in particular, large numbers of exhibition catalogues available. But there still appears to be a regrettable lack of thorough analyses studying the artistic concepts that give those paintings their highly suggestive effects. The characters who are portrayed are intended to inspire free associations but that seems no reason for art historians to go overboard, in an art historical sense. They seem to get the bit between their teeth and drag in every single writer, composer or thinker of the period – Kierkegaard, Baudelaire, Schopenhauer, Brahms, Wagner, Darwin, Nietzsche, Péladan, Huysmans, there's no end to the list. Not one art historian who pauses to ask what is actually going on in these paintings. And so the art of the significant figure, if I may call it that, is still not taken seriously in the academic world. Interestingly, film and stage directors from Luchino Visconti to Billy Wilder have made a study of the visual language of these paintings, using them as a source of inspiration for both costumes and *mise-en-scène.*

Back in 1972 sphinxes and centaurs from the late nineteenth century looked so fresh and new that we concentrated first of all on understanding the cultural context of these pictures. Echoing through the rooms of the Groninger Museum dramatic lieder from the period could be heard, and sentimental, sometimes melodramatic poems sounded, laden with tragic grief,

brimming with love and loss. In the catalogue accompanying the 1972 exhibition, Walter Schönau wrote an impressive essay on literature and visual art from the nineteenth-century period of the *Gründerzeit,* titled *The Secret: an art of centaurs.* It was then that we decided to hold a sequel to the exhibition in which we would display the heritage not just of one country, but deal with a specific theme from European *fin de siècle* art. Thirty years have passed and here we are. Fatal Women, *femmes fatales,* have stormed the Groninger Museum and taken possession. Shortly they will march on to Antwerp, to the Museum voor Schone Kunsten in that city.

By concentrating on one central theme it becomes almost inevitable that we compare works. It is remarkable the extent to which women who sealed the fate of men (and quite often that of themselves as well) differ from each other. Gradually you notice that not only do these women differ greatly, but so does the visual language with which they are portrayed. So we see not only a great many, but also many different types of *femmes fatales* painted in the *fin de siècle* period. It remains, however, a sub-category of a wider art-historical phenomenon: the iconography of the significant, or meaningful, figure. I would like to emphasize this because the group of pictures under consideration is often treated in isolation in the literature. As a result it is all too easily categorized into many kinds of cultural and social phenomena ranging from women's emancipation to the latest medical discoveries about the transference of syphilis. And so people forget, for that makes life easier, that *fin de siècle* art contains not only seductive Salomes but also martial males like the *Perseus* of Edward Burne-Jones and Böcklin's

11. *John William Waterhouse*, **La Belle Dame sans Merci**, *1893*,

oil on canvas, 112 x 81 cm. Hessisches Landesmuseum, Darmstadt

12. *John Collier*, **Clytemnestra**, *1882*,

oil on canvas, 239,5 x 148 cm. Guildhall Art Gallery, Corporation of London, London

*Der Abenteurer (*The Adventurer). Von Stuck painted both *Judith* and a mythical naked horseman galloping over dead bodies. But above all the artist saw himself as the embodiment of the manly hero who with his undying work overcomes death and matches himself against *femmes fatales*, destructive Fatal Women.

The artists who presented significant figures ensured that their creations were not limited to one straightforward explanation. The motivation of their actions is not given, nor do the stories have a beginning and an end. Take, for example, *Clytemnestra* by John Collier, from 1882 (ill.12). What a woman! Her husband, king Agamemnon of Mycenae, sacrificed their daughter Iphigenia in order to mollify the sea god Poseidon and ensure a prosperous voyage across the waves to Troy. Clytemnestra was left behind while her husband enjoyed himself being a hero in the Trojan War; she sought conjugal comfort with the somewhat ineffectual Aegisthus. When the Trojan War was over Agamemnon finally returned – with the captive Trojan princess Cassandra. Not good news for Clytemnestra. She determined to get rid of him. And since Aegisthus didn't feel up to a little murdering, she planned the execution in the king's own chambers.

So much for the story. The painting, however, illustrates another act. The murder has been committed. Collier's picture goes beyond the representation of history pieces, for Clytemnestra has already made history. The axe is bloodstained, as are her garments. She has sealed her husband's doom and now, with a grandiose gesture, pushes aside the heavy curtain of the chamber of horrors, and stands before me. But who am I – or rather, what does she make of me? Confronted by this woman, I shrivel and become a second Aegisthus. This canvas by Collier doesn't show a *femme fatale* enacting a bold deed within a picture frame. Rather, he has staged a confrontation with me. He presents a figure that arouses profound emotions. But everyone has to discover for themselves exactly what these feelings mean. It goes without saying that generally women will experience something different than men when they look at this scene. One person may associate it with 'womanpower', while others will place themselves in the role of the victim. Here is a woman stained with the blood of her murdered husband and everyone will have an individual reaction. Isn't this a bit melodramatic? It certainly is. But the real drama intended by a painting like this takes place in the mind of the beholder. Whoever ignores this aspect and overlooks it in their art-historical interpretation of the work, will be missing the underlying implications of these significant women.

People who are at home in the world of the theatre will tend to see dramatic scenes in many incidents from daily life. The artist James Tissot was a past master at lifting everyday reality and intensifying it with a dramatic glow. One of his finest paintings hangs in the Museum van Schone Kunsten in Antwerp, titled *The Embarkation at Calais* (ill.13). We see crowds of people milling on the quayside, all busy in their different ways. It won't be long before the boat sets sail. Then she comes and stands beside me on the deck. All the men around her fade into insignificance. Things are only relevant as a kind of backdrop to her being. She looks me straight in the eye,

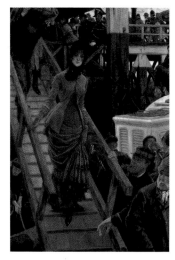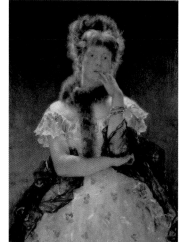

13. *James Tissot*, **Embarkation at Calais**, *1884*,
oil on canvas, *141 x 98 cm. Koninklijk Museum voor Schone Kunsten, Antwerp*

14. *Alfred Stevens*, **The Sphinx of Paris**, *1867*,
oil on canvas, *72 x 53 cm. Koninklijk Museum voor Schone Kunsten, Antwerp*

impassively. I look at her and know I will never again be free. Embarked for eternity.

The exhibition of thirty years ago, titled *The Secret,* illustrated types of allegory and symbolism in German art. A painting like *The Embarkation* wouldn't have fitted in at all. But if you think about the iconography of *femmes fatales* in European art you will realize it's not just a question of significant women with biblical or mythological antecedents. They can pop up anywhere and any time. It is the tasks of artists like Tissot to register their presence in such a way that they become unavoidable and stamp themselves forever upon one's memory. Sometimes the title of a painting already betrays the secret significance of the woman portrayed. Alfred Stevens, for example, painted with great gusto the portrait of an imposing woman (ill.14). Instead of immortalizing her in a dignified pose, he captured her making an almost insignificant gesture with her left hand. Her eyes are open wide and her eyebrows are raised in surprise. Do I frighten her? This seems unlikely, for the picture is titled *The Sphinx of Paris*. The title alone is sufficient guide to set us on the right track.

Judith and Salome, vampires and sphinxes, inhabited the imaginative world of the Norwegian artist Edvard Munch. Indeed, he has illustrated almost the entire list of players in the theatre of the *femme fatale*. Only now there isn't any play to be acted. This artist is not a stage director who wishes to impress the audience with his *mise-en-scène*. Munch's women do not embody a generally accepted notion that always and everywhere, beneath the varnish of civilization and the thin coating of outward appearance, there are uncontrollable forces and powerful desires at work. Munch created symbols through his work to express his own highly individual ambivalence about life. Here it is the artist who demands the main role. In fact, we should no longer speak in theatrical terms. Munch has experienced intensely the inner reality of all the people he paints. He created images to represent the existential fear of that love which always carries death at its heart. He paints a man, solitary and brooding on the seashore, names the picture *Melancholy* and writes of it: 'Man looking out across the sea. Beyond the horizon is an island of happiness. It is light there, and there we shall be together. But the waves are too high…'

Potentially, every woman whom Munch paints is a *femme fatale*, since she brings the expectation of happiness and at the same time the awareness that it is unattainable. Not only is the artist an outsider as far as the social scene is concerned, he actually stands outside life. In his work Munch positioned women in many different configurations. She represents every stage in life. He describes his *Madonna* (ill.15) as follows: 'It is the moment when the whole world ceases moving…In your face is all earthly beauty. Your lips, deep red like the ripening fruit you bear, open softly as if it hurts…the laughter of your body, new life shaking the bony hand of death. The chain linking a thousand generations of dead with a thousand coming ages, is completed.' Munch developed a remarkable language of imagery, which is immediately accessible to us more than a century later and pierces us with its authenticity. His method of stylization succeeds in convincing us that his representations are genuine expressions of things he felt about life. And more, we can also see them as pictures of existential

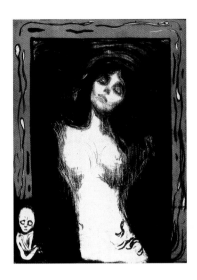

*15. Edvard Munch, **Madonna**, 1895.*
Lithograph, 60 x 44 cm. Munch Museum / Munch-Ellingsen Group, Oslo

experiences that have lost nothing of their timeless validity. This is why Edvard Munch marks the close of the exhibition on *femmes fatales*.

The two previous exhibitions showing art from the second half of the nineteenth century, which I had the pleasure of curating for the Groninger Museum, received completely different reactions from the public. *The Secret*, staged thirty years ago, aroused heated discussions about art and kitsch, good and poor taste (or lack of any taste), and about aesthetic criteria that we still hang on to without ever questioning why, whereby our view of the history of art is sorely hampered. The exhibition titled *Ilya Repin, Russia's Secret* evoked such pleasure and delight there was hardly any room for questions. If there were queries, it was something like — was the woman in the painting showing the unexpected return home of an exhausted man, to be seen as his mother or his wife? In the end, it is always quite unpredictable what emotions any given exhibition will arouse in the public. As curator of *Femmes Fatales*, I cherish a quiet hope: that people will come to see that *fin de siècle* art is just as fascinating today as it was in its own time. Expectations about art were engendered then, which artists of today are still trying to make good.

Schiermonnikoog, June 2002 *

* I thank Ben and Marianne Hijmans-Kleibrink, Elly de Jong and Thijs Tromp.

Marianne Kleibrink

THE MYTHS OF WOMANKIND

THE BATTLE OF THE SEXES

The *femme fatale* is a phenomenon that every woman should appreciate, for she is a symbol of emancipation. After all, handsome, powerful men are, by nature, fatal to women, particularly the disreputable Don Juans who pierce the heart of woman after woman – not to mention other parts of their anatomies – with never a thought for the consequences. All Greek gods fall into the Don-Juan category and their motto would seem to be: the more unwilling the virgin, the more frenzied the pursuit! For it was no less than the highest god of Olympus who brought low many women, notching up Europa, Leda, Io, Alcmene, Aegina, Asteria, Danae and Mnemosyne (ill.1). On the one hand, his behaviour is quite natural; everything belongs to him anyway, so the most beautiful and noble virgins must be his by rights too. But on the other hand: if gods can act like this, how coarse and unscrupulous are merely mortal males likely to be. And, sure enough, we learn from classical literature that at every military victory women were taken captive. They were either ravished on the spot and then killed, or for the rest of their lives paid the penalty for the fighting spirit of their husbands.

According to tradition a sexually unfulfilled man in ancient Athens was looked upon as pitiful and it was for this reason that so-called *pornai*, or whores, were said to have peddled their wares at only 25 cents a time. At least this is the way the relations were described in *The Reign of the Phallus*.[1] Its publication caused quite a stir when it appeared in the 1980s because it included erotic pictures from classical antiquity (ill.2). Before that time they had been stored in museological backrooms, which illustrates how, for a long period, our Western civilization couldn't cope with the way in which the classical world dealt with men's passions. After hard-core feminist views had died down, information gleaned from Antiquity began to be looked at once again from a new angle.[2] As we learn from classical literature, an affair with a boy or a *hetairos* could cost you dearly, mainly due to the fatal appeal which such lovers exercised. Xenophon even had a verb for this luxury, *katape-paiderastekenai*, or 'spending a fortune on lovers'. Installing a *hetairos* in your house was said to lead to your proverbial ruin. In the texts too there are no signs of post-classical shame. We learn from them that those lads that were too eager to ply their trade had abuse like 'baggy arsehole' hurled at them; and that the position the *hetairoi* charged the most for was called 'the race-horse'. It seems plausible that these activities could have become compulsive and thus have played a fatal role.

Our information about the women who sold their bodies in Antiquity contrasts sharply with reports about 'good', or even 'normal' women. As the latter were obliged to stay at home and were not spoken or written about, we know almost nothing about them. The image created emerges exclusively from fiction, particularly mythology. The myths served as a basis for plays, temple decorations, gravestones and similar artistic artefacts. In order to gain a picture of the historical truth we must then first learn to look through the mythological filter.

NYMPHS

In classical myths there existed a fictitious sort of *femme fatale*, which in the Athenian visual language of the fifth century

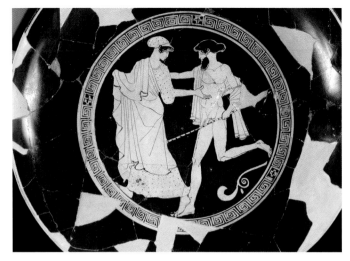

1. Zeus pursuing Aegina, painted by Pentesileia on a dish from circa 450 BC., Kunsthistorisches Museum, Vienna

2. Two men enjoying themselves with an older hetairos, drinking bowl by the so-called Pedieus painter, Musée du Louvre, Paris

before Christ would merge in with that of the *hetairos* of the time. The stories about Actaeon and Hylas show how fatal these characters could be for the men involved. The inquisitive Actaeon wanted to spy on bathing nymphs but, unfortunately for him, Artemis was in their midst. This goddess of wild, unadulterated Nature made sure that indiscreet onlookers were punished; suddenly Actaeon's hounds no longer recognized him and tore their master to pieces. Hylas was Hercules' young lover, who sent him into the woods to fetch water. One of the water-nymphs accidentally caught sight of the delicious young man when he bent across the water's surface with his bronze jug. She informed her sisters and since then Hercules and other lovers have called for him in the woods in vain, crying: 'Hylas, Hylas, Hylas where are you?' (ill.3).

Even in modern-day Greece every male was advised to be careful after midnight in case he should fall into the hands of the nymphs, as some of them employed surprise attack techniques of an extremely aggressive nature: not only did they prowl about in the back garden, but they also disguised themselves as nubile girls to entice ordinary mortals to enter into marital union with them. The poor devils that fell for this ruse could never satisfy the nymphs' excessive sexual desires on a long-term basis and so the nymphs took off again, leaving behind these completely deflated men. Many stories of this kind about nymphs and nereids have been recorded in an impressive anthropological study published in 1970 by the couple Richard and Eva Blum.[3] The stories about the insatiable sexual appetite of these sorts of vamps led to the coining of the term 'nymphomania'. In Antiquity and in the Greece of yes-

teryear they belonged to the realm of natural spirits. Because men in the wild experienced such extreme stimulation, their longing for such creatures led not only to the development of the insatiable woman, but also to the depiction of the naked temptress.

It started off innocently enough. In classical Greek reliefs nymphs are always depicted in groups of three. Usually they are shown performing a choral dance, as on many votary offerings which have been found in caves and wells, the places where they were venerated. The woollen cloaks of the dancing girls indicate cold, damp surroundings; the thick, stiff material of the cloaks means they were often unable to hold one another by the hand and had to hang on to the edge of the other's clothing instead. As the wool they were made of was white, it is no wonder that when peering up at the snowy tops of mount Parnassus or mount Olympus people might have thought they could see the dancing nymphs. Although difficult to imagine, from this anything-but-erotic picture arose the image of the fatal seducer – naked, prone on her back and recognizable by her unequivocal come-hither look, as captured by artists from Giorgone to Manet and Degas.

Athens in the fifth century before Christ was a melting pot of ideas and a place in which images were created at breakneck speed. Here they confused the nymphs which had once taken care of the little Dionysus (also depicted clothed, in a threesome) with the wild maenads from his later retinue. The mountain and foster-mother nymphs are fictitious, but maenads were imitated and played by real women, like those

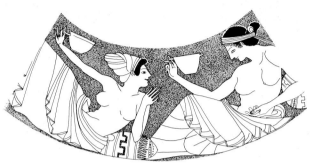

*3. **Hylas abducted by nymphs**, mosaic floor from the Iunius Bassus basilica in Rome, AD 320-350, lost*

*4. **Hetairoi hold a symposium**, drinking bowl from 525 BC, Antikensammlung, Munich*

hired for the symposium, the men's banquet, that often ended in a *komos*, a drunken procession in honour of Dionysus (ill.4). Just like the rest of the company the most they would be wearing was a loose cape in order to be able to submit to the men's sexual appetites at the flick of a wrist. The result of the merging of nymphs, maenads and real women in art is the reclining, lonely, naked form, which would eventually come to symbolize the 'virginal wilderness', with its implicit reference to male cultivation (ill.5).

The subtlety of this classical Greek world of images may easily escape the modern onlooker, so two striking examples are called for. Many of the coins minted by Greek colonial towns on Sicily are adorned by a nymph; the place itself is often named after her. Here the female body is a metaphor for the virginal, fertile, native landscape that was 'taken' by the errant Greek hero who, according to tradition, founded the city often depicted on the back of the coin. One of the earliest and most lovely depictions of an alluring naked nymph was cut into a gemstone – most certainly the jewel of an expensive hetairos, since other people rarely wore jewellery (ill.6). The owner must have been keen to appear innocent, as if he were a 'natural' seducer.[4]

DAUGHTERS OF LIGHT

If anyone was ever a true *femme fatale* it must have been Helen, most beautiful of all women. Although married to Menelaus, she was abducted by the Trojan prince Paris; she had been promised to him by Aphrodite as a reward for his deciding to elect her the most beautiful of all goddesses (ill. 7).

The way Helen was kidnapped by Paris from her husband's palace in Sparta meant that Menelaus' honour had been tarnished, so in an attempt to recapture his wife he and his warlord allies besieged Troy. After a ten-year siege the city fell, but in the meantime Helen had cost the lives of almost all the Trojans and many famous Greek heroes as well. European historians thought that fighting so furiously for a woman was so unlikely that all sorts of alternative explanations for the event were put forward. For instance they thought, quite wrongly, that the Greeks had economic motives for waging war against the Trojans. And Helen? Alas, she could not be blamed. Some sources state that that the tricksy goddess Aphrodite had given an *eidon* or *phasma*, an image made of airy spirit, to Paris and that the real Helen was in Egypt. She was even venerated in Laconia, in the southeast Peloponnese.

The sense of a story depicting pure losers like this one becomes clearer if we unravel the Helen myth further. Paris was not the first person to have carried her off. As a girl she had already experienced it once before when Theseus took her to Aithra in Attica. The name of the kidnapper sounds familiar, for wasn't it he that also took Ariadne from Crete - only to leave her behind in Naxos? Heroes like Helen, Ariadne and, really and truly, all damsels of the kidnapped-maiden type have an indisputably fatal aspect to them. Although they often bear princely and heroic children, they frequently cause the death of many others and force gods and heroes to carry out immoral acts. Religious studies explain these *fatal women* as 'faded goddesses', female personifications of several powers worshipped at some time in various Greek regions. Particularly

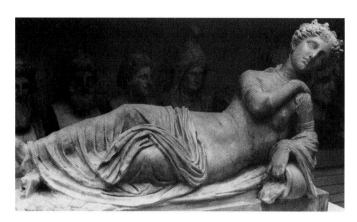

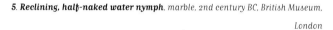

5. Reclining, half-naked water nymph, marble, 2nd century BC, British Museum, London

6. Reclining, half-naked nymph stroking a crane, a flying insect near her head, chalcedony, British Museum, London

powers of light and time, those who, for instance, know their way through the Labyrinth or the entrance to Thebes, like Ariadne and the Sphinx, belong to this group. Invariably they play a role in stories about the spilling of human blood: in the Labyrinth seven boys and girls are annually sacrificed while in front of the gate at Thebes only those who could solve the riddle of the Sphinx were spared execution.

Helen of Sparta was adept in making magic potions; exotic princesses like Medea and Circe were even more skilful than she. They came from the areas of Black Seas and from the region near Naples. Circe turned Ulysses' chums into pigs whilst Medea killed the powerful king Pelias. After she had shown that she could change a ram into a lamb by boiling the animal in a cauldron full of rejuvenating elixir, she proceeded to put Pelias into it to achieve the same result, only in his case she accidentally forgot to add the herbs to the water. In stories about the two of them no mention is made of unusual beauty or sensuality, but what is stressed is their ruses and sorcery. One of the reasons they resorted to such behaviour was to ensure that Ulysses and Jason could stay with them, however they were not successful because the pair were foreigners (ill.8). By the looks of it, people did sympathize with these women, because in classical literature they weren't punished by the gods. The famous complaint uttered by the leading lady in Euripides' Medea, about what misfortune her love for Jason had brought her, was apparently a widely supported lament. Medea was even able to escape after thwarting Jason by killing his children and later on in Athens she tried to poison Theseus,

her new husband Aigeus' son. Although her deeds are often associated with magic potions and poisonous draughts, she is also the prototype of the *femme fatale*, and portrayed with her sword is the forerunner in portrait of such women as Judith. Painted vases portray her like this in the child murder scenes and in depictions of Theseus pursuing his stepmother.

The background of women like Medea and Helen is even more complicated than sketched above: the first was descended from the sun god Helios and the second was supposed to be no less than a goddess of light. After having committed her gruesome deeds, Medea departed in a wagon drawn by snakes, sent by her forefather Apollo, to become the founding mother of the Medes, a tribe that had settled in the northern uplands of present-day Iran. Nevertheless, the myths about her child molestation are closely tied in with several Greek cults. In Perachora near Corinth, for instance, people celebrated a Medea festival in which seven boys and girls were 'hidden'. That calls to mind Ariadne's labyrinth where Athenian boys and girls were sent to perform liberation dances. Stories like these lead one to suspect that such sorceresses from later mythology were linked with shrines where initiation rites took place in early Grecian times. This did not make the Helens, Iphigeneias, Ariadnes and Medeas any less frightening. Quite the contrary, their loathsome character traits had an important significance for the adolescents who were undergoing the initiation. They had to prove they could conquer the 'evil goddess' and thus show their ability to protect themselves and their community that had sent them there from evil.

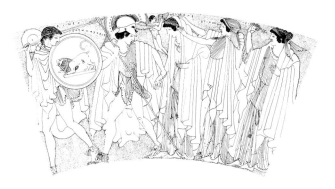

7. Paris abducting Helen, showing Aphrodite — the goddess who gave Helen to Paris
as a reward — arranging Helen's veil, goblet from 480 BC.
Charlottenburg Museum, Berlin

MOTHER GODDESSES

In all cultures around the Mediterranean there are stories featuring the mother of the universe and the god of the seasons. In these stories a sacrifice is made each year of a certain young god, as took place during the services for Cybele and Attis. Similar cults have been explained as vernal equinox festivals in which people celebrated the return of vegetation and vegetable life by the death of the deity, or at least the blood, as in the case of Attis who castrated himself. Such stories are said to be evidence of the original vegetation and moon celebrations; the abduction, the sojourn in the underworld or the annual death can be seen in this framework to refer to the dead months in nature or the three days in which the moon doesn't show its face. If you continue to bundle together these and related stories and cults then, all things considered, Mary and Jesus Christ fit into the same pattern, and allegations of fundamentalism arise.

Thus, unfortunately, there is now the Goddess Movement, based on inaccurate interpretations of archaeological information. Even before archaeology developed into a scientific discipline a number of books appeared – like Johann Jakob Bachofens *Mutterrecht* in 1861 and Sir James Frazer's *The Golden Bough* in the years 1911-1915 – which were to be decisive for a quasi-religious movement which had meanwhile acquired a large following. Its adherents believed that humankind in prehistoric times worshipped a mother goddess who was succeeded later in history by a male god. Characteristic for the movement is the belief that warriors must have brought the patriarchal religions with them during the Bronze Age between 4000 and 3000 before Christ. Bachofen and Frazer, on the other hand, alleged that the primitive matriarchal religion had been replaced by a more rational and manly variant, to distance themselves from the worldly and bloody rituals which the old traditions brought with them. After all, the mother of the universe, or Earth Mother, demanded a new young man every year and the sacrifice of the previous one. In Bachofen's chronology the oldest mother-goddess era can be traced back to the period in which the Amazons ruled over the earth. They made such a mess of the job that male rule was welcomed with open arms.

It is of course fine if women can find support in worshiping a Great Goddess. In addition to the Goddess Movement there are several philosophical movements that are more or less similar, like the Gaia Movement. This does not detract from the fact that the historical argumentation for a matriarchal beginning of divine worship is extremely shaky.

Nevertheless, this theory cannot be left unmentioned, because the notion of a mother goddess is in essence linked with the *femme fatale*. In order to be able to exist and to permit life on earth the mother of the universe demands the annual sacrifice of a young man. No wonder this led to a father god. But this gruesome myth is not generally celebrated in practice in a rigid way. During the festivities involving Adonis, a similar figure to Attis, the women in Athens fiddled around a bit with some plants on plates. This illustrates the principal that the myths really did relate ghastly deeds, but that in the cults grafted onto them people were seldom sacrificed or castrated.

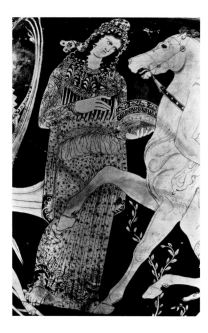

8. *Medea on her box with magic herbs*, *part of the Talos death scene, painted on an ornamental vase from circa 400 BC. The bonnet with earflaps is a reference to Medea's non-Greek origins. The dumb robot Talos was the guardian of the island of Crete, killed by Medea's sorcery because he did not want to allow the Argonauts onto the island. Formerly Jatta Collection*

I am not so much intrigued by the mythological implications and the cult explanations for the phenomenon of the *femme fatale*, but more by the origin and development of the ineradicable schemes which determine her depiction in the fine arts. The Cybele scheme is misleadingly simple: she is invariably portrayed frontally, standing or sitting on a throne. Furthermore, in Antiquity she was usually flanked by two dangerous animals or plants and trees to show that she ruled over nature. The customary picture of the rulers, in state attire, looking impassively in front of them, does not come out of the blue. Catherine II, Elizabeth, Beatrix, all of them exude an air of coolness: you might just as well die, because I am unassailable.

EMPRESSES

Only the supremely powerful women like Cleopatra and Messalina are truly dangerous for men. It is possible that a number of stories which have arisen involving them are mythical in character. The mere fact that such stories did the rounds, however, implies that they were indeed powerful enough to do what they were alleged to have done.

Cleopatra was able to hold on to Caesar and Anthony when the Roman army was clearly advancing and her love affairs were certainly tied in with state politics. She reigned, as the last queen of the Ptolomaic dynasty in Egypt, with her brother as her consort. When he had ousted her, she arrived, rolled in a carpet, as a suppliant before Julius Caesar in Alexandria. With the defeat of her brother, he gave her back her power once again and in return she bore him a son, the later Ptolemaeus XV. During her marriage to Anthony she played for even higher

stakes. He gave her control of half of the Mediterranean, called her the 'Queen of Queens' and Caesar's son the 'King of Kings'. It is interesting to note that she dared to present herself as the new Isis, whereby the goddess who demanded sacrifices and the power-mad queen were then united. It goes almost without saying that Cleopatra was portrayed frontally and statically.

Octavian, Anthony's rival in Rome and the later emperor Augustus Caesar, realized he was actually waging war against Cleopatra. He rightly saw in her the arch-enemy of the Roman states, which is why he referred to her as a *fatale mostrum*! [6] He was deaf to her appeals to be allowed to continue to reign with him when he won the battle at Actium. Out of sheer necessity Cleopatra decided to take her own life, for if she had not she feared she would have been dragged in triumph through Rome.

Messalina was barely an adolescent when she married the emperor Claudius, thirty years her senior. It is reported that she obtained so much power that she could give herself to a great number of men without being punished. The same could not be said for most of her partners who were almost immediately killed, something which was blamed on Messalina's intrigues. Rumour has it that Messalina in her longing for sexual adventures did not shun the brothel or the gutter. In AD 48 she was sentenced to death and the *damnatio memoriae* was pronounced on her. So after that no picture or text was allowed to remain as a reminder of her.

Recent research has revealed how all the gossip and slander about Messalina arose. She tried to maintain her position in all sorts of ways in the unstable world of the imperial court and

strove above all to ensure her son's future as the new emperor. Despite the ban, several Roman historians have recorded the story of Messalina without worrying about possible sanctions, but almost no pictures survived. The only known likeness, carved into a ring stone which is now in Paris, does not show a particularly sensual or beautiful woman. This contrasts sharply with the image presented in the many films made about her in the first half of the twentieth century, which drew their inspiration from this tragic historical character. From 1910 to 1930 four films about her were released and in the period 1930 to 1949 yet another seven. None were made by famous directors nor were any leading actors to be found among their casts.[7]

In Rome in the first century before Christ a different, more encouraging cliché arose with Messalina-type characteristics. Aristocratic ladies who often hung around in circles where culturally and politically high-ranking men were to be found, were the easy butt of intensive smear campaigns meant to force them back into the straightjacket of the modest matrona. The famous Clodia, upon whom Cicero in one of his speeches projected all his prejudices about female licentiousness, is an important case in question. Her story shows that the *femme fatale* in the Roman Republic was no longer a purely fictitious phenomenon either in word or in image, but that a woman existed who designed her own code of behaviour, which went beyond the extremely intolerant bounds considered fitting for her sex.

Gods and men were long able to do whatever they liked, the higher their rank the greater the impunity. In such a world the true *femme fatale* could not develop, but the imaginary version could, as we have so amply seen. The case of Clodia, however, indicates that the mythological frames no longer counted, or at least began to slacken. In the arts, on the other hand, the traditional images continued to exist, like that of the reclining, naked nymph, that of the woman with the sword and that of the alluring, untouchable mistress. The Romans copied them from the Greeks and after that they were re-launched with considerable verve by Renaissance artists. Their influence still continues, as can be seen in the way even present-day queens have chosen to have their portraits painted.

Marianne Kleibrink is professor of Classical Archaeology at Groningen University.

Sijbolt Noorda

JAËL, JUDITH & SALOME – FEMMES FATALES IN THE BIBLICAL TRADITION

In Rome in 1868 the young French artist Henri Regnault made an oil sketch of a woman he had met there. In Tangiers he developed the sketch into a portrait. Later he added strips of canvas on both sides and along the lower edge and produced a picture of a seated woman (ill.1). She appears before us in a relaxed pose, clothed in a literally gleaming and glittering skirt with a blouse that leaves her throat and right shoulder bare. On her lap lies a copper dish upon which rests an Arabian dagger sheathed in a damascene case.[1] Writing to his father, Regnault described the process by which the portrait came into being. He had contemplated various titles for the work: *A Favourite Slave Girl*, *A Poetess from Cordova*, *An African Woman*, *Herodias* – but finally decided upon *Salomé*.[2] And so the picture of a smiling woman in exotic dress entered cultural history with its own baggage. For those who are acquainted with European culture Salome isn't just 'any old female', nor an insignificant name. Indeed, her name is a banner, something of a signifier, and it is the lid that covers a box filled with associations, directives and implications.

Every culture has its own mental library containing names and stories, images, songs and melodies, collective memories and life experiences. These cover countless figures from fiction and real life, from the Emperor Nero to Captain Nemo, both Peter and Pinocchio, consoling words such as 'and they lived happily ever after' as well as nightmares like that of the murderer whose victim returns to haunt him. We find moralistic teachings about life – 'though a lie is quick as a serpent's tongue, truth will triumph in the end' – side by side with unpunished murderous deeds, the tale of the suitors killed by the vengeful Princess Turandot, fragments of actual history surrounded by a mixture of fantasies and dreams.

Our collective memory works like an ordinary memory. It stores the most commonplace occurrences along with the most improbable, suppresses the most frightening, transforms the most beautiful into recollections even more beautiful, takes the ugliest and tries to soften the rough edges. Sometimes the memory is a source of instruction and entertainment, then again it may provide material for propaganda or education, may be evidence of conformity or a spur to rebellion. No one holds the copyright and there is no teacher with the one correct explanation. The cultural memory grows and expands, just as it forgets. It makes astonishing connections between things and with the greatest of ease combines what appears vastly different. You open a drawer and to your amazement find it full of things that you had thought long lost and forgotten.

Interest in the collective cultural store varies greatly from age to age. Things people think important in one period are ignored in another one. In the public library of Culture some corners are busily frequented while others seldom attract interest, or only from the specialists. Stories and representations such as those about Salome are familiar to anyone with a little cultural baggage. She has been, as it were, selected from the collective memory and stored in the private data-base of artists and readers and viewers, frequently in a highly individualized version. This is also true of the concept of the *femme fatale*, the theme of the exhibition to be held in the Groninger Museum and Museum voor Schone Kunsten, Antwerp. The collective memory has many dangerous women in its records, with various forms, from various periods and provenances; they are seldom autobiographical, almost always a male fantasy. This is in direct ratio to the excessive number of male suppliers, curators and users of the cultural archives.

Interestingly, the *femme fatale* has been with us for much longer than you might imagine.[3] She's there in classical Greek myths, as Pandora, the first mortal woman, whom the father god Zeus, in a vengeful moment, presented to humankind not exactly as an unqualified delight. And Cleopatra didn't become world famous because of her linguistic skills. Then ten years

*1. Henri-Alexandre-Georges Regnault, **Salomé**, 1870,
oil on canvas, 160 x 102.9 cm. The Metropolitan Museum of Art, New York,
gift of George F. Baker, 1916*

ago we were introduced to Bella's *Dirty Weekend*. One morning she woke up and decided she's had enough of being leered at and metaphorically licked up by men, and arming herself with a hammer or stiletto she went to war.[4] Meanwhile, at the very moment that I sit writing this, Brian De Palma's film *Femme fatale* is showing at the cinema on the corner.

In one of the much-visited corners of our cultural archives we find the Bible. Much could be said about this collection of texts, by way of preventing misunderstanding and as evidence of its unique and specific character. But I won't go into that here, merely pointing out however that the Bible arose out of the age-old traditions of first the Jewish and then the Christian faithful. And beside this, the contents were continually reinterpreted and translated according to tried and tested notions and beliefs. This was done by scholars of greatly varying backgrounds, some sympathetic and some critical, some favourably disposed and some quite the contrary. Thus the Bible has become literally a piece of collectively-owned property. If it is true of any one book that its meaning rests with its readers, then it is certainly true of the Bible.

Dangerous, life-threatening women don't figure as the main theme in the Bible, but scattered through its pages they are certainly to be found, and they often play a major role. I shall discuss three biblical *femmes fatales* – Jael, Judith and Salome, in that order. The original history of Jael took place when the Israelites were a nomadic people, the story of Judith unfolds against the backdrop of the Maccabaean period, while Salome was a Jewish princess who lived in the first century

AD when the early Christians were beginning to split from mainstream Judaism. All three women have stood the test of centuries magnificently, it must be said, and possibly thanks above all to their chameleon qualities. Adapting their outward appearance to the changing time, they have thus remained recognizable down the ages. With each successive generation, new manifestations of Jael, Judith and Salome were adapted and produced for the eager public. I shall attempt to give an impression of this historic process in what follows. But I begin with an ancient telling.

JAEL – WITH HAMMER AND TENT PEG

[24]*Most blessed of women be Jael, the wife of Heber the Kenite, of tent-dwelling women most blessed.*
[25]*He asked water and she gave him milk,
she brought him curds in a lordly bowl.*
[26]*She put her hand to the tent peg and her right hand to the workmen's mallet; she struck Sisera a blow,
she crushed his head, she shattered and pierced his temple.*
[27]*He sank, he fell, he lay still at her feet;
at her feet he sank, he fell; where he sank, there he fell dead.*

[28]*Out of the window she peered, the mother of Sisera gazed through the lattice: 'Why is his chariot so long in coming? Why tarry the hoofbeats of his chariots?'*
[29]*Her wisest ladies make answer, indeed,
she answers the question herself:*
[30]*'Are they not finding and dividing the spoil?
– A girl or two for every man; spoil of dyed stuffs for Sisera,*

spoil of dyed stuffs embroidered, two pieces of dyed work
embroidered for my neck as spoil?'

[31]*So perish all your enemies, O LORD!*
But may your friends be like the sun as it rises in its might.[5]

Once upon a time, about three thousand years ago, the tribes of Israel were under the thumb of their Canaanite neighbours. King Jabin and his army general Sisera ruled with a heavy hand. The narrator of the biblical account needed few words to describe this situation, saving himself for his description of the heroic act that would bring this oppression to an end.[6] At the suggestion of the prophetess Deborah, Barak gathered about ten thousand fighting men and went into battle against Sisera. Wonder above wonder, although Sisera had 'nine hundred chariots of iron' Barak managed to decimate his entire army, and Sisera was forced to flee on foot. He sought refuge with a friendly nomadic clan headed by Heber the Kenite. Jael, Heber's wife, went out to meet Sisera and invited him into her tent. Her words are, 'Turn in, my lord, turn in to me; fear not.' But no sooner was he fast asleep than she took one of the tent pegs and hammered it through his head so that he lay fastened to the ground.

In the biblical account there follows the so-called Song of Deborah in which she retells the whole story, in the form of a psalm of praise to the God of Israel. The passage cited above is taken from the end of this song. The text is more than a straight narration of events. It contrasts Jael's apparent hospitality – 'he asked water and she gave him milk' – with her mur-derous action, told with rhythmic hammer-like words that echo the blows upon the tent peg. In conclusion there is an almost cynical account of how Sisera's mother waited, expecting his triumphant return, contrasting with the reality which is already known to the reader or hearer of the story. Neither Sisera nor a single man from his army will return home bearing their booty of damsels and costly coloured weavings. For the prophetess Deborah there is every reason to praise God and make the concluding wish that all his enemies may perish in like manner, while his friends appear irrepressible as the rising sun.

It isn't surprising that this story has survived three thousand years. Not only because it was preserved in biblical manuscripts but chiefly because it represented for Israel the inextinguishable hope of liberation. If things could turn out so badly for the oppressor in the days of Jael and Deborah, might this not also be true again?

Once a story like this has been absorbed into the collective memory of a national and religious community it becomes part of the standard repertoire of national history and serves to maintain faith in God. It is certainly unusual, in the context of a patriarchal society, that this story has women as the main actors, but that seems to make it all the more appealing. This is certainly enhanced by the contrast between the nomadic shepherd's wife and the army general, the calculating behaviour of the woman who has the whole situation in control and the man's naive confidence that nothing can happen to him because she's only a woman. Furthermore, there is an erotic element, although nowhere explicit in the text but suggested by the situation. After all, a man and a woman alone in a tent

at night...the imagination has a ball. Indeed, in some later Jewish traditions the lacunae in the text were elaborately filled in; a story was woven telling of a nightlong union between the lovely shepherdess and the army captain.

The Hebrew Bible became part of the Christian Bible and Christians applied the experiences and history of the Israelites to themselves and their own national history. Thus stories like that of Jael became internationally known. Indeed, Jael's deed of resistance is not only sung by contemporary Israeli songwriters but also served to encourage Dutch women in their struggle against the might of Spain during the sixteenth-century Dutch Revolt, as exemplified by Kenau Simons Hasselaar during the siege of Haarlem.[7]

But there is more to the story of Jael than her giving a man his comeuppance. From the first centuries of Christendom the Hebrew Bible was read by Christian theologians as if it were one vast typological preview of the new story of salvation. They were not so much interested in the military oppression of one tribe and the courageous resistance of another, as with the worldwide Battle against Evil. And they reinterpreted Jael against this background. They placed her in the same category as other courageous women, even with the chief Christian female model, Mary the mother of God, who through her virtuous deeds placed the serpent Devil forever under her foot. This interpretation of Jael shows the extent of the creative freedom that later readers – in this case Christian theologians – permitted themselves. Pause for a moment to recall the original figure of Jael – a nomadic woman who for obscure reasons best known to herself, lured the enemy captain into her tent and proceeded to murder him in his sleep. If we consider that she is praised by the prophetess Deborah as a meet instrument of Israel's god and centuries later seen by Christian scholars as the harbinger of Christian salvation, it will become clear that people and events are given significances and are named and labelled after the event in ways that they would not for a moment have suspected.

Jael is a prominent figure in the list of worthy women who were described in word and picture during the Middle Ages and the Renaissance. With her fixed attributes of a hammer and the famous tent peg she is on the one hand the personification of dauntless virtue worthy to be imitated and on the other hand a warning spectre embodying female guile and deceit.[8] The moralistic reading matter and illustrated prints of the period had a pronounced preference for the topos of the fickleness of females. The arguments to promote this theme were taken from biblical history and classical mythology. And Jael, of course, fitted in perfectly. The title page of a book from 1532 bearing the words *Dat bedroch der vrouwen* (The Deceit of Women) with as subtitle 'for the erudition and an example to all men, young and old, that they might know how deceitful and surly and how full of guile all women are' shows a woodcut representing the murder of Sisera by Jael . And this was by no means unique. Around 1515 Jael began a career as a warning example illustrating educational prints. In those years the engraver Lucas van Leyden marketed two series of prints showing Jael in the company of such figures as Adam and Eve, Samson and Delilah, the wives of King Solomon, Jezebel and Ahab, and, behold, Salome with the head of John the Baptist. This

row of beauties was to illustrate how deceitful and dangerous women had always been for men. The fact that each seductive lady in the list appeared with her male victim would suggest that the aim was the re-education of men. The moral to be learnt was: good men, beware! If monarchs and musclemen failed to resist female wiles, how much the more should the ordinary man be ever on his guard.

Thus a sympathetic attitude towards the heroine could apparently change into pity for the victim, the winner's perspective switched to that of the loser. For those who place themselves upon the other side – think for example of how the Song of Deborah gloats with malicious pleasure over the scene showing Sisera's mother – and consider history from the angle of the victim with the deadly tent peg through his head, then Jael is a pretty nasty piece of work. Not the helpful hostess, not the caring member of the service sector, which she pretended to be. This way of looking at things brings to light a classic hidden truth: since she is a woman and her victim is a man, Jael is transferred from the department of heroes and heroines to that of bad fairies and witches and other dangerous females. And the arguments used to convict her are summoned out of the deep recesses of the centuries through which women have been and are accused and judged.

JUDITH – WITH HIS OWN SWORD

Judith, the heroine of the biblical book of that name is no more nor less than a magnified and more detailed version of Jael. Like her precursor, Judith kills with her own hand the leader of the enemy (in his tent this time) whom she has seduced with her beauty. However, there is a twist in the story of Judith, for the man doesn't arrive innocently asking for shelter. Cunning as a double agent, Judith contrives to worm her way into the presence of the general, assisted by the combination of her great beauty and his lust. Then when he is sleeping she beheads him with his own sword.[9]

4She put sandals on her feet, and put on her anklets, bracelets, rings, earrings, and all her other jewelry. Thus she made herself very beautiful, to entice the eyes of all the men who might see her. [...] 16Then Judith came in and lay down. Holofernes' heart was ravished with her and his passion was aroused, for he had been waiting for an opportunity to seduce her from the day he first saw her. 17So Holofernes said to her, "Have a drink and be merry with us!" 18Judith said, "I will gladly drink, my lord, because today is the greatest day in my whole life." 19Then she took what her maid had prepared and ate and drank before him. 20Holofernes was greatly pleased with her, and drank a great quantity of wine, much more than he had ever drunk in any one day since he was born. [...] 4So everyone went out, and no one, either small or great, was left in the bedchamber. Then Judith, standing beside his bed, said in her heart, "O Lord God of all might, look in this hour on the work of my hands for the exaltation of Jerusalem. 5Now indeed is the time to help your heritage and to carry out my design to destroy the enemies who have risen up against us." 6She went up to the bedpost near Holofernes' head, and took down his sword that hung there. 7She came close to his bed, took hold of the

hair of his head, and said, "Give me strength today, O Lord God of Israel!" *8*Then she struck his neck twice with all her might, and cut off his head. *9*Next she rolled his body off the bed and pulled down the canopy from the posts. Soon afterward she went out and gave Holofernes' head to her maid, *10*who placed it in her food bag. Then the two of them went out together, as they were accustomed to do for prayer. They passed through the camp, circled around the valley, and went up the mountain to Bethulia, and came to its gates.

So Judith brought the decapitated head of Holofernes in triumph to the besieged city where she lived[10]:

*15*Then she pulled the head out of the bag and showed it to them, and said, "See here, the head of Holofernes, the commander of the Assyrian army, and here is the canopy beneath which he lay in his drunken stupor. The Lord has struck him down by the hand of a woman. *16*As the Lord lives, who has protected me in the way I went, I swear that it was my face that seduced him to his destruction, and that he committed no sin with me, to defile and shame me." *17*All the people were greatly astonished.

Just as in the case of Jael, these events give rise to a song of praise from the persecuted, who have been helped by the hand of their god to an unimagined victory[11]:

*5*But the Lord Almighty has foiled them by the hand of a woman. *6*For their mighty one did not fall by the hands of the young men, nor did the sons of the Titans strike him down, nor did tall giants set upon him; but Judith daughter of Merari with the beauty of her countenance undid him. *7*For she put away her widow's clothing to exalt the oppressed in Israel. She anointed her face with perfume; *8*she fastened her hair with a tiara and put on a linen gown to beguile him. *9*Her sandal ravished his eyes, her beauty captivated his mind, and the sword severed his neck!

*10*The Persians trembled at her boldness, the Medes were daunted at her daring. *11*Then my oppressed people shouted; my weak people cried out, and the enemy trembled; they lifted up their voices, and the enemy were turned back.

This song of thanks and praise by Judith balances her prayer for help and support before she undertakes her daring action[12]:

*10*By the deceit of my lips strike down the slave with the prince and the prince with his servant; crush their arrogance by the hand of a woman. *11*For your strength does not depend on numbers, nor your might on the powerful. But you are the God of the lowly, helper of the oppressed, upholder of the weak, protector of the forsaken, savior of those without hope. *12*Please, please, God of my father, God of the heritage of Israel, Lord of heaven and earth, Creator of the waters, King of all your creation, hear my prayer! *13*Make my deceitful words bring wound and bruise on those who have planned cruel things against your covenant, and against your sacred house, and against Mount Zion, and against the house your children possess. *14*Let

your whole nation and every tribe know and understand that you are God, the God of all power and might, and that there is no other who protects the people of Israel but you alone!

The story of Judith takes place in the sixth century BC. The Book of Judith was written centuries later as a propaganda narrative, recounting how a besieged Jewish city was saved by one of its pious female inhabitants. Jael, meaning 'mountain goat' in Hebrew, is a non-Jewish nomadic herdsman's wife who helps save the Israelites; Judith, meaning literally 'a Jewess' is presented as the model of Jewish female piety and patriotism, who undertakes a deceitful seduction strategy in order to subjugate the enemy leader. While in the case of Jael it is difficult to establish what is fact and what is fiction, with Judith we have no such problem. Hers is not a historic account but a detailed and imaginative educational text in which the prayers and poetic passages before and after the main story firmly emphasize the lesson to be learnt.

Although later readers of her story can only guess at Jael's motivation, with Judith we are left in not the slightest doubt. She deliberately plots the murder of Holofernes, calculating how to make use of his weak spots. Sisera's unsuspecting attitude and his underestimation of a woman make him vulnerable. He goes to sleep convinced that all is well. Nor does it occur to Holfoernes that he could have anything to fear from a woman. However, he is not only naively confident; he is the willing victim of his own lust.

Thus we should not be surprised to learn that at the reception counter in the cultural lending library there is more demand for Judith than for Jael. Quite simply, there is more meat in her story – the main characters are more fully fleshed and more subtly drawn. There is more to be had from the story of Judith. This becomes quite clear when we look at the many historical interpretations, the illustrations and the different versions of the Judith narrative.[13] Sometimes we find her pictured as a patriotic figure using her beauty in order to overthrow the national enemy, a heroine of the resistance; then again she may be seen as the strong woman who thwarts an attempted rape and avenges this planned violation with the man's own weapon, a sword. Dutch artists such as Maerten van Heemskerck have portrayed her in the former role while the Italian woman artist Artemisia Gentileschi presented her in the other. Such painters as Jan Massys and Cristofano Allori perceived her as an erotic icon, while on the southern portal of Amiens Cathedral she appears as the epitome of biblical piety and virtue. Some artists, such as Christian Friedrich Hebbel, see and stress her confusion and crisis of conscience, while others, including Prudentius, emphasize her self-control, wisdom, righteousness and courageous determination.

In Judith we find the paradox of vice and virtue while in her audience lurk the prejudices arising from an ambiguous mixture of innocence and guilt. In combination these create a legion of visions and identifications. Not surprisingly, she had many politically-oriented followers, ranging from Elizabeth I of England to the assassin of William the Silent. Then there was Charlotte de Corday d'Armont, who, using deceitful subterfuges, wormed her way into the presence of the French Revolutionary leader, Jean Paul Marat and killed him in his bathtub. Furthermore, in

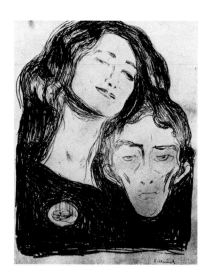

*2. Edvard Munch, **Salomé**, 1902,*
lithograph, 40.5 x 30.5 cm, Munch Museum / Munch-Ellingsen Group, Oslo

history the very same work of art has sometimes undergone re-markable transformations of interpretation. Donatello's bronze statue showing Judith and Holofernes was bought by Cosimo de Medici to symbolize his power and authority. But in 1495 after the Medici had been expelled from Florence, it was re-interpreted to become the symbol of bourgeois resistance. The statue was removed from the palace gardens and, complete with an appropriate new inscription, placed in the Piazza della Signoria where it stands to this very day.

SALOME – FEMALE LEAD GOES SOLO

Back to the painting by Henri Regnault, showing a brown-skinned beauty who in the course of the picture's creation was given the name of *Salomé*. This work was something of a novelty. Salome had rarely been presented on her own before, that is, without the accompanying head of her victim, John the Baptist. Regnault's friend Pierre Puvis de Chavannes had portrayed her several times between the years 1856 and 1869 in various ways, quite individual to him – as the one giving the executioner the command to kill, and then again as a thought-ful spectator at the execution.[14] However, in all his represen-tations of Salome, Puvis de Chavannes showed her as part of a fuller picture, that being the complete spectacle of the beheading of the prophet John the Baptist. Unlike his friend, Regnault omits almost all the circumstantial detail: no victim, no executioner, no sword, certainly no king or queen, only a copper dish and a dagger. From now on, Salome can perform solo, without her mother the queen or her stepfather king Herod, and even without the prophet. From being a walk-on (dance-on) part, she has become lead role.

Regnault's picture of Salome as main character soon found followers. Some of them, such as Alfred Stevens, are in many ways simply imitators. But even when Salome doesn't appear in solo performance, there is no doubt that she is the lead-ing lady – in works by Gustave Moreau (p.111,112), Jules Alby, Gustave Mossa (p.113), Max Klinger (p.107), Franz von Stuck, Lovis Corinth and many nineteenth-century contempo-raries. Salome in the title role – this is the nineteenth-century rendering of the tragic story about the king, the queen, the prophet and the damsel.

Salome solo, no stepfather, no mother, no victim to be seen, makes room for new interpretations and identifications. The *femme fatale* without sidekicks. So who are going to be her victims? In a lithograph by the Norwegian artist Edvard Munch we find an interesting demonstration of what can happen. It appears to be an echo of Regnault's *Salomé*. In 1903 Munch made three lithographs of the English violinist Eva Mudocci: an elegant detached drawing titled *The violin concerto,* a fas-cinating portrait of her, and a double portrait of which Mudocci herself said later, 'He also did a third one of two heads – his and mine – called Salome. It was that title which caused our only row.'[15] In the picture his head rests upon her shoulder entangled in the strands of her hair, creating the impression that she is playing upon him rather than her violin, and that he is ensnared by her power (ill.2).

Giving the name 'Salome' to this picture deprives it of any sug-gestion of tenderness and trust, calling up as it does bitter con-notations of the cruel woman whose lust and love resembles

a game with fire, and whose volcanic vengeance erupts when she is spurned. No longer is Salome the figure she had been down the centuries, a subservient performer, obedient to her mother's will. In the nineteenth-century version it is she who sets history rolling because she, Salome, desires the prophet John and he rejects her. With wily devices she manages to gain power over her weak-willed and lustful stepfather the king, who has control over the life and death of his subjects.

Who is this Salome and where does she come from? For those who know the Bible, it's not hard to find Jael in the Book of Judges. Judith is slightly more difficult, for she appears in one of the apocryphal books, not in the Hebrew Bible. But look for Salome and you look in vain. Her story is told in the New Testament, but she only figures as 'the daughter of Herodias.' Other sources tell us that Herodias had a daughter called Salome.[16] So it was decided by some later experts that the girl in the Gospel should be referred to as Salome, which from a historical perspective is inaccurate. But what is true and false when it comes to legends?[17]

The story is told in the Christian Bible, in the Gospel of Mark. This recounts events from the life and death of Jesus Christ. In the middle of a section dealing with the miracles performed by Christ and his great popularity, the evangelist notes that people wondered who this man could be. The question was also posed by King Herod and he found his answer in a nightmare. Herod identified Jesus with the prophet John the Baptist, whom he had had beheaded, and feared 'that John the Baptist was risen from the dead.' The Gospel goes on to explain this dreadful conviction of Herod's. Readers can find out why Herod thinks Jesus is the man he had ordered to be beheaded. It is a short story, skilfully told. It opens by introducing three main characters, Herod, John and Herodias, set in delicate balance[18]:

[17]For Herod himself had sent men who arrested John, bound him, and put him in prison on account of Herodias, his brother Philip's wife, because Herod had married her. [18]For John had been telling Herod, "It is not lawful for you to have your brother's wife." [19]And Herodias had a grudge against him, and wanted to kill him. But she could not, [20]for Herod feared John, knowing that he was a righteous and holy man, and he protected him. When he heard him, he was greatly perplexed; and yet he liked to listen to him.

So although Herodias would have liked to see John killed, the king respected and protected him. But the time comes when this balance between Herodias' bitter grudge against the prophet, and Herod's respect for him, is upset[19]:

*[21]But an opportunity came when Herod on his birthday gave a banquet for his courtiers and officers and for the leaders of Galilee. [22]When his daughter Herodias came in and danced, she pleased Herod and his guests; and the king said to the girl, "Ask me for whatever you wish, and I will give it."
[23]And he solemnly swore to her, "Whatever you ask me, I will give you, even half of my kingdom." [24]She went out and said to her mother, "What should I ask for?" She replied, "The head of John the baptizer." [25]Immediately she rushed back to the king and requested, "I want you to give me at once*

the head of John the Baptist on a platter." [26] *The king was deeply grieved; yet out of regard for his oaths and for the guests, he did not want to refuse her.* [27] *Immediately the king sent a soldier of the guard with orders to bring John's head. He went and beheaded him in the prison,* [28] *brought his head on a platter, and gave it to the girl. Then the girl gave it to her mother.*

Clearly, Herod got himself into a sticky situation in which his half-hearted bravado sold him short and he was forced to match his words with deeds. His fatal orders were the result of a chain of events introduced by two other sets of characters in the story – namely, the birthday guests and the dancing daughter of queen Herodias. The damsel's dance entrances Herod so much so that he offers her a virtually blank cheque and because his important guests witness this, he cannot renege on his promise. So when Herodias turns Herod's weakness to her own advantage, he cannot refuse Salome's request. The king is forced to comply with Salome's (Herodias') demand and sacrifice the prophet in order to save his own honour.

What did Mark the evangelist wish his readers to think when they heard this story? Clearly, the main players are Herod and the prophet. Herodias and her dancing daughter are simply catalysts in a narrative dealing with the tragic fate of John the Baptist. In the wider context of Mark's Gospel, the story of the prophet – imprisoned because of his ethical, critical remarks, and executed because of an unlucky train of events and the weak-willed king Herod, who reacts later with the words 'he is risen from the dead,' – foretell what will happen to Jesus Christ. Like John, Jesus finds himself in a delicate balance between authority figures who desire his death but at the same time are afraid of the crowds, who believe Jesus to be a prophet and listen to him enthusiastically. Because of this, it was some time before Jesus was actually arrested, and once he was arrested his innocence initially prevented any punishment from being meted out. Just as John was finally beheaded because Herod was manoeuvred into a position with his back to the wall, so Pilate felt forced to order the execution of Christ after trying unsuccessfully to have Barabbas crucified instead.

The parallels between the main Gospel story and the miniature version, also apply to later reactions in the narratives. Just as Herod reacted in terror to hearing about Jesus, with the thought that it was John risen from the dead through divine power, so we hear one of Pilate's soldiers, following Christ's death on the Cross, declare 'Truly, this man was the son of God.' Resurrection from the dead is of course every executioner's and murderer's worst nightmare, certainly if there were any doubt about the lawfulness of the killing.

Because of its close connections with the life of Christ, the story of Herod, the prophet John, and Herodias has been retold down the centuries, often with little additional details. What people recognized and could identify with, was the story's main plot-line. In the history of Christian piety and relic veneration the essence of the story revolved round the head of John the Baptist, symbol of martyrdom and reminder of the sacrifice of Christ's death. Furthermore, the character of Herod appealed to people's imagination. The Church Father Augustine perceived him as representing the risk of making rash promises and swearing oaths. In the sixteenth century the

story was used as instruction for princes, whereby Herod's actions are used to provoke a discussion concerning the relations between a monarch, the people and the law. This is illustrated in a play by George Buchanan who connects the question of the Scottish monarchy with this Gospel story; and also in the exegetic commentary by the Protestant reformer Calvin, who argues that Herod's abuse of power is a justification for a people's right to rebel against their anointed ruler, particularly if he or she happened to be a Catholic.

CHAMELEON QUALITIES –
SALOME, THE DEFINITIVE DIVA

Where is Salome in all this? For a long time she didn't have an independent part to play in the story, she was simply manipulated by her revengeful mother or she was seen in contrast to the decapitated prophet. However, slowly but surely she shifted into the role of leading lady and became the *femme fatale* of the nineteenth century.

In 1841 the foundations were laid for her definitive breakthrough. It was the French-German poet Heinrich Heine who turned the story topsy-turvy and wrote a richly imaginative work titled *Atta Troll, a Summer Night's Dream,* in which Herodias figures in new attire[20]:

Whether she was saint of devil,
I don't know. With women, never
Can one know where ends the angel
And the devil makes his entrance.
[...]

And in truth she was a princess
She was queen of all Judea,
Lovely wife of Herod, she who
Claimed the head of John the Baptist.
[...]
In her hands she holds forever
That bright charger with the head of
John the Baptist, which she kisses –
Yes, she kisses it with ardour.
For she loved him once, this prophet:
It's not written in the Bible,
But the people guard the legend
Of Herodias' bloody passion.
Otherwise there's no explaining
The strange craving by that lady:
Would a woman ask the head of
Any man she does not love?

Every night she emerges in a wild procession, embracing the head, tossing it up and catching it as if it were a ball. Then she spies the poet and greets him:

And I mused: what was the meaning
Of that enigmatic greeting?
Why did you, with eyes so tender,
Gaze on me, Herodias?

In the following episode of *Atta Troll*, the poet longs to become Herodias' companion. During the day he mourns beside her

grave while at night-time he longs to hunt with her through the forests.

For it's you I love the dearest!
More than that fair Grecian goddess,
More than that fair Northland fairy
Do I love you, my dead Jewess!
Yes, I love you! I can tell it
By the soul that trembles in me.
Love me, be my own belovèd,
Beautiful Herodias!
Love me, be my own belovèd!
Fling away the bloody charger
And the silly head upon it –
I've more savory dishes for you.

In Heine's version the vengeful feelings of Herodias are motivated by unrequited love rather than her anger at having her marriage to Herod criticized by the prophet. And if she can't have him alive, well then, she'll have him dead. Her passionate hunger for him is never sated nor satisfied. Every night she plays with his head, each night, without end. Nor is this the end for the poet. He isn't a spectator who can stay and observe from a distance, he steps right into the story. He is enchanted by her, longs for her, is in love with her. He mourns beside her grave during the day and longs to be with her at night. He offers himself to her as her lover, saying she should stop her silly games with the prophet's head. The fatal love of the one has become the fascinating ideal of the other.

Heine's bizarre poem about Herodias was not an isolated dream. His works head a series in which the theme plays an important part and whereby the role of the beautiful seductive Herodias is generally played by Salome. French poets and prose writers in particular contributed to this explosion of literary interest.[21] As it turned out, the theme could be adapted for a wide variety of works, of varying forms and expressing differing attitudes: it might be a romantic song of praise to Herodias/Salome as the belovèd beauty[22] or an ironic recounting of a bizarre story[23], or again, an imaginative presentation of a narcissistic Moon priestess[24] or even a well-balanced historical reconstruction[25]. The historical reconstruction by Gustave Flaubert is part of the intellectual fervour and the optimistic belief that the human intellect could solve every problem, characteristic in the second half of the nineteenth century of students and researchers of classical Antiquity and early Christendom, such as the French biblical scholar Ernest Renan. In the arts, however, it found no resonance. There the approach was that seen in Heine's *Atta Troll, a Summer Night's Dream* and in the poems and stories of Théodore de Banville, Stéphane Mallarmé and Jules Laforgue. The picture of Herodias mingled with that of Salome, including her obsessive passion for an unrequited love. But it is chiefly the fascination of the poet himself and his longing to become part of his own poem as the eager lover, which Heine's followers and imitators recognized and adapted in their own work. The underlying motivation was (sexual) pleasure or else the dream of being able to overcome the doom of a fatal love. It is as if these writers and artists simply had a menu to select, consisting of a real contempt for death, and

religious fantasies, sensual scenes, exotic opulence, personal life experience and timeless cultural traditions.

Salome's popularity as an icon of dangerous love, stylized hysteria and religious symbolism was established in paintings and in the theatre. The masses came to see her, attracted not by the originality of the poet[26], but by the titllating images, and the multimedial theatre enjoyed a heyday with full houses. She was helped to fame by the obsessive work of the artist Gustave Moreau, who devoted over a hundred drawings and paintings to the Salome theme. Then of course there was the play by Oscar Wilde, published in English with illustrations by Aubrey Beardsley (p.103), the operas by Jules Massenet and Richard Strauss, and the many hundred performances of Salome's Dance of the Seven Veils, which could be seen throughout Europe at the close of the nineteenth century. Salome adorned the billboards of museums and theatres and it was impossible not to have heard about her.[27]

For centuries the Christian Bible gave its own interpretation of the story about these four characters, the king, the queen, the prophet and the damsel, supported by the representations in art and literature which were determined by moral, or if you prefer, ideological, convictions and contrasts. The prophet was the righteous man, the king the vacillating ruler, who allowed his reputation to prevail over his sense of right and wrong, the queen was the malicious witch, while the daughter introduces the erotic, sexual element, confusing the king and trapping him into doing what the queen wants. In some settings all four roles were activated, generally one was selected and magnified, but in any case, morality triumphed.

Then things changed. From the nineteenth century on the story was retold in psychological terms; the motivation of the characters is presented and the attitude of the narrator is no longer determined by accepted (Judaic-Christian) morality. Then it becomes possible to develop new interpretations of the story and to introduce male fantasies: to present Salome or Herodias, or maybe both of them, as the *femme fatale*, while the king and the prophet become their victims, the first because he allows himself to be manipulated by women, the second because he rejects them.

In the collective cultural consciousness Jael, Judith and Salome have survived the tooth of time thanks largely to their chameleon qualities. Down the centuries they remain familiar because they are continually presented in new roles and against new backdrops. The red thread that links their earliest appearance and the present-day image is strong, though remarkably thin. Almost nothing remains of their former religious context nor the moralising interpretation of later centuries. That sense of *déjà vu* characteristic of the cultural memory has become associated, where the *femme fatale* is concerned, with such things as obsession and threat. These feelings underlie the memories about legendary, life-threatening women. And it is no coincidence that the triumphant aspect, the story of a victory gained, which permeates the biblical narratives, has now gone. The new versions show – almost without exception – in the spotlight or offstage, the painful humiliation of male honour, foolish naivety exposed.

Sijbolt Noorda is biblical scholar and chairs the committee for the New Dutch Bible Translation. He is president of the University of Amsterdam.

Eddy de Klerk

THE FEMME FATALE AND HER SECRETS FROM A PSYCHOANALYTICAL PERSPECTIVE

For many of us the idea of the *femme fatale* will evoke an image of a woman who attracts men in the same way as a bright lamp entices moths after dark. These creatures flutter around the lamp for a time, unable to extricate themselves from its circle of light, until finally, exhausted by the effort, they fall lifeless to the ground. Not a very pretty picture. The *femme fatale* exercises similar powers of attraction on men as one after the other they fall victim to her wiles. In contrast to nocturnal moths, this does not automatically result in their death, nevertheless having served their purpose, they are ruthlessly dumped or discarded. The power that tempts them is primarily of a sexual nature. It may be that alluring qualities of a somewhat different nature have a role to play, possibly both intellectual and cultural; but these are not imperative. Vamps are to be found in all walks of life. They won't all be as famous as the ones represented in this exhibition. But what exactly is a *femme fatale*? What are her character traits? Why does she act the way she does? What secrets lurk behind her behaviour? Below I shall attempt to answer these questions from a psychoanalytical perspective.[1]

DESCRIPTION

How does a *femme fatale* operate? One thing is for sure, she cannot accomplish anything without male counterparts, inversely they cannot possibly function without her as a perpetrator. They are dependent on one another for their roles. Not every girl will develop into a *femme fatale*, nor will every man fall victim to her wiles. Both must possess certain character traits which condemn them to one another. In the case of the *femme fatale* the following characteristics apply: an extreme form of independence, the conviction that she needs nothing and no one, the implicit assumption that she will be admired, the feeling that she is above criticism, her aim to run the show and a tendency to ban every sign of weakness, vulnerability or neediness from her emotional repertoire.

Moral considerations worry the *femme fatale* very little, if at all; she is above all else focused on power. Nevertheless she can, temporarily, adjust herself quite well to the wishes of her most recent victims, in some cases even make a flexible and compliant impression on them. This apparent contradiction is one of the idiosyncrasies in her character that demands an explanation. Her pronounced character traits mean that the *femme fatale* doesn't in general arouse much compassion among others. Men are seduced and devoured by her or, fearful of suffering that very fate, keep at a safe distance. Women fear her as a competitor. In view of their lust for power, one might think that many vamps would turn to politics. One who did was Cleopatra, the woman who initiated the fall of both Julius Caesar and Mark Anthony. Still, there are many other fields they can enter when embarking on their struggle for power.

The *femme fatale* gains her power from her sexuality: this gives her the opportunity to subdue men thus making sexuality a major weapon in her personal relationships. In this respect she is distinguishable from the nymphomaniac who, it is true to say, also uses sexuality as a means to an end, but does so to draw attention to herself. In both cases it might be

*I. Gustave Moreau. **Le Sphinx vainqueur**. ca. 1868. watercolour on paper. 31.5 x 17.5 cm. Clemens-Sels-Museum. Neuss*

better to use the term pseudo-sexuality to explain their behaviour. Whether the *femme fatale* gets a great deal of enjoyment out of it or not is of no importance, as long as the man falls for her and continues to rely on her favours. This allows her to use him for all kinds of non-sexual purposes, be they political, economic or otherwise. This type of manipulation suits the *femme fatale* down to the ground because basically she despises men who, in their desire for her, have shown their dependency. As she has scrupulously excluded all neediness in herself, she can't fail to be contemptuous of men who allow such weaknesses to govern them. One must remember that this is not usually a case of conscious scheming, as this behaviour is entirely natural to this type of woman.

To return for a minute to the image of the lamp and the moths, it is important to establish that what is involved is a single *femme fatale* and a series of men. To put it another way, this is a case of 'serial fatality'. Gustave Moreau has aptly brought this typical aspect to the forefront in his painting *Le Sphinx vainqueur,* circa 1868 (ill.1). In addition to the riddle that Oedipus must solve for her, the painter has depicted a throng of dead young men who apparently did not complete the task successfully. Other works in the exhibition mainly show single, dramatic events, often entanglements between two people like Judith and Holofernes or Samson and Delilah.

The concept of the *femme fatale* and the notions that accompany it are related to heterosexuality. This does not in any way suggest that the phenomenon does not play a role in other circles. On the contrary, there are both male and female homosexual variants. Alfred Douglas, the man for whom Oscar Wilde served a jail sentence is one example of what is termed a 'homme fatale'.[2] But does a direct male counterpart of a *femme fatale* really exist? It certainly does, someone like this is often referred to as a ladykiller. It is telling that this English term includes the notion 'to kill' and thus, just like the French adjective 'fatale', refers to death. On the whole this will be meant to be taken metaphorically and not literally, but this is not always the case. One with a reputation as a serial killer from the very start is the main character in the opera *Bluebeard's Castle*, composed in 1911 by Béla Bartók which was based on the story of the same name from the Fairytales of Mother Goose. Even in Dutch the most usual translation for the concept *femme fatale* is literally 'man devourer' – referring indirectly to death by use of the verb 'devour'.

Five themes can serve as starting points to examine in greater depth the secrets of the *femme fatale*: power, sexuality, serial behaviour patterns, death and the man as victim. In the following sections they will be addressed one by one.

POWER

Vamps were probably not born that way. It seems more likely that their typical qualities are formed during the process of maturation, although genetic factors may play a modest role too. In particular the fact that there are significant hereditary differences in the extent to which people search for stimulating experiences. Vamps may belong to those who long for kicks and thrills. They often have a healthy dose of vitality and entrepreneurial ambition in a rudimentary form. What can prove troublesome is that their lust for thrills is also their

way of avoiding nasty and anxiety-ridden experiences in their subconscious which they have failed to come to terms with. In all probability the specific personality of a *femme fatale* arises from the interaction between hereditary and maturation factors. The question then is can anything be said about this process, and particularly about the way in which her excessive penchant for power comes about. In itself, it is normal and productive that people gradually gain more control over their own life during the period of maturation from child to adult and that at the same time their influence over others increases. Vamps however strive for excessive, if not absolute, power. This deviation from standard normality calls for an explanation.

In order to understand why the experiences a *femme fatale* was exposed to as a child manifest themselves in an extreme struggle for power at a later age, it is important to look into what in psychoanalytical jargon is referred to as the 'implicit life scenario'[3] which records how we automatically relate to ourselves and to others. This automatic conduct springs from experiences which have been stored in the so-called 'implicit memory', which comes into operation straight after birth and which is not accessible to conscious memory. The so-called 'explicit memory', which contains our conscious memories, must first mature and only becomes active at a later stage, from about the third year of life.

The notion of an implicit life scenario – also referred to as a 'script'– implies that not only do we automatically adopt certain behaviour, but that subconsciously we also try to allot certain roles in the scenario to other people. What is the implicit life scenario of the *femme fatale*? To what relational field of influence was she exposed as a child? Whatever the case may be, she has experienced a threat in early life that forces her to perform a fatal pattern of interaction with her successive partners later on. The domestic environment in which she grew up as a child must in itself have been fatal for her. But in what way?

To ensure that the process of maturation runs smoothly children generally need the security provided by their parents. In the case of vamps this has, in some way or another, been missing. At least one parent has been too aggressive and threatening. In addition to this the same parent, or the other parent, has affectively neglected them. They may have provided a certain amount of care, but of a melancholy or changeable type, more in tune with their own needs than those of the child. Similarly a weak mother, or alternately an absent father, is sometimes a determining factor for this lack of security.

There is more than one early childhood situation which can later result in the specific behaviour of the *femme fatale*. Whatever the case may be, these all result in the child withdrawing part of her self behind a barrier. Or to put it more accurately: being forced to withdraw. Behind this screen she has since hidden away her indignation, longings and needs. Other types of people, having grown up in similar family circumstances, have entrenched themselves behind a comparable barrier. Some refer to it as a fortress – as is the case in *Bluebeard's Castle* – others to a mansion or palace, and others still to a glass wall, a screen or a brick wall, or maybe even a subterranean cave or an uninhabited island. The common factor

in all these descriptions is the idea of a protective layer which must withstand the threat of the parental outside world.

Children who have become so entrenched can only partly bond with parents and later with others. The part that ties them to their parents adjusts excessively to the wishes and moods of the parents, in the case of vamps, it is more accurate to say that they are subjected to this. Children must go along with the wishes of their parents if they are to survive and to have some chance of getting what they desire. After all, in the long-term they are completely dependent on their parents both physically and mentally, no matter how the parents behave.

The fact that vamps as children were served up a relational reality consisting of the threat of menace and affective neglect, means they must adjust to this. As adults they re-produce this reality as subconsciously as when it was stored in their implicit memory earlier on. The *femme fatale* chooses – albeit on subconscious grounds – the position of perpetrator. In as far as she has had to submit in childhood, on becoming an adult she adopts a position whereby others must undergo this same fate. In doing so she is following the example set to her as a child by the threatening parent. Now it is her turn to exercise as much power as possible over others, and more specifically over men who – equally on subconscious grounds – are inclined to adopt the position of victims.

Having been used to subjecting herself to the wishes of her parents as a child, the *femme fatale* can, in a chameleon-like way, go along with the wishes of her newest partner. She does so because she needs him to maintain her self-esteem. The man is meant to compensate for the emptiness and insecurity which she experiences inside and, in the hope that he will be a better parent figure for her than she had as a child, he is idealised. However, if he cannot live up to her expectations she becomes disillusioned and retreats once again behind her emotional barrier.

She does this with the help of a deep-rooted, dormant un-derlying fantasy that she is a distinguished and powerful person, often a queen. This imaginary superiority, which is so characteristic for the behaviour of the *femme fatale*, not only serves to cover her feelings of inner emptiness and inse-curity, but also provides comfort for the hurt and humiliation she underwent as a child. The fact that the current feeling of disappointment and affront constitutes an echo of the bitter experiences earlier on activates the fantasy. Once the man has failed as a compensatory parent figure she imagines she is so powerful that she no longer needs him. She takes revenge by dropping him in a merciless way and proceeds to look for another.

SEXUALITY

Children who suffer from affective neglect run the risk of sexualising their later relationships. Sexuality acts as a guarantee of physical closeness and excitement and forms a natural antibody against feelings of emptiness, deathliness and loneliness which arose from a lack of warmth and tender-ness in the early years. The sexualisation sometimes begins at a young age, for example in the form of brother-sister incest in the original family setting. It is even more serious, in view of the extreme difference in power, when parents (from their

own background of neglect) force themselves on their children through parent-child incest. Even if a child has not experienced this explicitly, sexualisation may play a role in adult relationships.

With vamps this is taken to extremes, undoubtedly compounded by affective deprivation in their younger years. Vampire stories provide a telling picture of the way in which they experienced their situation at the time: they felt as if they were being permanently drained. In later life children like this – now playing an active role – can suck others dry. This aspect can be identified in the English word for *femme fatale* 'vamp', derived from 'vampire', which has the following dictionary definition: 'adventuress, one who exploits men, an unscrupulous coquette'.[4]

SERIAL BEHAVIOUR PATTERNS

We have learnt from Freud that in their adult lives people are often inclined to repeat, in a serial way a single, traumatic situation they never managed to come to terms with in their childhood. The same scenario, with minor variations, no matter how damaging or self-destructive it may be, is doggedly re-enacted time and time again. The story mentioned earlier entitled *Bluebeard's Castle* may serve as an example of this type of serial repetition. In this case, it is true, the perpetrator is a man, but the behaviour of vamps shows a similar pattern.

Bluebeard already has a reputation for murdering women when his new love, Judith, appears on the scene.[5] Despite this, she is determined to gain access to his castle which is totally sealed off from the outside world. It does not require a great stretch of the imagination to interpret the building as a symbol of the chilling, totally enclosed innermost feelings of the nobleman, a building where, as a result of his murderous nature, everything is stained with blood. The fortress contains seven secret rooms. Judith, driven by the force of her love, is successful in opening six of the seven, and in allowing light and air to penetrate them. With every step she takes the fortress is shaken to its foundation, and as she approaches each room Bluebeard warns his beloved not to go in.

Despite these warnings, he acts as if he is relieved when she actually goes ahead and disobeys him. You might say that the part of his self that has withdrawn is pleased that someone is breaking through his isolation, chamber by chamber. Having arrived at the last room, Bluebeard does not just warn Judith, but well-nigh begs her to leave the door locked. When she disregards him and goes ahead, she is confronted with three women: one for the morning, one for the afternoon and one for the evening, who walk out one after the other. On seeing each of them Judith repeats that she cannot measure up to their beauty. Bluebeard then kills her because he cannot bear the fact that his beloved has managed to penetrate into his secret room. From then onwards Judith will be his woman of the night. The castle is once again locked and remains eternally inaccessible.

The interpretation of this story is simple if one considers that the sum of the four women represent different aspects of one consistent figure, namely the mother from Bluebeard's earliest childhood.[6] In that period his mother acted as woman of the morning, afternoon, evening and night: she stayed close

to him twenty-four hours a day and was constantly available on demand. But if she had kept him company with so much affection, why did the duke have to kill his later loves one by one, thus killing the adult successors of the early love between mother and child? Of course we know nothing about his life as a child, but it goes without saying that he didn't resort to murder without a reason.

Instead of being purely or predominantly loving, in all likelihood his mother figure must have been extremely threatening. Bluebeard was forced to retreat into his castle as a reaction to this. He secretly took revenge by detaching himself from the emotionally important outside world and, in secret, by not loving his mother. If, as a child, he had shown his anger towards this terrifying mother figure quite openly, he would have been punished in the form of new threats. In order to survive, Bluebeard had to hide his anger and in order to maintain normal contact he created an idealised and inviolable mother image. His behaviour is similar to the way a great number of subjects suffering under a feared tyrant will extol him to survive his regime. However, in some way or another, an outlet had to be found for the repressed aggression without tarnishing the mother of Bluebeard's childhood. Because his sweethearts in adult life formed a suitable and harmless target the aggression was transferred to them. They fell victim to it one after the other, Judith being the last in the series.

What is remarkable is that *Bluebeard's Castle* all centres around defensive aggression. Bluebeard would rather defend than go onto the attack himself. He emphatically resists Judith's attempts at opening the rooms by repeatedly warning her off. His protests are based on fear, which is conveyed in the story by the fortress being shaken to its foundations with every step that Judith takes. After she has opened the seventh room Bluebeard takes revenge and the anger he has bottled up towards his mother eventually springs to life. Actually his fury is really directed towards his mother, which soon becomes evident when he calls Judith 'woman of the night'. She forms together with the morning, afternoon and evening the original omnipresent dark aspect of his mother and the missing link.

The *femme fatale* goes through a cycle similar to that of Bluebeard as an adult. The open revenge she takes on the men who cross her path stems from the revenge she really harbours towards her terrifying father or mother, or towards both of them. No single victim in her adult life can ever compensate for this. In the background, and deep inside, the inner situation of the threatening parent figure dominating the child who withdraws in fear whilst fostering secret thoughts of revenge will always continue to exist. That is the main reason why new victims must constantly be found.

Another important reason for what, in principal, may be an endless stream is the fact that the desires which have been screened off by the barrier remain unfulfilled. This longing acts as an impetus for repeating the same scenario time and time again. This is the reason why Bluebeard continued to look for new loves. So the longing accounts for new loves, the grudge for new victims.

2. *Aubrey Beardsley.* **The Climax (Salomé)**. *1893.*
line block reproduction. 34.3 x 27.2 cm. Collection Alessandra & Simon Wilson. London

DEATH

The explanation for the role that death plays as a theme in the entanglements of vamps is closely linked to the above. Not only does *Bluebeard's Castle* have a fatal ending, so also do the stories of Judith and Holofernes, Salome and John the Baptist, the Sphinx who committed suicide after Oedipus had solved the riddle and Cleopatra, who before killing herself, had played a fatal role in the deaths of Julius Caesar and Mark Anthony.

If we are to understand this macabre phenomenon in a psychological sense then we must turn to the process described earlier, of the child that has instinctively withdrawn into itself – raising a barrier to protect itself from threatening parent figures or carers. The more extreme this screening off is, the greater the risk that they will not show much positive connection with the emotionally meaningful outside world. They feel a certain numbness towards others and harbour secret feelings of revenge. Children who grow up under these circumstances run the risk later on as adults of finding it difficult to muster feelings of compassion for their fellow men. On the contrary, they will often enjoy taking revenge because in doing so they put others into the powerless, threatened and dependent position they once experienced themselves.

Feelings of revenge come in all shapes and forms and may appear at various levels of intensity, the most far-reaching variant being the intentional robbing of a life. A final act like this becomes possible due to a combination of an extreme lack of empathy and a violent hunger for revenge. From this it may be deduced that a person with these character traits driven to perform such extreme deeds was probably scared to death as a child. A good example of this is Oedipus. As a baby his feet were pierced through and he was abandoned by his parents, later he killed his father without even realising it and was the ultimate cause of his mother's suicide. The violent situation which he had been exposed to as an infant was stored in his implicit memory and became directional for his subconscious life scenario.

We often find that vamps themselves come to a sticky end. It is as if from being the habitual perpetrator they suddenly end up in the opposite role, that of the victim. The silent hunger for revenge and the withdrawal of love from the primary carers (who in principal should be the first to qualify for it) is not without just reason, but evokes a crushing, albeit subconscious, feeling of guilt. This is an inner reality and demands penance. And how can someone settle their inner debts better than by offering themselves up as a victim?

A good example of this can be found in the play *Salomé* by Oscar Wilde, based on a well-known story from the Gospels, which Wilde wrote in the early 1890s.[7] Although in the Bible story the woman is a figure without an independent profile, Oscar Wilde turns his main character into an autonomous *femme fatale*, in sympathy with the preoccupations of his times (ill.2).[8] Originally he seems to portray her as the loyal daughter of Herodias until it becomes clear that she has her own priorities which stem from the murder of her father. When Salome was still a little girl her father, Philip, then married to Herodias, was strangled to death by order of his own brother, king Herod. Herodias, her mother, knew about the plot before-

hand but decided to continue her life as the wife of the sovereign. The prophet John the Baptist, who publicly condemned this new marriage, was arrested for voicing his opinions. Herod wanted to take revenge on him for his outspokenness. For a number of years prior to his death, Salome's father Philip had been imprisoned in the same pit in which John the Baptist was held prisoner. Countermanding royal orders, she had the prisoner fetched before her. This remarkable action can be understood as the result of a subconscious wish to see her father in front of her still in the land of the living. The longing that dated back to her childhood was carried over to the current situation and projected onto the person of the prophet. He is, as it were, her father come to life and as such a match for the king who, in spite of his responsibility as a stepfather, is strongly inclined to look lustfully at his little niece. Salome falls in love with John the Baptist, but he refuses to look at her, despite her urgent pleas, and after having refused her advances goes back to the pit.

These events prove to be insupportable for Salome. Her early history, in which her father disappeared into the pit never to appear again, and never to look at her any more, seemed to be happening all over again. That stimulated her to plan her revenge. Defying her mother Herodias' orders, who had noticed the amorous interest Herod has shown for her alluring daughter, Salome offers to dance for Herod. As a reward, now with her mother's approval, she asks for the head of John the Baptist. Although the king fears his curse and tries to break his word, his stepdaughter keeps him to his promise to give her whatever she wanted. Thus the prophet's head is hacked off; fate wounds him in the same part of the body – neck and throat – as Salome's father.

In doing this Salome not only gains revenge on John the Baptist, but also on the entire adult world who took away from her what she needed as an innocent child. In the way she does it – by killing someone who was really innocent – she identifies with the murderous social setting she grew up in as a child. Herod and Herodias were victims themselves, because they were subsequently confronted with the effects of the prophet's curse in which an echo of the revenge demanded by the father, rings through. The instigator of the calamity comes off badly: as a punishment for her improper request the king decides to kill the apple of his eye.

All in all, Salome seems to have carried with her a hidden longing for her possibly idealized father. Until she met John the Baptist she had never met anyone so honest in her perverse surroundings. This is why she fell in love with him straight away. Speaking to his severed head she expressed her feelings as follows: 'why wouldn't you look at me? If you had looked at me you would have loved me. I'm sure of it, you would have been very fond of me. And the secret of love is greater than the secret of death.'[9]

THE MAN AS VICTIM

The *femme fatale* plays a role for which the text was written in her early youth. The same holds for the type of man who falls for her and who cannot disentangle himself from her. This is the fate of the main character in the novel *Married Life* by David Vogel which was published in 1930.[10] His existence

was characterised by deeply-felt anxieties, despair and helpless anger as a result of the hurtful behaviour of his wife. She makes him undergo innumerable humiliations which become more extreme over time. This brings about a situation of total alienation and hate in which he eventually kills her.

It is extraordinary that the man does not seem to be able to see the nature of his marriage relation at any time at all. He glosses over the deliberate baiting by his sadistic wife in all sorts of ways, even when she makes love with someone else right under his nose. When he eventually realises what she is really like, he cannot muster up enough strength to leave. This inability to take action can be retraced to his early youth. In that period children too are not able to leave their parents, no matter how threatening these may be for them. However, the fact that details about the earlier years of the main character are missing in the book means one cannot be certain why he should act the way he does.

In the case of Edvard Munch, the Norwegian artist born in 1863, the reasons are a lot clearer. He maintained ambivalent relations with three partners in a row, trying unsuccessfully to form alliances with them. Moreover, he built up an oeuvre including scenes showing sexually aggressive women figures which were given titles like *Vampire* (p.167), *Harpy* (p.166), *The Sphinx*, *Salomé* and *Under the Yoke*. They are repeatedly about characters who seduce the man, who rob him of his lifeblood, or even worse, of his life. Just like Oscar Wilde, for Munch the theme of the *femme fatale* was in keeping with the preoccupations of his age. However, he also had more personal motives for painting the pictures.

At the age of five he had stood at his mother's deathbed; she died of a lung haemorrhage as a result of tuberculosis.[11] Apart from losing her, in an emotional sense he also lost his father who started to suffer from depression, became obsessively devout and was sometimes violent in his behaviour towards the children. Munch's aunt, his mother's sister, took on the role of carer and provided a loving alternative to his father but she could not recompense for the loss of his mother. Edvard turned his attention to his sister Sophie, two years his senior, with whom he already spent a lot of time anyway. Her premature death, also caused by tuberculosis, devastated the then fourteen-year-old boy once again, made worse by the fact that it reminded him of the loss of his mother.

Encouraged by his aunt, and despite some misgivings on his father's side, Munch began to develop his drawing talent which opened up the prospect of an artistic career. He was described as being shy and withdrawn; he communicated with others through art. So much so that in later life he saw his paintings as children. The fact that he meant this literally is shown in the way he constantly surrounded himself with his work, which he sometimes scolded. He could not part with it easily, no matter whether it was for a sale or an exhibition. In either case there was a danger that the paintings would be jealous of other people's paintings. Art was not only work for Munch; it was so much a part of his life that he also related to the theme of the *femme fatale* mainly through this medium. Apart from various incidental – thus emotionally secure – sexual contacts, he is known to have entered into only three longer-lasting relationships.

3. Edvard Munch. **The urn**. 1896.
lithograph. 46 x 26.5 cm. Munch Museum / Munch-Ellingsen Group. Oslo

4. Edvard Munch. **On the Waves of Love**. 1896.
lithograph. 30.5 x 41.5 cm. Munch Museum / Munch-Ellingsen Group. Oslo

The first was with a married woman who worked her way through a series of lovers before dashing into her next marriage. It was immediately fatal for the artist when she left him for someone else. Gradually he took to the bottle. Her leaving him left such a deep scar that he only began a brother-sister, that is, non-sexual relationship with the second. This woman then threatened to kill herself with a pistol in an attempt to get Munch to commit himself. When he grappled with her to retrieve the weapon the gun went off by accident which cost him half his left ring finger. After this event his life moved into an ever-deepening crisis. Munch's third relationship ran a fitful course, running hot and cold alternately. Understandably his girlfriend felt rather offended when he depicted her as Salome, portraying his own head as that of John the Baptist's.

Meanwhile Munch had also lost his father and brother, the one died when he was 26 years old and the other when he was 32. Furthermore one of his sisters became mentally ill and was admitted to a mental institution. He himself feared he would have to undergo similar treatment, and in his mid-forties he did indeed have to be nursed in a psychiatric clinic for a while. It is remarkable that his artistic production did not suffer from these surroundings in any way. After he had recovered, the artist swore he would end his roving life, give up alcohol, nicotine and women, and continue his life as a hermit on his own estate. Nevertheless, in his work the themes of illness, death and women continued to fascinate him unabated: he constantly repeated the same scenes which he executed with minor variations using different techniques each time.

Munch died at the age of eighty amidst the paintings which had tied him to the outside world, but which had also served as a shield against it.[12]

Inasmuch as he was able to enter into a relationship with women before his psychiatric treatment, there was always the threat of his losing his loved one through illness and death, just as he had his mother and sister. The sexual side of relationships also caused him anxiety; he was frightened of losing himself in the process. Although Munch's demise was not in the end caused by one of the women he experienced as so threatening, he could only save himself by no longer entering into loving relationships with them.

FINALLY

Despite the damage they do to others, and their apparent triumphs, vamps do in fact deserve our compassion more than anything else. As a child a vamp is so frightened by others and so deprived of affection that as an adult she can only maintain her position in the outside world (which she experiences as threatening) with an excess of aggression and comforting power strategies. Unfortunately however she cannot accept any feelings of compassion from others because to her way of thinking this would be a sign of weakness. Ultimately the *femme fatale* is doomed to loneliness, unless she becomes capable of feeling empathy towards the fearful, needy child in herself – an aspect of herself which normally speaking she doesn't want to acknowledge.

Eddy de Klerk is a clinical psychologist and psychoanalyst.

Jacqueline Bel

THE FEMME FATALE IN LITERATURE: THE BEAUTIFUL, MERCILESS WOMAN

She reclines upon a tiger skin in front of a crackling log fire, eating strawberries soaked in ether. During her performances she lures and corrupts every male present with the sinuous movements of her voluptuous body. Goetia, exotic exile from Russia, is both anarchist and priestess of black magic. In her salon in Paris she is hostess to the world of fashion and society. At one point she prophesies that she will suffer a violent death, and a shudder of pleasurable horror ripples through her guests. 'There was something both marvellously attractive and at the same time abhorrent about going to visit her. Both avant-garde and *fin de siècle*, dancing in her hotel and flirting with the thought that people might explode in tiny particles during a waltz and be ground to dust upon hearing a fiery declaration of love.'[1]

In this way Frits Lapidoth, a now entirely forgotten Dutch writer, gives an impression in his novel *Goëtia* written in 1893, of what was the very height of fashion in literature and the visual arts at the close of the nineteenth century: decadence, anarchy, the mystical and the exotic. Furthermore, the novel describes a type of woman who was highly popular in *fin de siècle* literature and visual art – the *femme fatale*. The seductive woman who lured men with her remarkable eyes, brilliant as precious stones, who seduced with her long tresses and milk-white skin, who enticed men to their doom; the utterly beautiful, cruel woman who brought death and corruption in her train (ill.1).[2] She appears against different backdrops: the mysterious Middle Ages, the contemporary urban scene, or Eastern Antiquity.[3] The Italian literary scholar Mario Praz, in his famous study *The Romantic Agony*, characterizes the Fatal Woman by referring to the well-known poem by John Keats titled *La Belle Dame sans Merci*. This beautiful and pitiless woman emerged in the second half of the nineteenth century – and especially in the *fin de siècle* period – to replace the Byronic hero, the bold handsome male who attracted and then ruined virtuous females.

The *fin de siècle*, literally meaning 'end of the century', is usually taken to cover the period from 1890 to 1900, but in practice it expands to include a lengthier time. During those closing years of the nineteenth century the term was used to indicate that a period of history was coming to an end; a civilization was on the wane. Various historians have characterized this period at the turn of the century as one filled with ambiguities: on the one hand there was a very real fear of decline and fall, while at the same time it was a period of immense richness.[4] However, what seems to have gained the upper hand in the literary scene was the sense of decline and decay, and this is a major theme in the literature of the period.

Numerous literary movements emerged in the course of the nineteenth century. The cry of art for art's sake, *l'art pour l'art*, was first voiced in 1835 by Théophile Gautier in the introduction to his novel *Mademoiselle de Maupin*. In the 1870s and 1880s the French novelist Emile Zola launched the idea of 'naturalism', which propagated the notion of representing reality as faithfully and accurately as possible. Then in the 1890s, Decadence, Symbolism and Mysticism, movements that frequently cannot be clearly distinguished from each other, once again deflected public attention from the presentation of real-life situations.

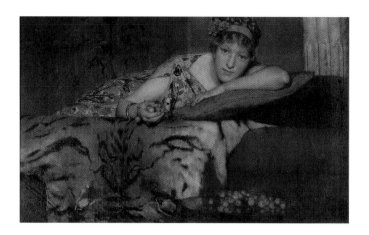

1. *Sir Lawrence Alma-Tadema*, **Cherries**, *1873.*
oil on canvas, 79 x 129.1 cm. Koninklijk Museum voor Schone Kunsten, Antwerp

DECADENCE

If we are to place the *femme fatale* within a literary movement then probably the most appropriate is that labelled Decadence, although she was already signalled in Romantic writing and has some associations with Symbolism.[5] Keats's poem *La Belle Dame sans Merci* written in 1819 illustrates this quite clearly. It should be noted, however, that his 'faery's child' is nowhere near so cruelly destructive as the later *femme fatale*.

I saw pale kings, and princes too,
Pale warriors, death-pale were they all;
Who cry'd – "La Belle Dame sans Merci
Hath thee in thrall!"

In the *fin de siècle* period many artists and scholars had the feeling that civilization was on its last legs. The German writer Max Nordau expressed this sense of decline and fall in his popular but highly controversial book *Entartung* (Decadence) published in 1893. In his words the mood of the time revealed 'an attitude dominated by feverish agitation, listless lack of energy, and a fearful sense of doom'.[6]

Decadence in the literary sense can be described as an independent movement in art and literature, having no social, religious or moral attachments, with its roots in the Romantic Movement, which it pursues to the utmost logical conclusions.[7] It aimed to improve upon Nature, or even to make it superfluous. The principle of art for art's sake emphasized the importance of beautifying traditional forms, often at the expense of their content. Fascination with all that was new and unusual produced a climate in which exoticism and deviance from the accepted sexual patterns were quite acceptable. Indeed, it was the done thing to flaunt one's decadent behaviour and to delight in the decline of civilization. Furthermore, those periods in history when decadence and corruption had been rife, such as during the decline of the Roman Empire, became highly popular.

Decadent art was emphatically antibourgeois, was in fact a kind of contrary aesthetic: in it, all standards were reversed. Naturally, this also applied to the image of the woman. The type of woman who was most valued by men at the end of the nineteenth century was the dutiful caring housewife and mother, the faithful spouse. This model was replaced in decadent art by a self-centred, showy, pleasure-loving, male-devouring monster. Because such a woman no longer devoted her time to what should be her primary task – the reproduction of the species – some people saw in these figures a threat to the continuation of humankind. In the collection of short stories titled *Le vice errant* published in 1902, Jean Lorrain prophesied the Fall of the House of Noronsoff: the males of this distinguished family had a curse upon them whereby the women whom they married were of the wicked and destructive variety. The disaster overtaking this family was symbolic for the destruction of the whole of society. In 1888 Marguerite Eymery, writing under the pseudonym of Rachilde, explored the same theme in *Madame Adonis*: 'The Parisians, creatures of pleasure. So, Louise will not bear any children. You can see, she's too small and narrow...no hips, no pelvis... it means the total depopulation of France.'[8]

In 1884 the Bible for the decadent movement appeared in *A Rebours* (meaning something like 'against the grain,' 'against nature') by J.-K. Huysmans, the famous novel that may also be considered as a frequently diverting handbook for the disciple of decadence. The book describes the adventures of a young and disillusioned aristocrat called Des Esseintes who, finding the world empty and meaningless, decides to retire and lead an autarkic existence. He creates his own self-sufficient world in a country house outside Paris. In this new scenario women do not occupy a place of great importance. There is an ancient female clad in medieval Flemish costume, acting as housekeeper, but Des Esseintes disdains to set eyes upon her. Otherwise, no living woman appears in his new life – only ghostly female figures inhabit his remembrances. Despite this, the book is a cornerstone to our understanding of the context in which the notion of the *femme fatale* developed.

Des Esseintes has a library – which may be considered as a reference source for the art of decadence – containing books in Latin by depraved representatives of that language as well as by medieval Church Fathers, and works by such writers as Gautier, Edgar Allan Poe, Gustave Flaubert and Auguste Villiers de l'Isle Adam. Not surprisingly, the French nineteenth-century *Symboliste* poets Charles Baudelaire and Stéphane Mallarmé are well represented. The works of many of these writers are spiced with Fatal Women. Possibly the only authors missing from the list, who contributed decisively to the concept of the *femme fatale*, are Algernon Charles Swinburne, Gabriele d'Annunzio, Frank Wedekind, Stefan George and Louis Couperus.[9]

In this novel about Des Esseintes we find a detailed description of the interior furnishings of his home, which was designed with special colours, church furniture and 'organs of smell' intended to set in motion certain trains of thought. The chief criterion for his interior furnishings was that all the objects in his house should not only be attractive but also artificial. Thus one of the rooms is furnished like a cabin aboard ship, complete with porthole and fish. The decadent hermit cultivates flowers, which have to look artificial and frequently have perverse and repugnant shapes. A major element in his life are precious stones. Indeed, he has decorated a giant tortoise's shell with gold and rare jewels. The slow movement of the creature makes the precious stones scintillate and glow. As already mentioned, there are no women in Des Esseintes's hermetic world – he is, in fact, impotent and has replaced the creatures of no importance with two 'locomotives recently put into service on the Northern Railway.' The beautiful steam-engine creations that he prefers have the characteristics of the *femme fatale*.[10]

'One of these, bearing the name of Crampton, is an adorable blonde with a shrill voice, a long slender body imprisoned in a shiny brass corset, and supple catlike movements; a smart golden blonde whose extraordinary grace can be quite terrifying when she stiffens her muscles of steel, sends the sweat pouring down her steaming flanks, sets her elegant wheels spinning in their wide circles, and hurtles away, full of life, at the head of an express or a boat-train.

The other, Engerth by name, is a strapping saturnine brunette

given to uttering raucous, guttural cries, with a thick-set figure encased in armour-plating of cast iron; a monstrous creature with her dishevelled mane of black smoke and her six wheels coupled together low down, she gives an indication of her fantastic strength when, with an effort that shakes the very earth, she slowly and deliberately drags along her heavy train of goods-wagons.'

The only way in which Des Esseintes can enjoy a woman is when she has been transmuted into art. Thus he has two paintings showing Salome, by Gustave Moreau, a painter very much in vogue at that time. Des Esseintes provides a detailed description of these works, which he considers to be master-pieces. He had for years been obsessed with the biblical fig-ure. In Moreau's paintings he finally sees the realization of the superhuman and mysterious Salome of whom he had always dreamed (p.111,112).

'Not only was she the dancer who with the lascivious motion of her hips aroused a moan of desire from the old man watching her like a creature in heat; the swaying of her full breasts and her gently-rounded belly, the quivering of her thighs, broke down the king's defences and deprived him of his willpower. She became, in a way, the symbolic goddess of undying Lech-ery, the divine form of immortal Hysteria, the beauty that is cursed, raised above all other beauties by a rigidity that stiffened her flesh and hardened her muscles; the monstrous Beast, indifferent, irresponsible, insensitive, poisoning – just like Helen of olden days – everything that approached her,

everything that looked upon her, everything she touched.'[11]

With these words, Huysmans sums up the *femme fatale* as she appeared in works of the *fin de siècle*.

DEVELOPMENT

In the tradition started by Mario Praz, the development of the *femme fatale* as a literary concept begins somewhere around the end of the eighteenth century.[12] Various international cross-connections may be found, particularly between French and English writings. The archetypal Fatal Woman can be met in the late eighteenth-century in her original state in the Gothic novel, a genre characterized by its descriptions of supernatural happenings. However, this had its predecessors in the episto-lary novel, such as *Les liaisons dangereuses* by Pierre Choder-los de la Clos, published in 1782, and the work of the Marquis de Sade. Generally speaking, the wicked woman has a counter-part who is good. Later, in *fin de siècle* work, we encounter the *femme fatale* contrasted with the *femme fragile*. The reverse of the powerful Fatal Woman is delicate, innocent and etherial-ized, often frailly poised on the brink of the grave.

In *The Monk* by Mathew Lewis, a Gothic novel from 1795, the beautiful Mathilda, evil incarnate, disguises herself as a nov-ice nun and penetrates a monastery with the aim of seducing a monk. She succeeds in this, when she threatens to stab her ravishingly beautiful breast. 'Oh! that was such a breast! [...] A raging fire shot through every limb; The blood boiled in his veins and a thousand wild wishes bewildered his imagination. "Hold!" He cried in a hurried faltering voice. "I can resist no

2. *Félicien Rops, **La tentation de St. Antoine**, 1878,*
pencil on paper, 73.8 x 54.3 cm. Koninklijke Bibliotheek van Belgïe
(Royal Library of Belgium), Brussels

longer! Stay, then Enchantress; Stay for my destruction!'"[13] Evil triumphs. Then each morning the monk rises from his bed of sin, poisoned by passion. After a while the monk lusts after another fair damsel, the innocent Antonia: having murdered her mother, he rapes Antonia. It transpires that this was his own mother and thus the maiden is his sister. A pact with the devil, incest, matricide, blasphemy and androgyny – all these elements that will later come to be associated with the *femme fatale*, appear in this story. Nevertheless, the character of Mathilda in this novel is simply an instrument of the Devil, just as her opposite number, Antonia, functions merely as an innocent lamb led to the slaughter.

Keats's poem *La Belle Dame sans Merci* from 1819 positions itself squarely in the Romantic tradition: it expresses discontent with the world, rejection of the here and now, and rebuts realism. The poem tells of the meeting between a (medieval) knight and a beautiful woman who takes him to a fairy cave where they make love. In a vision the knight sees pale kings and princes – presumably previous victims of the fairy woman – who warn him against *La Belle Dame sans Merci*, the beautiful, merciless woman. He awakens from his dream, to find himself 'alone and palely loitering', forever wandering in a wintry landscape, forever lost. The fairy woman, although displaying many of the traits of the *femme fatale* – she is beautiful, dangerous, powerfully dominating and threatens calamity – yet nevertheless is not maliciously evil. The knight and the pale princes of his dream would appear quite simply to be enchanted by her.

Most studies of the history of the *femme fatale* next discuss Gautier's *Mademoiselle de Maupin* from 1835. In this the art-for-art's-sake (*l'art pour l'art*) theme is championed and we meet an androgynous woman who has some of the features of the *femme fatale*. A few years later Gautier developed the concept of the *femme fatale* in *Une nuit de Cléopâtre,* placing her in an exotic, Eastern setting. In this he was one of the first to link the cultivation of the artificial with exoticism in time and space. With his introduction to the posthumous edition of Baudelaire's *Les fleurs du mal* in 1868, he can be seen as the major pioneer of the Decadent Movement.[14] Baudelaire, a great admirer of both Gautier and Poe, introduced many *femmes fatales* in his collection of poems titled *Les fleurs du mal*. We meet one such in *Le Vampire*:

Beast, who bind me to you close
as convict to his chains.[15]

And in *Allégorie* (Allegory):

It is a lovely woman, richly dressed,
who shares her wineglass with her own long hair;
the brothel's rotgut and the brawls of love
have left the marble of her skin unmarred.
She flouts Debauchery and flirts with Death,
monsters who maim what they do not mow down,
and yet their talons have not dared molest
the simple majesty of this proud flesh.
Artemis walking, a sultana prone,
she worships pleasure with a Muslim's faith

and summons to her breasts with open arms
the race of men enslaved by her warm eyes.
Sterile this virgin, yet imperative
to the world and its workings what she knows:
the body's beauty is a noble gift
which wrests a pardon for all infamy.[16]

Meanwhile in England, the poet Swinburne shocked the public in a similar way. His collection bearing the title *Poems and Ballads*, published in 1866, is larded with sadomasochistic writing and the *femmes fatales* whom he presents in these poems are cruel, dominating, erotic and sterile. They often have the nature of a vampire.

Flaubert's exoticism becomes visible in his *Salammbô* from 1862, in *La tentation de Saint Antoine* (The temptation of St Anthony) from 1874 (ill.2) and in the short story *Hérodias*, published in 1877 in the collection of three short stories, *Trois contes*. Salammbô, the Eastern priestess of ancient Carthage who, seemingly unperturbed, takes part in child sacrifices, provides an excellent example of Flaubert's famous *impassibilité*, or dry-eyed impassivity. For him, art should present an amoral concept of beauty. The gruesome and the bizarre should be merged into one aesthetic whole. In his novels the cold, heartless woman is worshipped, while the man is consumed with passionate desire. Yet it is not so much an escape into a period of history with which the writer feels a certain compatibility, as was the case with the Romantics. Rather, the aim is to emphasize the autonomy of literature as opposed to religion, morality and social values.

SALOME

In the course of the nineteenth century the character of Salome attracted quite a few writers. Best-known is the work by Oscar Wilde, a play first written in French in 1893 that immediately caused a considerable scandal. The plan was to produce the play with the then famous star Sarah Bernardt in the title role, but the authorities banned it. Biblical characters were forbidden to appear in a stage production. A year later Wilde's friend Lord Alfred Douglas translated the play into English – incidentally very poorly – and the book was published complete with illustrations by Aubrey Beardsley (p.103). However, not until 1905 was the work premièred in London. Despite this, the story rapidly became world famous when the composer Richard Strauss adapted Wilde's play into an opera of the same name, which was first performed in Berlin in the same year (1905).

In his one-act play Wilde took the well-known Gospel story about John the Baptist and re-focussed it with Salome as central figure. Hearing the voice of John the Baptist – Wilde gives him his Hebrew name of Jokanaan, meaning 'Yahwe (God) is merciful' – resounding from the pit in which he is held prisoner, Salome immediately wants to talk to him. No one is allowed to see him, on strict orders from the king, but she manages to seduce one of the guards, Narraboth, and so gets what she wants. She tells Jokanaan that she loves his body, which is white as the lilies of the field. But he spurns her, insults her and her mother and refuses either to look at her or listen to her words. Upon hearing this, Salome announces that it is not his body which she loves – she now decides it is a ugly as a leper's – but his hair, black and luxuriant as bunches of grapes.

And when John calls her a daughter of Sodom, she switches her interest from his hair to his mouth, declaring: 'It is thy mouth that I desire, Jokanaan. Thy mouth is like a band of scarlet in a tower of ivory. [...] There is nothing in the world so red as thy mouth. Let me kiss thy mouth.' When this request is also spurned, Salome repeats threateningly: 'I will kiss thy mouth Jokanaan. I will kiss thy mouth.'[17]

Meanwhile king Herod and his wife Herodias (the mother of Salome) hear the voice of John the Baptist proclaiming the coming of the Messiah, the Redeemer. The queen demands that the prophet be delivered to the Jews but Herod hesitates because he fears that John actually is God's messenger. Eager for distraction, he orders Salome to dance before him and, entranced by her voluptuous beauty, declares that he will give her anything she desires. She performs the dance of the seven veils and then makes her request: 'I would that they presently bring me in a silver charger ... [...] The head of Jokanaan.'[18] Herod at first refuses to behead John, promising her instead half of his kingdom, precious jewels and curious peacocks. But she is adamant and with her mother's encouragement continues to ask for John's head until finally the king gives in. Shortly after this the head of John the Baptist is carried in on a silver charger and Salome speaks to it: 'Ah! Thou wouldst not suffer me to kiss thy mouth, Jokanaan. Well! I will kiss it now. I will bite it with my teeth as one bites a ripe fruit.' Her lengthy monologue ends with a truly gruesome act – she kisses the dead man's mouth with ecstatic and extensive passion. 'Ah! I have kissed thy mouth, Jokanaan, I have kissed thy mouth. There was a bitter taste on thy lips. Was it the taste of blood?

... But perchance it is the taste of love... They say that love has a bitter taste...'[19] Herod, totally shocked, calls her a monster and orders his soldiers to put her to death. The illustration by Beardsley, showing Salome indulging in this final ecstatic kiss, also attracted a great deal of discussion. The erotic appeal of a decapitated head was something quite new.

The dialogues in Wilde's play are sober. He latched onto previous interpretations of the character of Salome – such as the stories about queen Herodias by Mallarmé and Flaubert, written in respectively 1864 and 1877 – emphasizing her pale complexion and her sense of reserve, and identifying her with the moon. In some earlier versions of the John the Baptist story, queen Herodias gets the blame and is seen more or less forcing her daughter to ask for the prophet's head as a reward for her dancing. With Wilde, however, the execution of John is quite clearly Salome's choice: 'I do not heed my mother. It is for mine own pleasure that I ask the head of Jokanaan in a silver charger.'[20] Running through the play like a red thread is the theme of 'looking'. Narraboth looks lecherously at Salome, she in turn at John, while he gazes towards higher, invisible forms. King Herod leers at Salome, which ultimately leads to John's death, Narraboth commits suicide and at the end of the piece Salome herself is killed. Although the punishment meted out by Herod might suggest she was merely getting her just deserts, another interpretation is possible. Having achieved the climax of pleasure, there is nothing left for the heroine but to die. Thus Wilde voices in the play the idea that art is an amoral conception of beauty.[21] Wilde's play may be the best-known exposition of the Salome theme, but the subject was

taken up by not a few nineteenth-century authors. In 1847 Heinrich Heine gave Salome's mother a role in *Atta Troll* and placed her relationship with John the Baptist in an erotic light: 'Would a woman ask for the head of a man she does not love?' As mentioned above, Flaubert set his short story *Hérodias*, one of the three tales in *Trois contes*, against an Eastern setting, while before him Mallarmé had written on the biblical story in his *Hérodiade* from 1864. Other French writers who took up the theme included Jules Laforgue and Jean Lorrain, while an English contribution came from Swinburne in his *Poems and Ballads* of 1866. Representing the Dutch language, in 1906-1907 P.N. van Eyck translated a fragment from Mallarmé's account while the Dutch writer Annie Salomons used the Salome-theme in her *Verzen* (Verses) from 1910. In Flanders the writer Pol de Mont described the (in)famous kiss in his poem *Schelome's dood* (Salome's death) that appeared in the collection *Iris* illustrated, among others, by Fernand Khnopff:

The dancer ceased her sinuous movements and stood still...
The head of John the Baptist stared at her.

It gazed upon her with so strange a look
filling her soul with horror and with dread.

It made her shudder, filled her with rage and grief...
Straight to the head she strode, bent down and bit

with teeth like razors, bit his lips to bleed,
grabbed at the thick hair, smote in furious rage

the head and cast it down, to roll
across the coloured carpet, over which
The brilliant red showered like violent rain.[22]

CHARACTERS

Salome was neither the first nor the only *femme fatale* in literature. As Praz points out in his above-mentioned study *The Romantic Agony,* 'There have always existed Fatal Women, both in mythology and in literature, since mythology and literature are imaginative reflections of the various aspects of real life, and real life has always provided more or less complete examples of arrogant and cruel female characters.' Undeniably, however, they appear with marked frequency from the second half of the nineteenth century and certainly in the *fin de siècle*. Several of these women are characters from the Bible, mythology and history.[23] Others are creatures of the writer's imagination, such as Leonie van Oudijck, the *femme fatale* who appears in the novel set by Dutch author Louis Couperus in the former colony of the Dutch East Indies (today Indonesia) and titled *De stille kracht* (The Hidden Force). In this book, published in 1900, Leonie begins a virtually incestuous relationship with her stepson and her son-in-law to be.[24]

Apart from Salome and Herodias there are quite a few women in the Bible who exhibit characteristics of the *femme fatale*. There is for example Eve, who, seduced by the Serpent, in turn corrupted Adam, as is described in the poem *Lilith* (1879) by the Dutch writer Marcellus Emants. Then there is the figure of Judith, who has a biblical book devoted to her, describing how she heroically hacked off the head of the enemy chief,

Holofernes.[25] In this group we may also place Mary Magdalene, the perennial temptress, patron saint of prostitutes, to whom the English poet Dante Gabriel Rossetti dedicated a song, while in 1897 she received a memoriam in prose from Dutch writer Maurits Wagenvoort.[26]

In history there were notable *femmes fatales*, perhaps the most famous of all being Cleopatra, queen of Egypt (p.79). This beautiful monarch is frequently presented against an exotic background, and shown as a heartless creature who murdered the men with whom she had just spent the night.[27]

In *Mademoiselle de Maupin* (1835) Gautier describes her *sublime cruauté*, that is, her sublime cruelty. Ten years later he wrote in *Une Nuit de Cléopâtre*: 'How can we describe in the French language, which is so chaste, so icily prudish, the sense of being transported by passion, the enormous, powerful gushing of emotion, that does not fear to mingle blood and wine…'[28] To quote Praz, 'Flaubert follows Gautier in that he worships in Cleopatra the perfect incarnation of antique desire…' and Praz goes on to cite, in French, 'He worshipped the courtesan of Antiquity… the woman who was both beautiful and terrible… the pale creature with fiery eyes, the serpent of the Nile, who coiled around you and strangled you…'[29] In his poem from 1866, *Her mouth is fragrant as a wine,* the English poet Swinburne embroidered on this theme.

Classical mythology was also a fine source of Fatal Women, apart from the Bible and history. There were figures such as Leda, Phaedra, Dido, Clytemnestra, Medea and of course Helen of Troy, the most beautiful woman in the world, for whose sake entire phalanxes of Greek and Trojan warriors bit the dust and a ten-year war was waged. There are frequent, though often brief, references to Helen and the other Greek heroines just mentioned, in the literature of the nineteenth century. The writing of this period also delights in a kind of 'grotesque', that is, mythical creatures such as chimaeras (monsters with the head of a lion, body of a goat and tail of a serpent), or Harpies (creatures with a woman's head and trunk, and a bird's wings and claws), and Sphinxes, which had a female head and bare breasts and the lower body of a lion. The Sphinx was particularly popular in the *fin de siècle* as the symbol of the mysterious and unanswerable – the Sphinx posed apparently insoluble puzzles. Baudelaire, the idol of the Symbolistes and the decadent movement, immortalized this image of icy impassivity in his poem of 1857, *La Beauté*, from *Les fleurs du mal* where he writes in the second verse:

With snow for flesh, with ice for heart,
I sit on high, an unguessed sphinx
begrudging acts that alter forms;
I never laugh – and never weep.[30]

The French writer Villiers de l'Isle Adam refers in his *Contes Cruels* to the *Sphynx cruel, mauvais rêve, ancien désespoir,* the cruel sphinx, the nightmare vision, the age-old despair.

In his novel from 1900, *Van de koele meren des doods* (The Deeps of Deliverance), the Dutch writer Frederik van Eeden provides a description of the Fatal Woman in terms of a sphinx. The main character in his novel, Hedwig, is having her portrait painted by the artist Johan. More than just a friend, he is in

love with Hedwig, but his feelings are not reciprocated. Later, he commits suicide. 'The sphinx-like features emerged larger than life from the right-hand side of the drawing. It was indeed Hedwig's profile ...It was Hedwig's small, straight nose, her fine, delicately-shaped mouth, and her wide-open grey eyes beneath the arched eyebrows with their slightly surprised air. But the eyes gazed icy and cruel, and at the corner of the mouth which turned delicately upwards there hung a gleaming red drop of blood. The complexion was a ghastly blue-grey, and the hair was blue. The naked torso had two full breasts, drawn in detail, and the claws of a griffin which clutched the bleeding body of a man and a skull.'[31]

In his story *Van de onzalige erfenis* (Unholy Inheritance) published in 1902, the Dutch writer Couperus describes a woman as having 'eyes like burning coals, hair like serpents, both sphinx and vampire,' whereby he establishes a hybrid of Medusa and vampire within the domain of the *femme fatale*.[32] Incidentally, Oscar Wilde satirised the sphinx-like creature in a posthumously-published story from 1904 titled *The Sphinx without a Secret*. A woman figures in this account, who spends her time making puzzling and mystifying references to her past love-life. This drives her husband to distraction, until he finally discovers that the whole act is a mere cover for hollow emptiness – she is 'a sphinx without a secret'. Another source of stories about *femmes fatales* was folk tales and medieval accounts. This is particularly marked in the writings of the English pre-Raphaelites, such as Dante Gabriel Rossetti, also in *La reine Ysabeau* by Villiers de l'Isle Adam (1883) and in plays by the Belgian poet and dramatist Maurice Maeterlinck.

CONCLUSION

Although the *femme fatale* played an important part in *fin de siècle* literature she was of course not the only type of woman to be found in literary writing. The nineteenth century has outstanding women protagonists in both prose and poetry, Flaubert's *Madame Bovary* from 1857 being one of the first. Indeed, there are many remarkable women in French nineteenth-century literature: *Germinie Lacerteux* by Edmond de Goncourt from 1865 and *Nana* by Zola from 1880, to mention only two. Furthermore there are subtle and strong portraits of women to be found in Russian and Dutch literature of this period – think of *Anna Karenina,* Tolstoy's creation from the years 1873 to 1877, or *Lidewijde* by the Dutch writer Conrad Busken Huet, from 1868, *Juffrouw Lina* by Marcellus Emants from 1888 or *Eline Vere* by Couperus, from 1889.[33]

At the end of the nineteenth century women in Western society occupied an inferior position in comparison with men. Generally speaking, these men cherished an ideal picture of women as a somewhat fragile, dependent creature who would provide a stable home atmosphere for him while also being a caring and dutiful mother, wife and hostess. However, things were changing in the patterns of male and female roles, partly as a result of the Industrial Revolution, and by the *fin de siècle* many new ideas were afoot. The movements for emancipation of women were gaining ground and both men and women were speaking out for greater equality. But the cruel beauty who enslaved men was not a creature of everyday reality nor did she represent the current ideal. And the suffragettes rejected her as firmly as they rejected the image of the submissive, dutiful wife and mother.

It is remarkable that most of the literary portraits of *femmes fatales* are the work of men. In theory, the antibourgeois female figure fitted well into a decadent world picture and was most acceptable in the artistic circles that rejected the established social conventions. For them the woman should be seen as the symbol of extravagant, idle opulence. Yet it seems paradoxical that the seductive, dangerous woman is so vividly present in literature, particularly when we consider that her male creators often show decided symptoms of misogyny. This is true not only of such a figure as Des Esseintes, the main character in Huysmans's *A Rebours*, but also of famous poets such as Baudelaire, Villiers de l'Isle Adam and Wilde. Freud has explained the paradox in terms of childhood traumas and indeed introduced the term 'castration complex'. He describes men who see women as devouring monsters to whom they nevertheless submit with a mixture of lecherous pleasure and repulsion. Despite this information, it remains hard to see why such women should have gained so prominent a place in decadent literature. Possibly the dandy type was insufficient to represent antibourgeois attitudes. In certain cases it may be argued that female characters with androgynous features represent a male projection, whereby the *femme fatale* can be seen as a parallel to the male dandy. More important possibly is the fact that most cases where the *femme fatale* appears are not only antibourgeois art but also poetical texts, that is, texts carrying a literary message. The all-important factor is artistic autonomy: art has no truck with morality, it is purely and alone Beauty's servant.

The *femme fatale* in *fin de siècle* literature was to become ever more cruel and remote, culminating in Oscar Wilde's *Salomé*, who desires only to kiss the mouth of a corpse. Interestingly, she became a highly popular character and partly due to her, the image of the *femme fatale* was to become familiar far and wide. Ironically, the exclusiveness that the Decadents had longed for, the idea of making art for the chosen few, was done to death by the enormous popularity of this female type. Thus, although there were several literary portraits of Fatal Women made after 1893 – in Dutch notably by the writer Louis Couperus – the originally French *Salomé* forms the pinnacle in the tradition of the *femme fatale* and at the same time ushers in the finale of a literary concept.[34]

Jacqueline Bel is lecturer in Dutch Literature at the University of Leiden and the Free University of Amsterdam.

Kristien Hemmerechts

THE RADIANT WOMAN

When Mira first saw the woman who would become the love of her husband's life, she came rushing out of her shady house. Its thick walls and tiny windows kept out the sun, so even at noon it was deliciously cool inside. Mira looked at the woman and could have sworn she was radiant. Literally. She was bathed in an incandescent light; the way saints are portrayed in some religions. Mira knew people could not radiate light and that the woman's radiance could only mean one thing: the transition from shade to sunlight had been too sudden. She chuckled at her foolishness, blinked her eyes and looked again. The woman was still radiant. She retreated into her house and bumped against the laundry basket. She stopped in her tracks, blinked her eyes and slowly began to count. By thirty-five she could again see clearly. In next to no time she had found her sunglasses. She popped them on her nose and hurried outside. The woman was sitting at a little table peacefully drinking a glass of tea. And she was still radiating. Fortunately the sunglasses did their work. The rays gradually became less intense and by the time the woman's long elegant fingers had held her glass to her lips for the last time, she was no longer bathed in a heavenly glow. Mira now had a chance to take a proper look at the woman, but almost immediately she was hit by a second shock: this woman was made for her husband. She knew this because she herself was overcome by an overwhelming longing. She wanted to caress her milky white skin and brush her long brown hair. She wanted to nestle her head between her breasts and curl up at her feet. But above all she wanted to feast her eyes on her.

Mira, who loved her husband deeply, was accustomed to feeling what he felt. She often felt it sooner than he did. Psychologists - who have devoted extensive studies to this phenomenon - speak of empathy or even of symbiosis. Mira had never set eyes on these studies, nor was she familiar with words such as empathy or symbiosis, but undoubtedly she would have thoroughly agreed with everything they had written on the subject. A degree of empathy is desirable, but in large doses it can be detrimental to both parties. The empathiser leads a double life. He or she experiences everything twofold, joy as well as sorrow. Often he or she is overwhelmed by the most conflicting emotions, and tossed to and fro like a rudderless ship on a stormy sea. Take Mira, for example, now she had been confronted with this radiant woman. The one half of her was ecstatic; the other half was in a blind panic. The one half wanted to dance with joy, the other to roll on the pavement moaning and groaning.

The pressure is just as big for the object of empathy. He or she never knows a moment of privacy or peace. He or she can keep nothing, nothing at all, to him or herself. The desperation this engenders is sometimes so great that he or she is driven to take his or her own life, or that of the other. Thank God many people yoked together by empathy eventually arrive at a *modus vivendi*. The empathiser learns to keep his or her knowledge of the feelings of the other to him or herself, while the empathisee endeavours not to make any wild emotional leaps. Unfortunately this is not always possible, for instance, when the love of his or her life suddenly pops up in town completely unannounced. He or she does not yet realise it, but the damage has already been done.

Mira had long since reconciled herself to her empathic ability. To her mind the advantages still outweighed the disadvantages. She could allow her husband all the freedom he wanted, because actually he was never really free of her. No matter how great his apparent liberty, she was always well aware of his comings and goings. If necessary she could steer his life with the necessary discretion. In this way she had more than once preserved him from disaster. Mira loved her husband with heart and soul and would have preferred to spend every minute

of the day with him, but she understood that he needed his space. Thanks to her empathy she was with him even when she was not. In fact, she had actually partially become him. Wherever he was, whatever he was doing, whomever he was with, nothing was still a secret to her.

Mira walked back into her shady house and once again bumped against the laundry basket. She took off her sunglasses and sank down into the chair, in which she had been reading the newspaper before she had gone outside to watch the radiant woman drinking a cup of tea. If the paper had been thicker, she might have missed the woman and she would now be helping her sister draw up the guest list for the surprise party she was planning for her husband. Her sister was married to a much older man who would be celebrating his seventieth birthday in a month. Mira had never understood how her beautiful sister could bear to have that aged body in her bed, but now she envied her. She would never have to worry about other women.

After an hour Mira ventured outside again. The woman was gone. Less than a quarter of an hour later she was sitting with her sister in the shady patio - built at the insistence of her aged brother-in-law's first wife - and cursing the lot that had coupled her with a handsome and alluring man. And what's more, he had no money, so she would never have her own patio. Because her husband was devoid of any empathic ability, she could think what she wanted. Even if she were to meet the love of her life some day, he would still be blissfully unaware of any danger. But the rub was that he was the love of her life. She had told him that at least a hundred times and she had never given him any cause to doubt her words. Her sister was meanwhile flicking through her address book and jotting down name after name in a list. The whole town seemed to belong to her intimate circle. Mira daydreamed that the radiant woman

was leaving on the first bus, disappearing as suddenly as she had appeared. This comforting thought was simultaneously so unbearable that she had to hold on to the table to stop herself going out and looking for her. Now, she thought.

Whether it happened at precisely that moment is uncertain, but whatever the case, her husband had certainly seen the radiant love of his life by lunchtime. Tony, who truly had no talent at all for making money, had just finished sweeping the pavement outside the baker's and was leaning on the handle of his brush to admire his work. A great many people threw the wrappers of the goodies they had bought at the baker's on the ground, and so he passed by there every day. In exchange the baker occasionally gave him pastries, which he then brought home to surprise his Mira. He had just taken a cigarette from behind his ear and was about to light it when his mouth fell open. That woman was radiating! 'Can I get something to eat here?' she asked, as if radiating were the most normal thing in the world. He nodded, because no sound would come from his mouth. And then he heard the smash of china. 'My heart,' he thought, but it was the baker's assistant who had also never seen a woman radiating and had let an expensive plate slip from his hands in shock. Tony hurried inside with his dustpan and brush. Never before had he swept up shards with such enthusiasm. His sweeping was like a delirious dance. Only a heart of ice would have been unmoved and Anna did not have a heart of ice. Just as in a real musical she danced along with Tony spontaneously, unerringly taking all the steps she had to take. Tony leapt onto the counter, pulled Anna up behind him, pirouetted with her to the till, tap danced amongst the trays of chocolates, picked out a delicious chocolate and popped it into her mouth. The baker and his wife, all the baker's assistants and customers applauded wildly. Bravo! Bravo! As if he were in the limelight every evening, Tony accepted their applause with a deep bow while a blushing Anna made an

elegant curtsey. Tony landed on the ground with a supple spring and caught Anna in his strong arms. When the applause had died down he took his brush and carried on sweeping with his back hunched. Everything about Anna simply screamed that she had never before danced with a road sweeper, and he would have understood if she had wanted to forget this moment of madness as quickly as possible. But Anna was a radiant woman and what's more she was made for him, and so she tapped him on his shoulder and asked him whether he knew of anyone who rented out rooms. And so the road sweeper and the radiant woman set off in search together. Unfortunately the hotel was barely three blocks away, and the road sweeper, who now really had to get back to work, decided not to prolong the walk unnecessarily.

When Tony put his cart in the shed as he did every day at around six o'clock and pushed open the door of their humble dwelling tired but content, he was not greeted by the aroma of a delicious meal for the first time since he had been living with Mira.

'Mira?' His heart skipped a beat. 'Mira?' He was on the point of running outside to ask the neighbours where Mira was, when he heard the whisper of her voice.

'Here.' She sounded as if the house had collapsed and she was giving a feeble sign of life from beneath the rubble with her last ounce of strength. And as far as Mira was concerned the house had collapsed. All day she had been brooding about what she should do now her dearest Tony had met the love of his life. She had not given a thought to food or to shopping. She had not even taken off her sunglasses.

'Are you ill?'

So much genuine concern echoed from his voice that she rallied. Perhaps she had been worrying needlessly. 'A little. And it's so hot! I felt as fit as a fiddle this morning and then suddenly... How was your day?'

'I've been dancing! It was as if I had wings. I simply sailed through the bakery.'

'You were dancing at the baker's?'

He nodded.

'Alone?'

'No,' said Tony, who knew there was no point in lying to his wife. Mira fought against her tears in vain. All was lost! That woman had stayed in town and had shamelessly seduced her husband! Go, she wanted to scream, I know you are in love with her!

'What was her name?'

'Whose name?'

'You know whose name.'

'Anna.'

It was the perfect name for a perfect woman. 'I'm hungry, Mira.'

She wanted to yell 'Ask your Anna to cook for you', but she felt such a love for this wonderful man that she knew that she could never refuse him anything. Tony had made her happier than she had ever thought possible and now he was about to make her deeply unhappy. She forced herself to stand up and went out to fetch some vegetables from her garden. No matter what delicacies Anna might offer him, she would never be able to equal her soup.

Whether it came from the dancing or not, Tony slept like a log that night. He was snoring before Mira had even had time to snuggle up to him. She rolled him on to his side, but he snored on undisturbed. All night long she wandered through the three small rooms of their house, bumping the one time into that damned laundry basket, the next into Tony's rocking chair. She didn't want to turn on the light even though ten searchlights could not have woken Tony. The one moment she did not want to live a second longer, the next she was dreaming up ways to murder Anna. To her dismay she suddenly found herself out in

the street staring at the hotel façade. She was holding a stone in her hand as if she were planning to throw it at a window. She flung it to the ground in despair. When she pushed open the door of their house, she heard Tony snoring. It was unbearable.

At breakfast she looked so wretched that even Tony noticed, and usually he only had eyes for himself, just as Mira only had eyes for him. 'You know what? You have a nice rest in bed today. I'll do the shopping and then I'll cook you a delicious meal!'

'But you couldn't cook to save your life!'

'Of course I can! How do you think I managed before I met you?'

'So haven't you always known me?' Mira burst into tears. Tony - who had never comforted anyone - had no idea how to cope with his crying wife, so he simply repeated his offer: today he would take care of the housekeeping.

'No! Everybody saw you dancing with that woman yesterday. If they don't see you in town today, they'll think I'm keeping you home.'

'Mira, I only danced with her!'

'Oh, Tony, my sweet blind Tony!' She threw her arms around him and hugged him to her as if for the last. 'Go to her! Go! She is made for you!'

'What are you on about?' Tony, who knew his wife knew him better than he knew himself, had gone as white as a sheet. 'It's you I love, Mira. You're the love of my life!'

'No, no! You love the way I love you, but you don't love me.' She threw her hands in front of her eyes. 'Tell me what colour my eyes are.'

'I don't know.'

'You see. That woman was radiant with happiness. And no wonder!'

'Mira, I don't give a damn about Anna. It's you I want! What does it matter whether or not I love you the way you love me? Is it written down somewhere exactly how we are supposed to love each other?'

Mira shook her head stubbornly. That woman was his fate. He could not escape her. As if he could read her mind for once, he said: 'Let's go away for a while, you and I. We've never taken a holiday. We can visit my old army friends. And when we come back, she'll be long gone. Nobody will still remember her.' But Mira would not listen to reason. In a flash she had seen what had to happen. When he came home this evening he would find her gone. Every trace of her presence would be erased. Not even a drop of the soup with which she had hoped to ensnare him yesterday evening would remain. He and his beloved could have the place to themselves. The dice had been cast. Bewildered Tony walked over to the shed where he stored his dustcart. Every now and then he stopped. A deep frown formed on his forehead. But no matter how much he thought, he could not think of any argument with which he could talk Mira round. If she found he had to live with Anna, then she must have a very good reason for it.

Anna was totally unaware of the upheaval she had wrought in the life of that crazy road sweeper. In the brief paragraph she had devoted to him in her diary she had not even made any attempt to describe him. Most of all she had been pleasantly surprised by the great ease with which he and she had twirled through the shop. 'Never realised I was such a good dancer!' she had noted with satisfaction. Meanwhile she had been completely preoccupied by the business for which she had undertaken her long journey. On his deathbed her father had confessed to her that years ago he had fathered a child by a woman with whom he had had a brief but passionate love affair. When she had told him she was expecting his child, he had broken off contact with her. He had not kept any of

her photos or letters, but now he felt the end of his life approaching the existence of that unwanted child was nagging at his conscience. Could she make sure it knew the name of its father? Would she agree to relinquish a part of her inheritance to her brother or sister? What could a person say to a dying man? Anna had soothed him with promises, even though she had no intention of sharing her inheritance. Her father's illness had been long and serious. She had nursed him lovingly and patiently. With the little money that had not been swallowed up by his doctors, she finally wanted to buy herself a little freedom. She had undertaken this journey purely out of curiosity. The thought that she might already have seen her little brother or sister suddenly made her pulse race. Perhaps she was staying in his or her hotel. Perhaps it was him she had danced with yesterday!

At that moment she glanced out of the window and saw her dance partner appearing around the corner. He was pushing his cart but his gaze was fixed on the façades, as if it was them he had to clean and not the road. If anyone could help her, it would be him. Without reflecting further she rushed downstairs.

'Anna!' She had forgotten his name, but her sweet smile more than made up for that. Of course he would be pleased to help her. He would take her to the old midwife. And if she didn't know, they could call at the old schoolmaster's. Anna began to radiate again from pure relief. Tony heaved a blissful sigh. Mira was right. This woman was the love of his life.

Mira had meanwhile picked up the photo Tony had had taken for her years ago and was pressing her lips to the glass. How typical of her Tony that he had not asked for a photo of her in return! She laid the photo on top of the clothes she had packed. The one half of her heart was bubbling with delirious joy; the other was in deepest mourning. She walked through the three humble rooms she had shared so happily with her Tony. He would be loving another woman there from now on. He would be cooking meals for her and putting out vases of flowers for her. It was her he would be caressing until she was purring like a cat. With tears in her eyes Mira heaved her suitcase from the bed and pulled the door shut behind her. She would never return.

While Anna and Tony were being ushered inside by the old midwife's maid, Mira was falling weeping into the arms of her sister, who could not make head or tail of Mira's story. She had her maid prepare a room for Mira, and asked her to only come down to dinner when she had dried her tears: her husband could not abide crying. 'I am a nun,' thought Mira when she saw the single bed her sister had had made up for her.

Mira felt Tony's disappointment when the midwife told Anna her half sister had only lived for a couple of days. Later the mother had married a man who was willing to overlook her past, but to their mutual anguish he had not been able to give her any children. And then a tumour had been discovered in her womb and within the month she was dead. Anna left the old midwife's house shaken to the core. She was barely radiating. Although she had had no intention of relinquishing a cent of her inheritance to her sister, she was now missing her. Was it possible to miss someone you'd never met? she asked the road sweeper. Tony answered 'yes' without hesitation. He was convinced he had missed Anna ever day of his life. He put his arm around her and hugged her to him. Anna laid her head on his shoulder gratefully. Now her search had come to nothing she did not have an ounce of energy. Intoxicated by Anna's scent, Tony did not see the surprised looks of the passers-by. Even before they had reached his house the news had spread throughout the town: the street sweeper had left Mira for a beautiful younger woman! And not a day later everyone knew the two were living together and that Mira had taken refuge with her sister.

It was as if the whole town was grieving. Mira's sister saw her party fail because everyone was thronging around Mira. The whole evening there was only one topic of conversation: How had that woman been able to bewitch Tony? And was it true that anyone who looked too long at her rays would never have eyes for anything else? Shouldn't the adulterous couple be driven out of town?

It took all of Mira's powers of persuasion to convince them to leave the two in peace. Finally she stammered 'He loves her,' whereupon everyone stared at her with genuine compassion. 'If your husband is in love with someone else, then you have to keep him away from her!' the wife of a rich banker advised. And who would be sweeping the road now? All he ever did now was run errands for her or take her for walks. Apparently he even cooked for her! What sort of example was that for the youngsters? Lust, laziness, neglect of work... Mira felt how the tide was turning against her. She had brought this about. If funeral processions had to edge their way through swirling rubbish from now on, it would be her fault. Every marriage that foundered would be on her conscience. Every woman who refused to cook for her husband would have been roused to rebellion by her. And love was no excuse for all of this.

Mira knew what she had to do. She sneaked away to her room, put on her overall and slipped out of the house. She pushed open the shed door and pulled out the cart that had stood there unused since her departure. She would begin with the church square and then she would give that wide avenue where families strolled on Sundays a going over. Without looking up she slaved away until she heard the first cockerel crowing. The litter that people dropped! They should be ashamed of themselves! Every night Mira took the cart from the shed, and every morning she brought it back. Now people were less inconvenienced by Tony's love, they also had fewer objections to it. After all it was Mira who had left the marital dwelling. People seemed to forget she had ever lived with Tony. They became accustomed to seeing her with her sister, and if they wondered anything it was why Mira was always looking so tired. Sometimes Mira saw Tony with Anna in the street. And that confirmed what she also knew for certain without seeing him: Tony was in a bad way. He had lost at least five kilos and in one year he seemed to have aged ten. She did not have to worry that he would see her, because he only had eyes for Anna, just as Anna only had eyes for Anna. She was as radiant as a queen, and was basking in the love poor Tony was showering her with day and night. What had she done to him? Every time she pushed her cart into the shed at sunrise, Mira imagined she could hear Anna snoring blithely while Tony restlessly tossed and turned.

And then one day, when she was hurrying out of her sister's house, she saw a radiant young man. Nonplussed she blinked her eyes and pinched herself in the arm. Yes, he was still radiating. Mira had to hold herself back from rushing up and embracing the stranger. Her deliverance was finally at hand! Anna fell for the newcomer that very same day and the young man was also irretrievably lost. Mira found her Tony crying in their house. He begged her for forgiveness. She said she didn't know what she had to forgive him for. Could he help it that she wasn't the love of his life?

'But you are.'

'No I'm not. But it doesn't matter.' That night Tony showered Mira with kisses and whispered at least a hundred times that he loved her. 'Stroke my breasts.' She had never asked him such a thing before. She was startled but Tony lovingly set to work. He was her Tony and yet he was different. Less self-assured, more fragile. Sometimes she now forgot about him for hours on end. Sometimes he had a headache and she didn't notice. 'You are neglecting me.' He rewarded her with a kiss. They hung a sign on their house that said 'nutritious meals available here' and in next to no time they were rushed off

their feet with work. Customers who mentioned Anna were politely asked to take their business elsewhere, but otherwise everyone was welcome. Her cooking was so delicious that nobody wanted to talk about Anna. The house became too small but Mira stubbornly refused to move. People were queuing up outside. Just the way it should be, she thought. At night she let herself be caressed by Tony and if she was in the mood she also caressed him. Neither of them ever went out of the house without sunglasses. They claimed to be immune to rays, but neither of them really believed it. And the other two? They radiated so hard that everyone said: It must be from happiness. But nobody ever said that to Tony or Mira. When they were around, people acted as if Anna had never existed.

Kristien Hemmerechts is a writer and lecturer in literature.

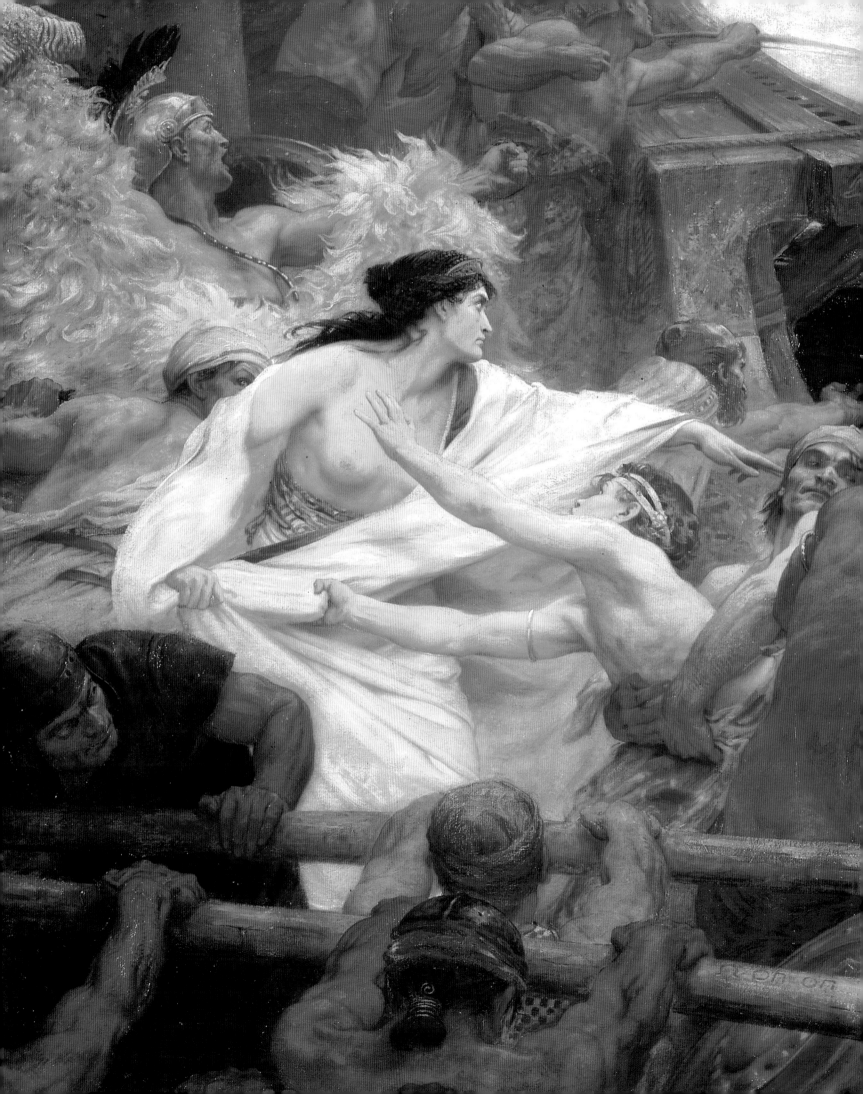

MYTHICAL WOMEN

Christien Oele

DRYOPE FASCINATED BY APOLLO IN THE FORM OF A SERPENT 1884

Bronze, 92 cm (height)
Victor & Gretha Arwas Collection, London

What more appropriate lover could there be for the *femme fatale* than a serpent? Like her, the serpent is sly and secretive, dangerous and unfathomably mysterious. Both of them inspire at the same time fascination and revulsion. They both have an icy, noiseless, suffocating embrace which is mortal for many. Fatal woman, fatal snake – they make a perfect pair.

There are many instances in the *fin de siècle* where serpent and lady perform a duo. Time after time artists and sculptors would present charming female nudes in the intimate embrace of a scaly lover. Eve, Lilith, Hermione and the nymph seen here, Dryope, are all called upon to illustrate the warm relationship flourishing between women and reptiles. And it was not a question of lady meets ant, or even adder – no, these reptiles were metres-long pythons as thick as your arm, who with their serpentine coils could easily entwine a woman's body. There is a mixed message in these representations. First, such portrayals reveal the perverse nature of women – after all,

you must be pretty degenerate if you want to cuddle a slimy snake. Secondly, the snake symbolizes the danger inherent in the *femme fatale*: intimacy can give way at any moment to a deadly suffocating stranglehold.

The original Dryope of classical mythology wasn't a *femme fatale*. She was an innocent young nymph who was raped by the randy god Apollo. He slyly disguised himself as a small tortoise. When Dryope lifted him onto her lap to play with him, he swiftly changed into a treacherous serpent and that was the end of innocence for the poor nymph. This bronze statue, however, tells a different story. Not violent rape but pleasant foreplay appears to occupy these two lovers, entranced with each other's presence. Evidently Barret Browning wasn't planning to represent this ancient tale as accurately as possible but rather to illustrate woman and serpent intertwined as an artistic motif.

CLEOPATRA TRYING OUT POISON TO THE CONDEMNED 1887

Oil on canvas, 165 x 290 cm
Koninklijk Museum voor Schone Kunsten, Antwerp

In the course of the nineteenth century Cleopatra grew to become the *femme fatale par excellence*. The myths that accumulated around the Egyptian queen all contain the essential characteristics of the Fatal Woman: she is extremely beautiful, sexually sophisticated and full of murderous passion. One after the other, Cleopatra seduced Roman generals, and the men who had spent the night with her paid the penalty next morning – they were killed on the spot. Apparently Cleopatra greatly enjoyed the spectacle of seeing people die. You can't come any more fatal than that!

Thus in the *fin de siècle* Cleopatra frequently appeared in pictures and literature. A choice selection of paintings illustrates this monarch's exotic and decadent life. Many different writers described in subtle detail her abuse of power, the extravagance and sexual excesses that marked her life.

In this picture of Cleopatra, Alexandre Cabanel has captured a moment when the queen, looking utterly bored, observes the death throes of one of her victims, while in the background the body of a previous victim is being carried away. It is not exactly clear who these men were – possibly they were prisoners condemned to death. But in the hothouse environment of the *fin de siècle* people were all too prone to see them as the queen's lovers. In exchange for his life a man was permitted to make love with Cleopatra for one night.

This legend in particular captured the imagination of artists at the close of the nineteenth century. Indeed, many were delighted at the link the Egyptian queen made between sex and death:

Ah Cleopâtre! Je comprends maintenant pourquoi tu faisais tuer, le matin, l'amant avec qui tu avais passé la nuit. Sublime cruauté...grande voluptueuse, comme tu connaissais la nature humaine, et qu'il y a de profondeur dans cette barbarie! (Gautier 1835)

For writers likeTheóphile Gautier, Cleopatra was the ultimate woman. Her beauty and her personality were so alluring that a man would gladly sacrifice his life in exchange for the supreme pleasure of spending one night with her.

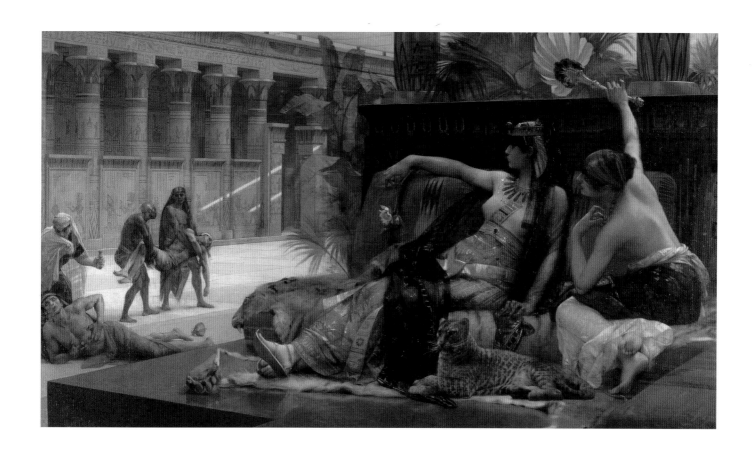

CLYTEMNESTRA 1882

Oil on canvas, 239.5 x 148 cm
Guildhall Art Gallery, Corporation of London, London

John Collier was a respectable member of the English aristocracy. He painted portraits of well-known politicians and captains of industry. He tried to render the likeness of his sitters as accurately as possible and has indeed been called the champion of orthodox painters. It is striking that even this upstanding gentleman became infected for a while with the *femme fatale* virus and portrayed, along with his grey politicians, several mermaids, the occasional witch and evil mythical women, such as the Clytemnestra seen here.

Clytemnestra was the wife of Agamemnon, king of Mycenae and commander in chief of the Greek troops who fought in the Trojan War. Before he was allowed to set off for battle, the gods demanded a sacrifice from him. This was no ordinary request: he was to offer up his own beautiful daughter, Iphigenia. He managed to lure the girl away from her mother's watchful care; he knew that Clytemnestra would never permit him to kill their child. After her daughter's (apparent) death, the queen swore revenge on her husband for his false trickery. After ten long years away at the Trojan War, Agamemnon, the victorious hero, returned to his kingdom. Clytemnestra received him with apparent rejoicing, rolled out the red carpet, so to speak, and announced that a grand banquet was being prepared to celebrate his triumphant return home. But first she desired to bathe him herself and wash away the dirt and dust of his travels. Once he was in his bath, she threw a net over him, and hacked off his head.

The painting shows Clytemnestra immediately after the murder. She presents to the viewer the bloodstained axe with which she beheaded her husband. Not a flicker of regret, no suggestion that she was beside herself with rage, but quite calmly and even proudly, she stands with the axe. We see a woman without mercy, someone who quietly waited ten long years to take her revenge. Her appearance radiates the desire to kill. People who saw the painting towards the close of the nineteenth century were so appalled that it had to be removed from an exhibition. It must have come as a huge shock to the respectable Collier to learn that he was publicly rejected because the *femme fatale* whom he had created was seen as contravening – indeed, an insult to – good taste.

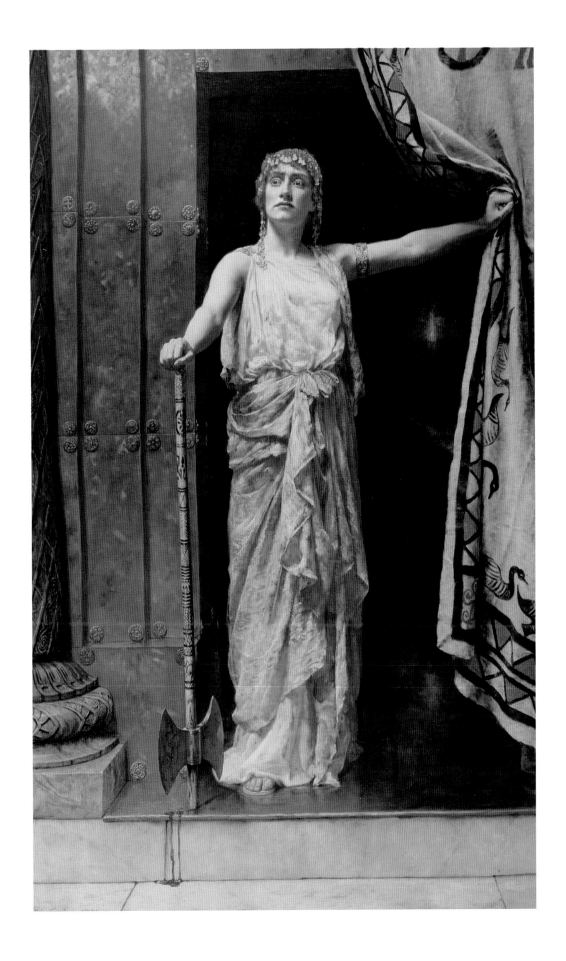

THE GOLDEN FLEECE 1904

Oil on canvas, 155 x 272.5 cm
Bradford Art Galleries and Museums, Bradford

Medea was a *femme fatale* who inspired artists and writers in many periods. This is evident from the dates of the two pictures of Medea shown in this exhibition. One is the previously described painting by Frederick Sandys, dating from 1866-1868 and the other is the picture seen here by the English artist Herbert Draper, dating from 1904. The tragic figure of this woman from classical mythology who initiated so many unspeakable horrors became an inexhaustible source for those who wished to take up the theme of the evil woman.

Here we see a half-naked Medea before the act of chopping up her brother Apsyrtus and hurling the pieces into the sea. Not surprisingly, this deed had been preceded by a series of dramatic developments. Ignoring the wishes of her father, king Aetes, Medea had helped her lover Jason to gain the much-coveted golden fleece. The two then attempted to escape by boat, but were hotly pursued. When her father's ship began to approach quite close, Medea had the brilliant idea of killing her young brother and throwing his limbs overboard one by one. As she had anticipated, her father stopped sailing to gather up his dead son's remains. In this way Jason and Medea managed to escape.

Draper's picture shows Apsyrtus clutching at his sister's robe and trying to attract her attention. However, with not a flicker of mercy she looks the other way while indicating with a finger what she intends – into the water with him. Behind Medea, the golden fleece gleams in the light, while her shining white skin contrasts with the dark colour of the men around her. In the upper right corner of the canvas the sails of the pursuing ships can be seen approaching.

Draper painted classical stories with exquisite attention to detail. Although he too portrayed Fatal Women he never went over the top in picturing bloodthirsty excesses. This painting doesn't show any hacked-off limbs or weapons raised to strike. The young Apsyrtus is still unharmed and it even looks as if Medea plans to throw him into the sea in one whole piece. Possibly the gruesome details of the original story were a little too much for Draper to stomach.

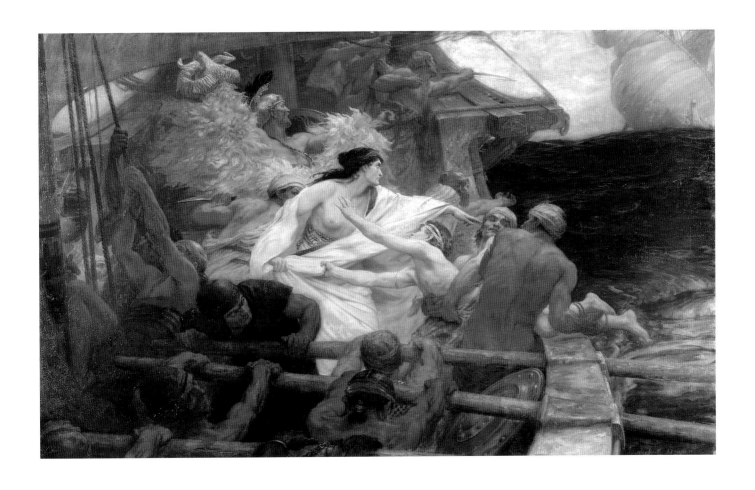

LAMIA 1899-1900

Bronze, ivory and opals, 61 x 55.3 x 25.4 cm
Royal Academy of Arts, London

There are varying accounts of the goddess Lamia in classical mythology. Some sources say she was a snake-woman, a demon who murdered children or an evil all-powerful seductress who could change her shape. Others tell of a group of Lamias: nymphs of surpassing beauty who enticed young men to their destruction. After consuming their youthful energy, the Lamias drank the blood and devoured the flesh of their young victims. In this way they may be seen as the ancient precursors of the vampire.

In 1820 the English poet John Keats wrote *Lamia,* a poem that was to prove an inspiration for later nineteenth-century writers and artists. In Keats's poem several of the Lamia myths are integrated. He recounts how the young Lucius fell in love with Lamia, an immortal demon – half serpent, half woman – who took the form of a lady of exceeding beauty, in order to seduce him. His decision to marry her turns out to be the death of Lucius. Just before the marriage ceremony he looks at his belovèd and discovers that she is quite the reverse of what he had believed.

"Begone, foul dream!" he cried, gazing again
In the bride's face, where now no azure vein
Wander'd on fair-spaced temples; no soft bloom
Misted the cheek; no passion to illume
The deep-recessed vision: all was blight;
Lamia, no longer fair, there sat a deadly white.

The shock is so profound that Lucius dies on the spot.

The life-size bust modelled by sculptor George Frampton would seem to show this moment of truth about Lamia. Her lover discovers that beneath the deadly-white skin there lurks some murky secret. The sculpture, with its almost-closed eyes and frozen rigidity poses questions about its identity. Are we looking at an inaccessible beauty or a terrifying demon? Is this the fatal snake-woman who sucks empty her male victims or is this woman imprisoned in her bronze armour? We cannot expect an answer from this Lamia, wrapped in a mysterious wordless silence. Her ivory countenance might be a death mask, were it not that the goddess herself is immortal and it is in fact she who sends others to their death.

MEDUSA'S BLOOD 1898

Lithograph, 21.5 x 14.5 cm
Koninklijke Bibliotheek van België (Royal Library of Belgium), Brussels

Medusa should surely not be missing from a collection of the *femmes fatales* in classical mythology. This terrifying woman with her head covered with writhing snakes was literally petrifying: anyone who looked upon her face was instantly turned to stone. The young hero Perseus, after some exciting adventures, managed to behead her by means of a trick. In this painting Fernand Khnopff, like many an artist before him from classical Antiquity onwards, presents the decapitated head. Rising from the tangle of serpents, which the monstrous woman had instead of hair, one snake is seen coiling upwards, to slake its thirst in the blood that oozes from the neck where the head has been hewn off. At the base of the painting we perceive the winged horse Pegasus, the son of Medusa who was born out of that same blood. Curiously, Khnopff shows Medusa's head with the top sliced off as well. Because there is no forehead, we are confronted all the more keenly with the fierce, flaming eyes.

The giant Atlas made the unhappy discovery that a dead Medusa could be as fatal as a living one. Atlas was so unpleasant to Perseus that the hero held the head of the dead monster in front of the giant – and, yes, he was immediately turned to stone. His craggy shape became known as the Atlas mountain range. Clearly, even death did not deprive Medusa of her formidable and fatal force.

CIRCE 1902-1906

Bronze, 58 cm (height)
Victor & Gretha Arwas Collection, London

Proud and powerful upon her pedestal stands this female nude. She stares fixedly into the distance, while her raised hands make a gesture of defiance. Beneath her feet a tangle of men's bodies swarm and writhe, totally engrossed in a bestial orgy. The statue shows Circe, the all-powerful sorceress from classical mythology, who without a shred of mercy played upon men's sexual desires. For her, men were despicable earthy and earthly mortals.

Like the artist John William Waterhouse, Bertram Mackennal was inspired by the story in which the enchantress transformed the companions of Odysseus into swine. Mackennal too presents Circe as a seductive and supremely beautiful woman with a delicious body and a powerful charisma. By placing her on this pedestal, the sculptor illustrates the extent of Circe's sexual attraction. She caused men to exhibit the lowest feelings they possess: everyone who looked upon her was changed into an animal, driven by feral lusts and passions. Her magic forced men into a morass of bestiality.

Mackennal's statue was first put on show in the Paris Salon exhibition of 1893. It was greeted with exuberant praise and drew large crowds. In London, however, the sculpture was banned from public showing at first, because the orgiastic men were considered too provocative. But in 1894 the piece was exhibited with a piece of scarlet cloth wrapped around the pedestal.

MEDEA 1889

Oil on canvas, 149.8 x 88.9 cm

Williamson Art Gallery and Museum, Wirral Museums Service, Birkenhead

Gustav Adolf Mossa (1883-1971)

DIANA CA. 1906

Watercolour, pencil and ink on paper
Victor & Gretha Arwas Collection, London

HELEN 1881

Oil on canvas, 91.7 x 71.5 cm
The Art Gallery of New South Wales, Sydney, acquired 1968

Helen of Troy was the most beautiful woman in the world. Although she was the wife of king Menelaus of Sparta, the goddess Aphrodite, or Venus, promised her as a reward to the young Trojan prince, Paris. At their first meeting the two fell deeply in love. Helen left her husband and child and eloped with Paris to his home, the city of Troy.

So far not a new story – Helen is an adulterous wife who goes off with her lover. Certainly, she is exceptionally beautiful, but she is neither wicked nor intentionally a *femme fatale.* Nevertheless, her adultery was the cause of the most famous struggle in classical Antiquity: the Trojan War. Ten long years, and thousands killed on both sides, all to avenge the insult to Menelaus. Helen's remarkable beauty demanded innumerable victims.

In the *fin de siècle* she became one of the most popular *femmes fatales.* Like Salome, Judith, the Sirens and the Sphinx she was frequently portrayed – although in a fundamental sense, she was quite different from the others. Unquestionably, she indirectly caused the deaths of countless men, but in fact she herself harboured no evil intentions. True, she deserted her family because she loved another man, but that's where her trespass ends. Helen is a kind of innocent *femme fatale*. Possibly this is why the English artist Edward Poynter portrayed her with a somewhat surprised expression. With slightly anxious eyes and her hand on her heart she gazes upon the devastation that she has caused. Almost as if she's wondering how on earth it all could have happened.

When the painting was first exhibited in 1881 it caused a considerable commotion. Because the lady in the picture was clearly not only Helen of Troy, but also bore a remarkable resemblance to Lillie Langtry. The latter was reputedly the most beautiful woman in London and, it was whispered, the mistress of Edward, prince of Wales. Birth of a scandal! For the picture was interpreted not only as the portrayal of a classical myth but also as a comment upon the woeful consequences of adultery.

Frederick Sandys (1829-1904)

MEDEA 1866-1868

Oil on panel, 62.2 x 46.3 cm
Birmingham City Museums and Art Gallery, Birmingham

Day by day
She saw the happy time fade fast away
And as she fell from out that happiness
Again she grew to be the sorceress
Worker of fearful things, as once she was.

Medea has been portrayed since classical Antiquity as a wicked woman. In his poem *Life and Death of Jason* from 1867, the English craftsman, designer and writer William Morris suggests that, overwhelmed by misfortune, she was driven to her atrocious deeds. She used her magic powers to destroy those who were closest to her. She murdered her children herself and had her brother killed and then chopped into pieces. This painting by the English artist Frederick Sandys shows Medea stirring a poisonous drink with one hand while the other clutches at the blood-red coral necklace she is wearing. On the table before her lie magic incantations used to make her potions, as well as the ingredients: toads, berries and shells. The sinister still-life arrangement is encircled by a scarlet thread. Behind Medea on the wall appear reminders of the journey she once made with her lover Jason: in a tree on the right hangs the golden fleece that she helped him to steal from her father, while on the left is the ship in which the pair then escaped.

The Medea here is a frightening, vicious and wicked figure, but not a typical *femme fatale*. The atrocious acts that earned her her evil reputation were not undertaken in cold blood, but out of violent passion. When the story began, Medea was a girl whose guy seemed to love her; later she was a deceived wife. She committed murder not because she loved to kill, but to avenge herself. Nor is she a seductress she didn't try to lure men with her beauty. Consequently, this painting doesn't show a semi-naked woman in a lecherous pose, as do most of the other portrayals of *femmes fatales*.

Nevertheless this Medea from 1868 has similarities with the nineteenth-century iconography of the *femme fatale*. Her form, filling the frame, creates the same oppressive, claustrophobic atmosphere, further emphasized by the narrow stretch behind her and the table in front. And her white skin, long soft neck and thick dark curls are all attributes of the *femme fatale*. However, she is anything but erotic. There is no suggestion that she's out to seduce her viewers, but rather to terrify them.

CIRCE OFFERING THE CUP TO ULYSSES 1891

Oil on canvas, 146.5 x 91 cm
Gallery Oldham, Charles Lees Collection, Lancashire

According to classical mythology, Circe, daughter of the sun god Helios, was a sorceress. She could transform people into animals, as recounted by the English writer John Milton in his masque *Comus,* first performed in 1634. Here he describes her habit of turning men who bothered her into pigs:

Who knows not Circe,
The daughter of the Sun? whose charmèd cup
Whoever tasted, lost his upright shape,
And downward fell into a grovelling swine.

The Greek hero Ulysses, during his wanderings after the ten-year siege of Troy, landed up with his companions on the island where Circe held sway. This painting shows the moment at which the hero approaches her in order to free his comrades. Already enchanted swine, they snuffle contentedly around, while Circe attempts to charm their leader with her magic potion.

John William Waterhouse portrays Circe with references to her magic powers. Lying helpless at her feet is a man whom she has changed into a pig, while another hoggish creature can be seen sniffing round the edge of her throne with his sleepy snout. In contrast to the bemused pigs, the lions surmounting the feet of Circe's throne cast fiery glances at her following victim. The footrest is decorated with the head of Medusa. Arms raised, Circe holds ready her magic implements – a goblet of drugged wine and a magic wand. However, these fail to take effect on Ulysses, for he is protected by a special herb that makes him immune to any kind of magical spell. Nevertheless, his form reflected in the mirror behind Circe doesn't emanate self-confidence but rather cautiousness, even fear.

Circe, with her closed eyes, mouth slightly open, long flowing locks and half-uncovered bosom, is the typical *femme fatale* of the nineteenth century. Although her actual power lies in the magic drink, Waterhouse has emphatically pictured the enchantress as a sexual temptress. Her fatal attraction is symbolized by her physical beauty. It isn't so much magic as her luscious body that drives men to distraction. The painting thus reveals how stories from classical mythology gained a completely new significance using the iconography of the *femme fatale.*

CIRCE INVIDIOSA 1892

Oil on canvas, 180.7 x 87.4 cm
The Art Gallery of South Australia, Adelaide
South Australian Government Grant 1892

In a painting by John William Waterhouse from 1891, discussed previously, the sorceress Circe is shown transforming men into pigs. In the work seen here she is also portrayed on the point of casting one of her magic spells. But this time the victim is a woman. The poor unfortunate has presumably aroused the violent jealousy of the enchantress, for everything has taken on a green tinge – the witch's form, the water and the poisonous potion.

According to classical mythology the sea god Glaucus fell in love with the nymph Scylla, but she spurned him time and again. Driven to distraction, he consulted the sorceress Circe. Hadn't she got a magic potion to make Scylla fall in love with him? But the enchantress had other ideas. While the handsome sea god was beseeching her for help she had become inflamed with desire for him. She tried to seduce the young god and make him forget the sea nymph, but all to no avail. Glaucus desired only Scylla, unrivalled in his eyes even by the mighty Circe. The sorceress, enraged at his outright rejection, decided to cool her temper with a little magic action. Mixing one of her powerful potions, she poured it into the waters of a small cove where Scylla often came to bathe. On dipping her feet into the water, the beautiful sea nymph was transformed into a hideous monster with six heads and a triple row of teeth. Utterly disconcerted, she crept away and hid beneath a craggy rock in today's Straits of Messina, opposite the far-famed whirlpool of Charybdis. From this hiding place, filled with despairing rage she was to trouble and torment sailors for centuries to come.

Based on this story, Waterhouse has represented Circe standing upon a fearful sea monster and pouring her poisoned potion into the waters of the bay. Green is the colour of envy. The doom-laden liquid, the waves of the sea, the monster, Circe's skin and her gown – all are saturated with green.

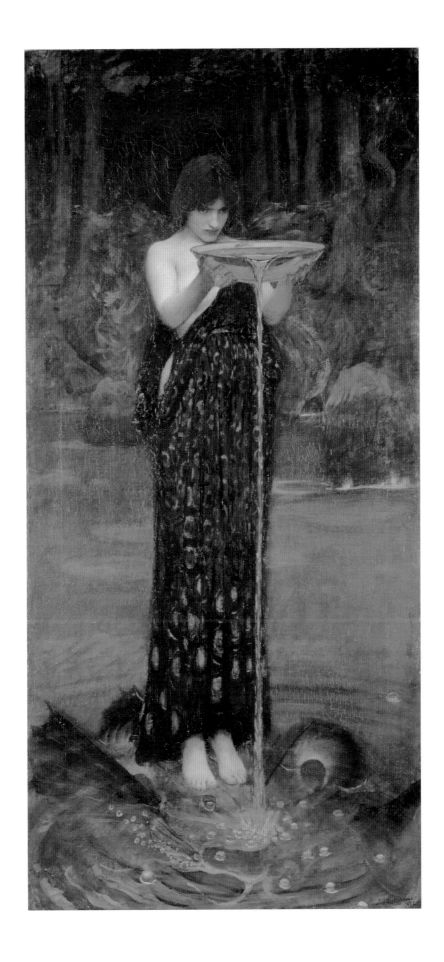

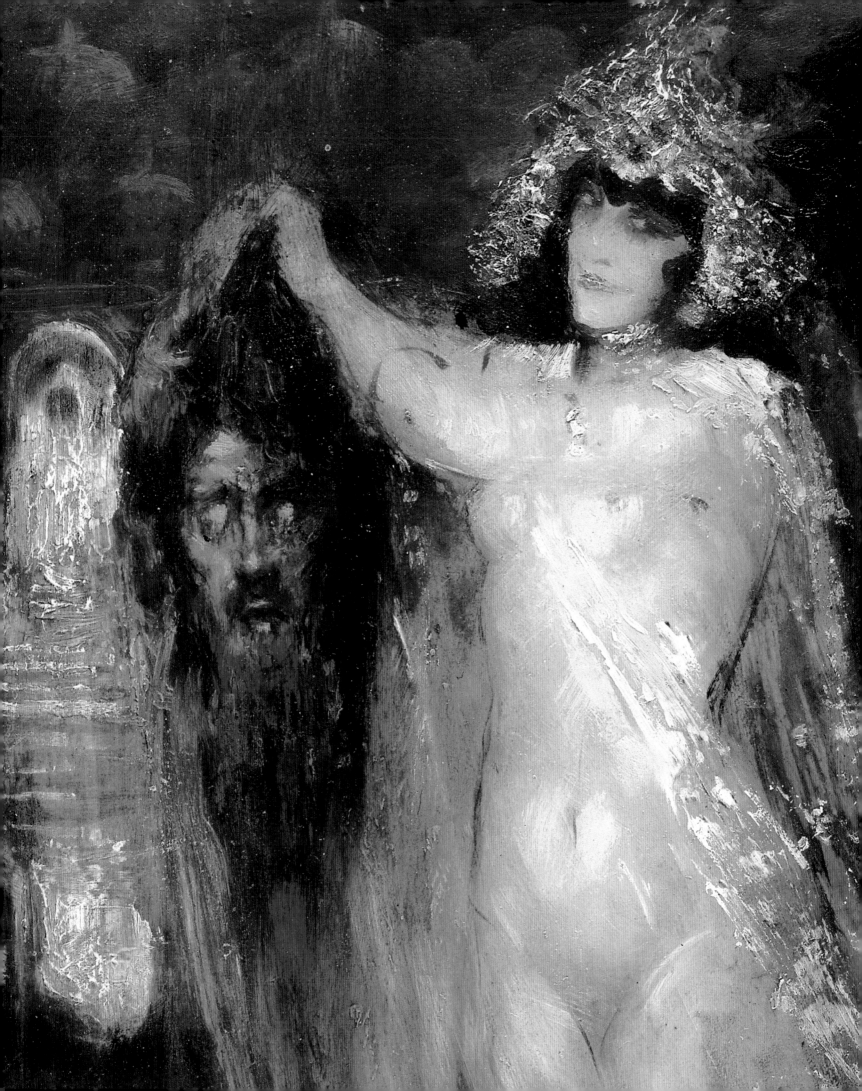

BIBLICAL HEROINES

Christien Oele

THE CLIMAX (SALOMÉ) 1893

Lineblock reproduction, 34.3 x 27.2 cm
Alessandra and Simon Wilson Collection, London

This is one of Beardsley's illustrations to Wilde's *Salomé*. The original is lost and the drawing is now best known from this roughly same-size lineblock reproduction published in 1906 by John Lane (who owned the drawings) as part of a loose-leaf portfolio of seventeen of Beardsley's nineteen designs for *Salomé*. In his play, Wilde gave a distinctively *fin de siècle* and compelling twist to the Biblical legend by imagining that Salome lusted after the Baptist and brought about his death in revenge for his spurning of her advances. When brought his head she seizes it, harangues it in a great prose poem of passion, triumph and despair (she has killed the thing she loved) and finally embraces it in death as she could not in life, crying 'Ah! J'ai baisé ta bouche, Iokanaan, j'ai baisé ta bouche ('I've kissed your lips …'). These words, of Wilde's original French text, were inscribed by Beardsley on his earlier drawing of this scene, presumably made shortly after he first read the play in, again presumably, late February or March 1893 and which secured him the commission to illustrate the English edition. (The first, French, edition of the play was published simultaneously in Paris and London on 22 February 1893. A copy was inscribed by Wilde to Beardsley with the date 'March '93'.) The moment depicted in both drawings is thus that immediately following Salome's necrophiliac act, as she gazes with grim, heavy satisfaction at her prey.

Linda Zatlin described in her book *Aubrey Beardsley and Victorian Sexual Politics* (1990) that Salome's face bears 'marks of hardness and cynicism' as a result of her 'evanescent success in reversing the rules of power when she bargains with Herod for the Baptist's head as if she were a man'; to the Victorians she represented 'a distortion of femininity … caused by her desire for vengeance and her acceptance of a masculine role to achieve it.' The title's pun on the sexual meaning of climax has also not been overlooked.

In *Aubrey Beardsley* (1987) Ian Fletcher crucially points out that 'Salome has assumed … the appearance of that central emblem of Romantic beauty and horror, the Medusa [whose] face and hair can kill at a glance, and it is this power that Beardsley most dramatically portrays in Salome's hungry peering at Iokanaan's severed head and in the head's blind reciprocating gaze'. But he stresses too that the Baptist also is represented as a Medusa: 'hermaphroditism, self-reflectiveness and the fatality of unmediated nature are unforgettably focused here'. It remains only to add that in the play, Salome herself, following her triumphant, quasi-orgasmic cry, is at once killed. (SW)

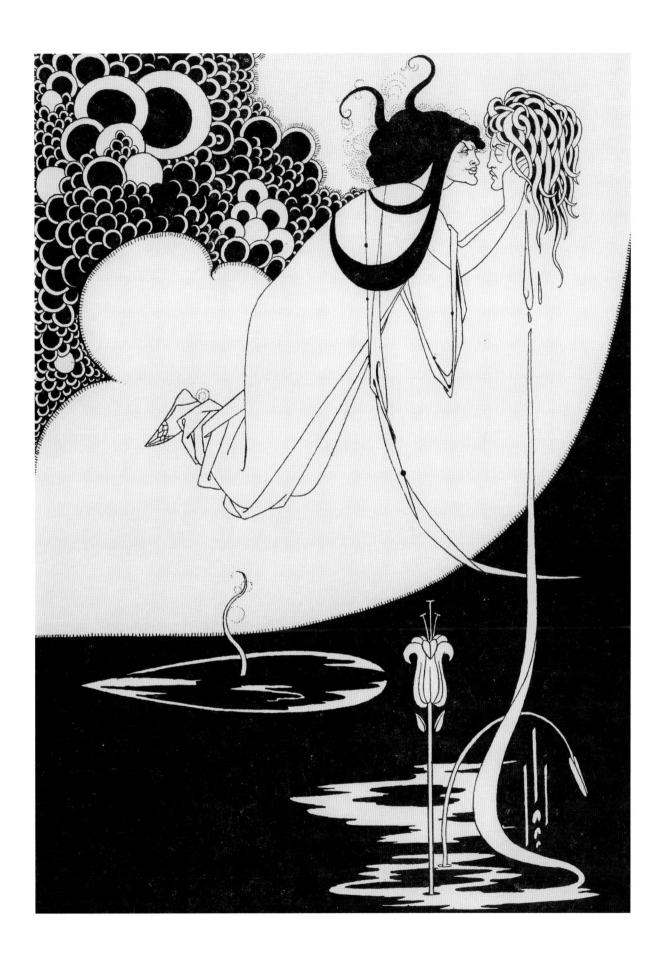

SALOMÉ

Gouache (varnished) on paper, 59.5 x 50.5 cm
Private Collection, France

The Salome painted by the French artist Georges-Olivier Desvallières is an evolved mutation of Gustave Moreau's representations of the same subject. The gouache shows a stage later in the story – the dance is over and John the Baptist has been beheaded. Also, certain late nineteenth-century elements have been added to the picture.

Thus we no longer see Salome as an attractive young woman performing a voluptuous dance, but as an evil shrew making off with her victim's head. The essential moments in the Salome story merge here in one blinding moment – the dance and the beheading combine. In a whirlwind of jewellery, veils, limbs and freshly streaming blood, Salome performs her dance of death. This is no naieve daughter but an independent person, a murderous beast of prey, revelling as it proudly displays its victim. Lifting up the head of John the Baptist by the hair, she smiles with malicious pleasure, while a look of scorn fills her dark eyes.

It was this thoroughly wicked Salome who enjoyed huge popularity in the *fin de siècle*. Several artists showed her eagerly embracing the Baptist's decapitated head. Some even had her kissing the mouth of the dead man, as she does in the one-act play by Oscar Wilde, written in French and published in English translation the following year, 1894. The French writer J.-K. Huysmans gives the following classic description of Salome in his novel *A Rebours* (Against Nature) published in 1884:

'Not only was she the dancer who with the lascivious motion of her hips aroused a moan of desire from the old man watching her like a creature in heat; the swaying of her full breasts and her gently-rounded belly, the quivering of her thighs, broke down the king's defences and deprived him of his willpower. She became, in a way, the symbolic goddess of undying Lechery, the divine form of immortal Hysteria, the beauty that is cursed, raised above all other beauties by a rigidity that stiffened her flesh and hardened her muscles; the monstrous Beast, indifferent, irresponsible, insensitive, poisoning – just like Helen of olden days – everything that approached her, everything that looked upon her, everything she touched.'

With these words Huysmans also provides one of the most famous descriptions of the *femme fatale*.

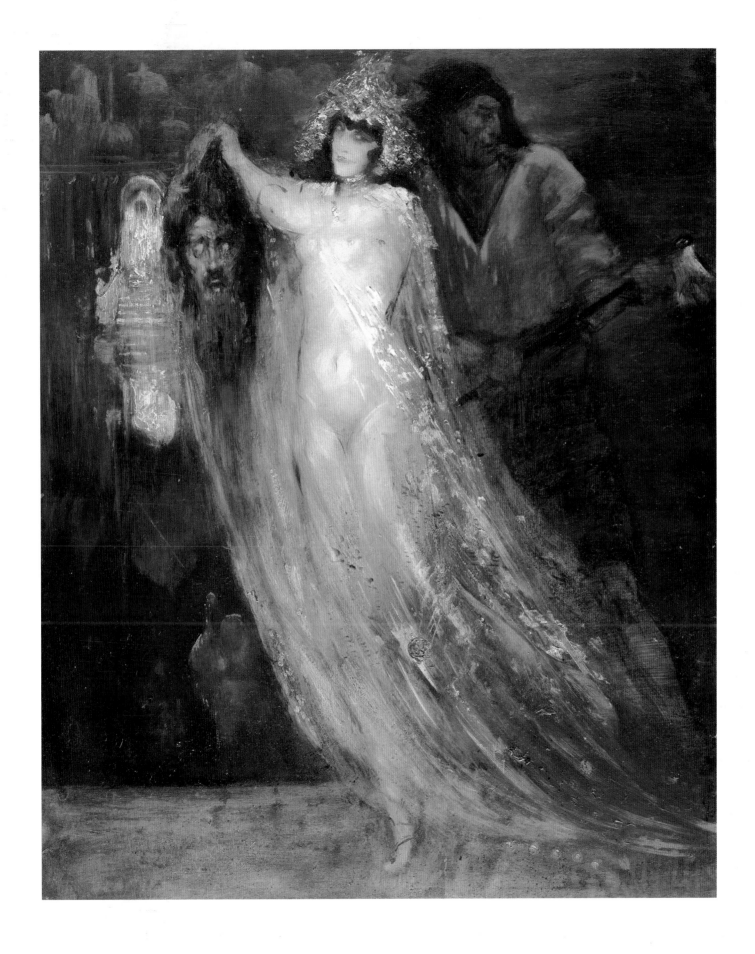

THE HEAD OF THE NEW SALOME 1893

Bronze, 70 cm (height)

Van Gogh Museum, Amsterdam

Paler than a winter morning
whiter than the wax of candles
are the hands of this fair maiden
crossed before her virgin bosom.
Crimson with the blood of hearts
is the garment that she's robed in,
bleeding hearts that died for her.
At the corners of her cruel mouth
Lurk corruption and decay,
And her smile is spiced with scorn.
Deep within her blue-black eyes
hard and cold like diamonds
that gaze on distant fantasies,
her impenetrable thoughts are spinning
a circle of impossibles.

This poem is taken from Joséphin Péladan's novel *Le Vice Suprème*, published in 1884.

It seems highly probable that it inspired the German artist Max Klinger to create this Salome. With an ice-cold gaze, she towers above her surroundings. Her pose admits no compromise, her arms are firmly folded; this bronze statue is chilly and repelling.

Klinger called his creation *The Head of the New Salome* and with the word 'new' he implied the modern Salomes who peopled the *fin de siècle*. One critic, on seeing the work, wrote that the artist had portrayed the 'modern vampire'. She was 'the woman who in a wondrous way combines sensuality with savagery, cool calculation with the wildest, most depraved feelings.' This modern vampire isn't only a threat to prophets from the past; she can still seduce men today, would seem to be the artist's message.

SAMSON EN DELILAH 1909

Oil on canvas, 125.6 x 175.8 cm
Städtisches Museum Gelsenkirchen

Undeniably, the German artist Max Liebermann has painted one very naked *femme fatale* on this canvas. The Delilah bending over Samson's sleeping form in the act of snipping off his locks is a grey, fleshy, somewhat flabby female. No seductive poses here, no languishing looks, costly garments or luxurious locks of hair. While other artists give their biblical characters an erotic setting, Liebermann has stripped this Delilah of every scrap of attraction or appeal. Clearly, this woman is not intended to seduce the viewer, but rather to repel.

Liebermann was known as the 'disciple of the Ugly'. His raw realistic style contrasted sharply with the paintings of his more romantic colleagues, whose pictures presented dreams of fairytale prettiness. Liebermann chose to present real-life people – peasants and labourers with both feet firmly on the ground. He rarely took a biblical topic for his work.

This painting should be seen as a reaction to the over-imaginative representations that became fashionable towards the end of the nineteenth century. Indeed, it looks almost like a cartoon, or satirical print. Evidently, Liebermann wished to de-mystify this Old Testament story. What he presents is not a half-veiled mystery, but the undecked truth about the *femme fatale*. She is an appallingly ugly, evil-minded woman of terrifying proportions.

SALOMÉ

Oil on canvas, 80 x 40 cm
Musée Gustave Moreau, Paris

Of all the *femmes fatales* who populated the *fin de siècle*, none so fired the imagination as the renowned Salome. Indeed, she became the ultimate symbol of female recalcitrance and writers, poets, painters and musicians saw her as embodying all the features of the *femme fatale*. Nevertheless, the biblical figure who was her prototype seems to have been simply an innocent young woman.

In the Gospel of St Mark the story is told of the affair between king Herod and his sister-in-law, Herodias. The prophet John the Baptist condemned their liaison, thereby arousing the fury of Herodias, who managed to get him imprisoned. So enraged was Herodias that she begged the king to kill John, but this he refused, partly because John was so popular. Queen Herodias, however, didn't give up. At the king's birthday party she encouraged her daughter Salome to dance before the guests. So seductive was this dance that the king promised to give Salome whatever she asked for. At her mother's suggestion, the young woman asked for the head of John the Baptist. It was impossible for the king to go back on his promise – so John's head was shortly thereafter carried in on a platter and presented to the princess.

In the biblical account Salome only plays a minor part, being quite simply manipulated by her vengeful mother. However, in the course of the nineteenth century she increasingly played the star role. Not Herodias but Salome was seen as the evil, bloodthirsty woman who demanded the head of the prophet. With her voluptuous dancing she had deliberately contrived his death.

In the 1870s the French painter Gustave Moreau unleashed a veritable Salome mania among artists. He was one of the first to take the biblical belly-dancer and make her the subject of his works. The two sketches here show her dancing. She is seen dressed in costly raiment and jewellery, in her hand a lotus, flower of sensual pleasure, and at her feet a black panther, symbol of savagery and rapaciousness. Although the dance was performed to delight king Herod, he is not in the picture. Thus it looks as if the viewer is standing watching, like Herod. The sketches suggest how the old, voyeuristic king looked longingly at the lascivious movements of his step-daughter and was so aroused by her dancing that he promised to give her whatever her cruel heart desired.

SALOMÉ DANSANT

Watercolour, 72 x 34 cm

Musée Gustave Moreau, Paris

(Groninger Museum only)

SALOMÉ 1907

Watercolour, pencil and ink on cardboard
Victor & Gretha Arwas Collection, London

THE TEMPTATION OF ST. ANTHONY 1878

Pencil on paper, 73.8 x 54.3 cm
Koninklijke Bibliotheek van België (Royal Library of Belgium), Brussels

The temptations of St Anthony had long been a favourite topic of artists, but it received a new impetus with the publication in 1874 of a novel by the French writer Gustave Flaubert. In his *La tentation de Saint Antoine,* Flaubert sketched the life of the hermit in a distant desert where temptation after temptation pursued and plagued him. The descriptions of the seductions of the flesh for which the poor old man knew no defence, inspired several generations of artists to pick up the paintbrush. Ferdinand Götz, Lovis Corinth, John Dollman and Paul Cézanne illustrated the holy man attempting to resist the advances of a voluptuous female. Sometimes there were just a couple of naked ladies, at other times there would be literally swarms of female nudes pestering the saint and clearly Anthony had a very rough time of it in the *fin de siècle.*

In his drawing from 1878 the Belgian artist Félicien Rops restricted himself to just one woman. With her flaming red hair and luscious body she is seen hanging upon the cross before which Anthony had just been piously praying. 'It's easy to grasp the point,' Rops wrote about this work. 'The holy man St Anthony hastens to kneel at his prie-dieu, haunted by visions of lustful concupiscence but at the same time Satan, a typical red monk, plays a little joke on him. He removes the figure of Christ from the crucifix and replaces it with a gorgeous girl – every self-respecting devil has a few of these tucked up his sleeve. Naturally, this is all just a pretext for painting a delicious female nude.'

As Rops suggests, religious and mythological subjects were often no more than an excuse for painting naked women. Here, however, we are not looking at an everyday nude: this is a devilish hallucination hanging upon the Cross and afflicting an old man. At the close of the nineteenth century the (male) preoccupation with female flesh was such that all sorts of excuses were invented for painting evil female temptresses. In the *fin de siècle,* physical beauty alone was not sufficiently spicy. Things only got really exciting when an element of danger was added.

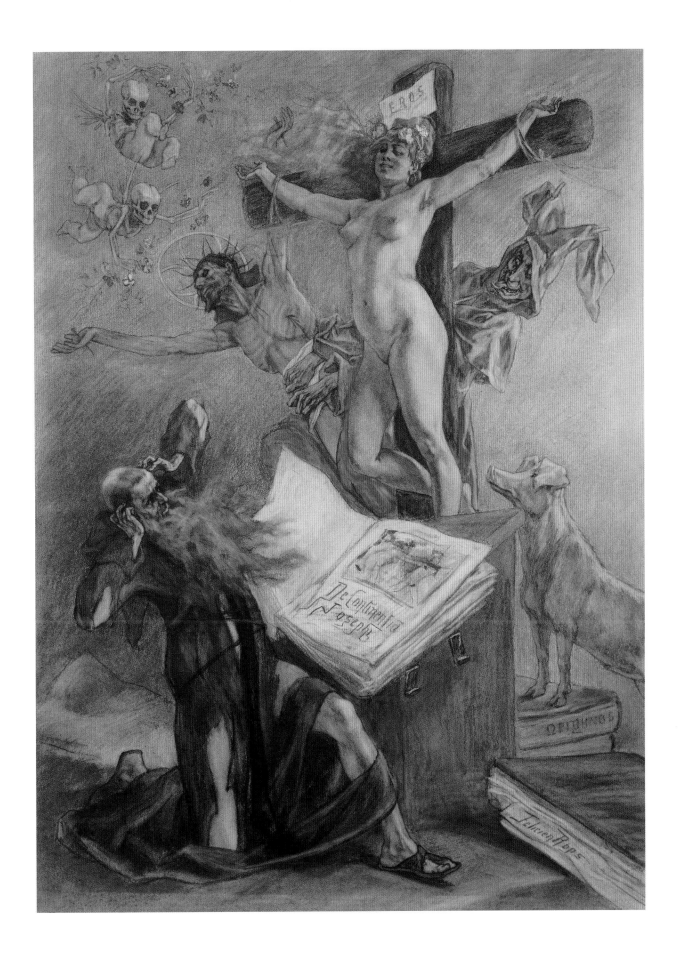

Franz von Stuck (1863-1928)

JUDITH AND HOLOFERNES CA. 1926

Oil on cardboard, 54 x 50 cm
Courtesy Galerie Katharina Büttiker, Zürich

From pious patriot to bloodthirsty killer-babe; the transformation of the biblical Judith in the course of the nineteenth century is a telling disclosure of how tales from the classics gained a new shape in the cult of the *femme fatale*. Judith was initially a symbol of the virtuous woman, of self-sacrifice and courage, but later artists painted her as a malicious shrew who seduced the poor soldier Holofernes with her devouring lust and promptly hacked off his head. She became the subject of numerous pictures and a prototype of the *femme fatale*, a woman who uses her sexual attraction to manipulate unsuspecting men and lure them to their doom. Single-handed, she murdered her male victim.

In the biblical Apocrypha we read of the beautiful, god-fearing widow Judith. The city where she lived was besieged by the Assyrians, led by their general Holofernes. Judith thought up a guileful scheme that would get rid of this enemy. Changing out of her widow's weeds, she adorned herself in beautiful garments and jewels. Then she and her maid set off for the enemy camp. On seeing Judith, Holofernes invited her to dine with him in his tent. During the meal he drank enormous quantities of wine and so fell into a deep sleep. Judith ordered everyone out of the tent and proceeded to chop off his head. She then popped it into her maid's food bag and the two of them set off for morning prayers. Back in her own city, Judith showed the head to her astonished and delighted fellow countrymen. They immediately attacked the leaderless foe and put them to flight.

In the *fin de siècle* Judith was generally pictured as a charming nude armed with a gigantic sword. It is often suggested that she and Holofernes have just been making love. At times she appears as a female vampire, casting a greedy glance at the still bleeding head of her victim. Some artists show her kicking the head with apparent glee. The German artist Franz von Stuck made a series of scenes showing Judith with raised sword in the act of beheading her sleeping prey. He painted six versions of this scene, all virtually identical as regards composition. Von Stuck experimented in this series primarily with colour and technique. The painting seen here emphasizes the dramatic scene by contrasting the proud pale body of Judith with the dark shape of the besotted Holofernes.

SALOMÉ CA. 1922

Gouache and watercolour on paper, 30 x 25 cm

Victor & Gretha Arwas Collection, London

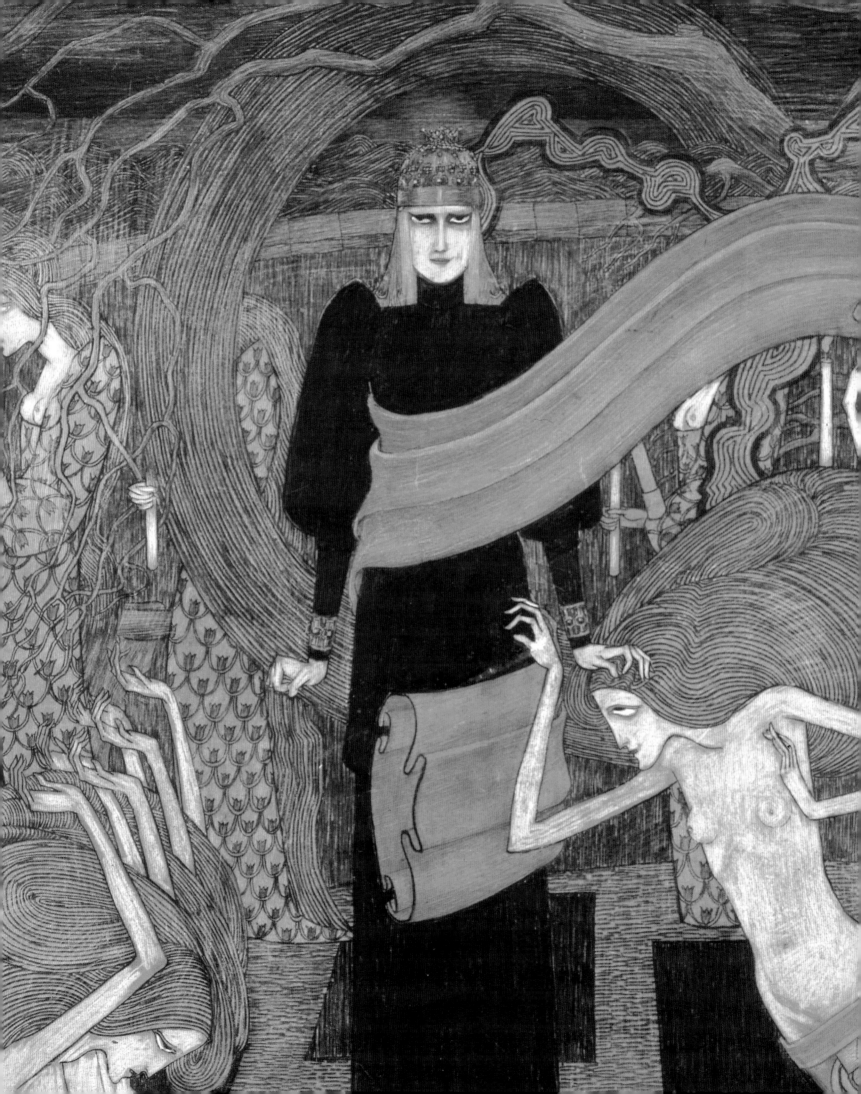

SIRENS & SPHINXES
(FIGURES OF FANTASY)

Christien Oele

ULYSSES AND THE SIRENS 1910

Oil on canvas, 126.8 x 152.5 cm

Leeds Museum and Galleries (City Art Gallery), Leeds

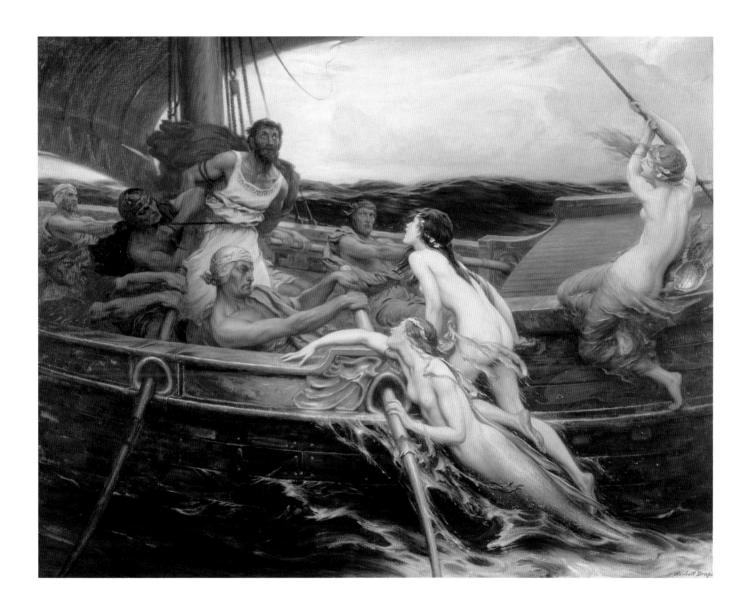

František Drtikol (1883-1961)

(SFINX) CLEOPATRA 1913

Oil pigment print on paper, 34.8 x 46.6 cm

Museum of Decorative Arts, Prague

The Czech photographer František Drtikol was obsessed with the idea of the *femme fatale*. He continued to make pictures showing Salomes and Cleopatras until well into the twentieth century. The female shape here is a combination of all the notions about the fatal women of ancient Egypt. He called it Cleopatra and the woman's *coiffure* suggests the legendary monarch. She lies on a pedestal bearing the inscription 'SFINX' and indeed her pose would seem to suggest that mysterious creature.

This Cleopatra illustrates how woman and sphinx became one. While the sphinxes of Toorop and Moreau may still be recognized as mythical monsters, and with Rops woman and sphinx are merged in an intimate embrace, Drtikol has his woman and monster blend into one being. The sphinx is a woman and the woman is a sphinx. One and the same creature, this monster is evil, elusive and ravening.

The sphinx is usually shown as representing a profound unsolved riddle but this one doesn't leave many questions unanswered. Laughing, the woman nestles her naked body upon that of an equally nude man – which we strongly suspect is a corpse. Her hands grip his chest like the claws of the mythical beast of prey and pressing upon them she raises her body so that the light falls fully upon her breasts while her loins press hard upon the unresisting male form. Undeniably, this is the femme fatale with her vanquished victim. His head rolls off the pedestal, she gazes triumphantly on high.

THE SIREN 1895

Oil on canvas, 100 x 185 cm
Villa Romana Florenz, Florence

Around the end of the nineteenth century sirens and mermaids were so popular you would frequently come across pictures of them in all shapes and sizes. There they were, swimming in the ocean waves, clinging onto the rims of boats, accidentally caught in a fisherman's nets, adorning rocks and beaches, lurking in grottos and streams – you couldn't escape the sweet seductive tones of these luxuriant-haired ladies of the deep. There are just a few stories about mermaids who were nice to know but the majority of these watery damsels appear to have had an evil, predatory nature. Their aim was to seduce innocent, defenceless men in order to drag them to the bottomless depths of the sea.

It isn't surprising that these mythical beings appealed so greatly to people's imaginations. After all, sirens symbolize two aspects of the female that in the *fin de siècle* period people found exceptionally intriguing. First, there is the animal aspect of a woman, and second there is their inscrutability. The female psyche was as unfathomable, mysterious and dangerous as the dark depths of the ocean.

This monumental painting by the German artist Max Klinger shows a Siren passionately embracing her victim. All the elements in the picture contribute to the wild and savage impression of the scene. The sea churns its tempestuous dark waves crested with white foam, the gloomy light reveals layered sombre grey clouds, and we are transfixed by the pair of lovers. The Siren's embrace is so fervent it looks as if her male victim is being held in a wrestler's grip. Nor does he appear to return the hug – far from it. He tries to avoid touching her body and indeed it seems that his left hand attempts to push her away. He looks like someone trying to free himself from a stranglehold. The Siren apparently has two tails and has twined them round the man's legs. It isn't exactly clear where her tails begin and the man's legs finish and this contributes to the notion that the two are fusing together.

This picture by Klinger represents in a remarkable way the Sirens' fatal attraction. It is almost self-evident that the man isn't going to survive this embrace. The Siren forces him against her breast, entwines and imprisons his limbs with her tails and, metaphorically speaking, swallows him whole. Soon his lifeless body will sink to the bottom of the cruel sea.

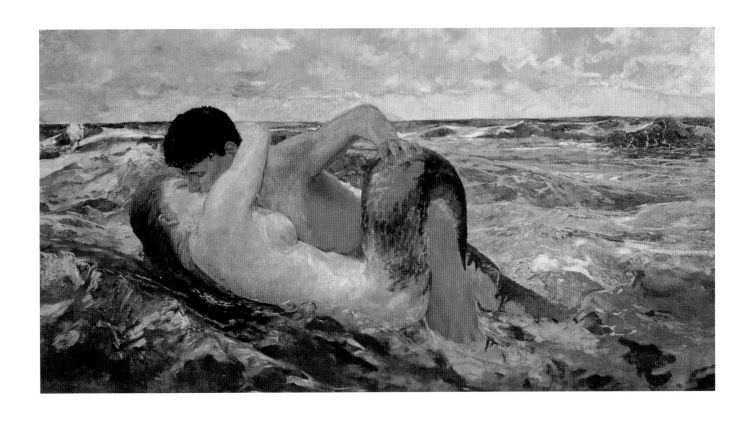

LE SPHINX VAINQUEUR CA. 1868

Watercolour on paper, 31.5 x 17.5 cm

Clemens-Sels Museum, Neuss

(Groninger Museum only)

In this painting the French artist Gustave Moreau shows the mythical Sphinx, seated upon her mountaintop. Filled with an icy calm this queen of enigmas towers above the mutilated bodies of her victims. They are so many that the mountain appears to consist entirely of corpses.

Such a heap of male corpses and wrenched-off limbs is a familiar theme in Moreau's work. And there is always a bloodthirsty, malicious female triumphing over the dead. Sometimes she is called Helen of Troy, sometimes Salome, or Cleopatra or the Sphinx – but whatever her name, Moreau perceived almost every legendary woman as a devouring monster. The novel

A Rebours (Against Nature) published by J.-K. Huysmans in 1884 offers a vivid impression of Moreau's Helen:

'She stands out against a sinister horizon, drenched in blood, and clad in a dress encrusted with gems like a shrine. Her eyes are wide open in a cataleptic stare. At her feet lie piles of corpses. She is like an evil goddess who poisons all that approach her.'

It is both interesting and curious that this citation may also be read as a description of the Sphinx.

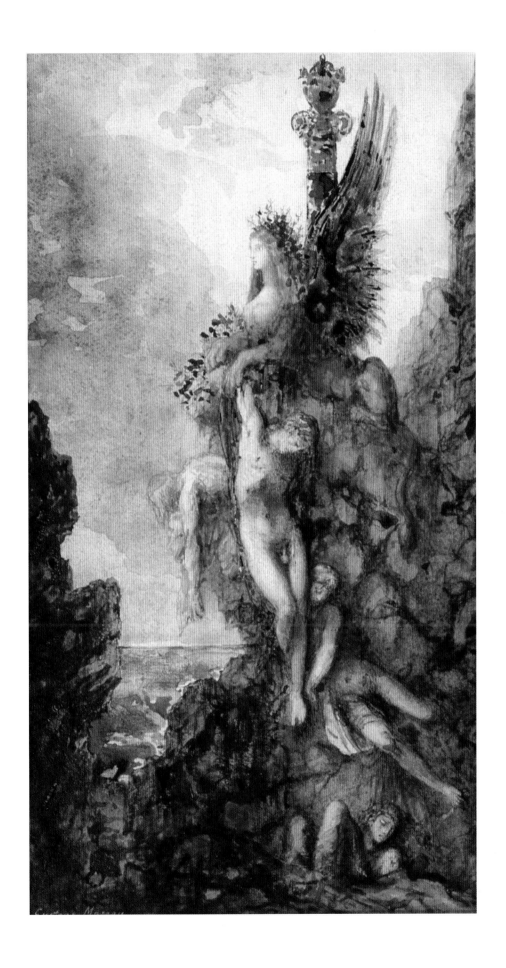

Félicien Rops (1833-1898)

LES DIABOLIQUES, LE SPHINX 1879

Gouache, watercolour and colour pencil, 29.7 x 20.4 cm
Private Collection, Courtesy Galerie Ronny van de Velde, Belgium

LES SATANIQUES 1882

Gravures au vernis mou (series of five sheets)
Private collection, Belgium

The Belgian artist Félicien Rops created this Sphinx as the frontispiece for the book titled *Les Diaboliques* by the French author Barbey d'Aurevilly. This collection of short stories relating the doings of devilish women caused such a scandal that the book was banned from publication. In Rops's illustration a naked woman embraces a Sphinx whilst the Devil watches with interest. The bodies of the woman and the mythical creature meet in intimate embrace and it appears as if they melt and merge together. The warm female flesh and the cold stone of the Sphinx press so close to each other, there is not a hair's breadth of space between them. The illustration suggests that the essential riddle of a woman cannot be solved even by the Devil.

In Rops's oeuvre the woman and the Devil as a couple crop up quite frequently. The series of prints titled *Les Sataniques*

represents their intimate association. According to this artist, Woman was the Devil's consort. He easily gained access to her because of her bestial, perverse, weak and ignoble nature. And unfortunately, men were then the ones to suffer, in the view of Rops. Because just as women were possessed by the devil, so were men possessed by women. Satan gained access to men via women. In short, with their devilish seductive arts women lured men from the strait and narrow path.

With *Le Sphinx* Rops suggests that even the Devil doesn't always know what's going on inside a woman. In the tense triangle between Devil, Sphinx and Woman the Devil plays the part of voyeur. Together, the Sphinx and the woman have sworn a pact that surprises even him.

130

Carlos Schwabe (1866-1929)

DEATH AND THE GRAVEDIGGER 1895-1900

Watercolour and gouache over pencil, 75 x 55.5 cm

Musée d'Orsay, Paris (kept in the Printroom, Musée du Louvre, Paris)

(Groninger Museum only)

A wintry evening in the cemetery. A few dead leaves shiver on the weeping willow. Some snowdrops peep through the snow-covered soil. An old gravedigger has just finished preparing a new grave. His work completed, he realizes that his time has also come to die – this snowy night, death will take him to the hereafter.

Carlos Schwabe presents death in the form of a woman. She sits on the rim of the freshly-dug grave, like a black angel. Her wings resemble two huge scythes. They reach down so far that they enclose the gravedigger in a deathly embrace. The angel is not a malicious being: she is not wrenching the old man out of the world but rather seems to indicate in a friendly manner that his time has come to take leave. Suddenly panic-stricken, he drops his shovel and clutches at his heart.

Through the centuries the figure of Death had been portrayed as a man with a scythe but in the *fin de siècle* Death changed sex. Angels of Death could now be found all over the place. They might appear as anything from charming females smiling sweetly behind black veils, to wicked witches with long lank hair covering a grinning fleshless skull. Death had become a maiden. This transformation is yet another example of the preoccupation with female evil that was so prevalent at this time. Not only were people obsessed with the sinful and perverse aspects of women, they even went so far as to declare that all evil was female. Vampires, monsters, devils and contagious diseases – in the *fin de siècle* everything that was foul, infectious and fatal was shown in a seductive female shape.

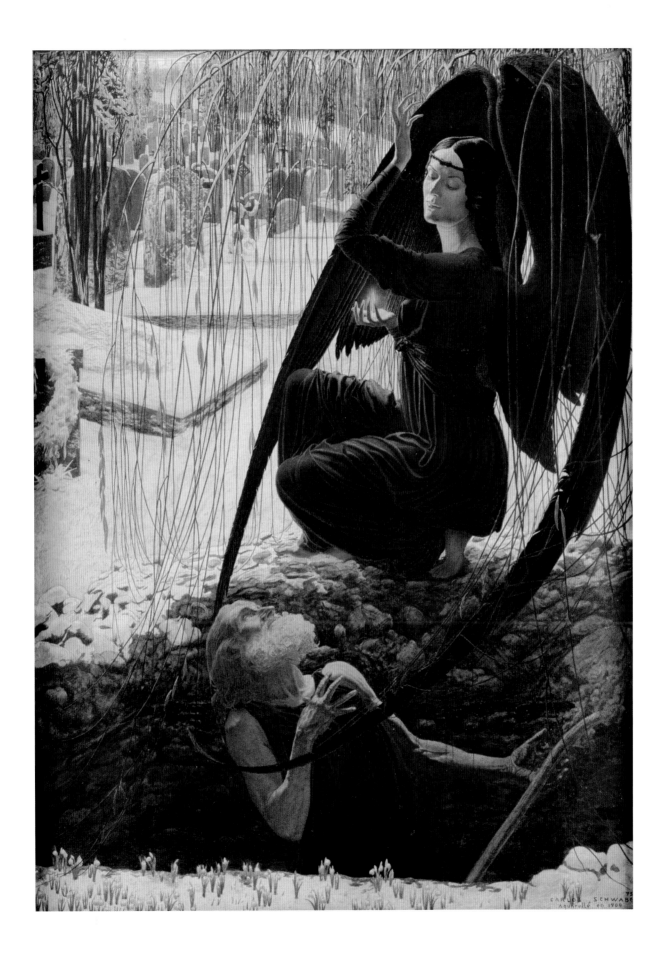

CARLOS SCHWABE
Aquarelle 40 1900

THE SPHINX 1892-1897

Black chalk, pencil and oil pastel on canvas, 126 x 135 cm

Gemeentemuseum, The Hague

(Groninger Museum only)

In the *fin de siècle* the Sphinx became a highly popular theme. This hybrid creature with a woman's breasts and a lion's claws inspired many an artist. The nineteenth-century Sphinx is a descendant of the Sphinx who figures in the classical Greek story of Oedipus. She is described as having a woman's head, a lion's body, a snake's tail and an eagle's wings. She took up residence in a mountain pass, and every male who passed that way was presented with a riddle to solve. If they failed, they were strangled and devoured. In this way the Sphinx consumed countless victims. When Oedipus comes up with the right answer, however, she is overcome with fury and plunges off the mountainside to her destruction.

There are several elements in this myth that make the Sphinx highly suitable in the cult of the *femme fatale*. First, there is the dramatic ferocity of this female creature. Some illustrations show the Sphinx surrounded by her victims' torn-off limbs while in others she clasps a defenceless man to her breast in a deadly embrace. The second reason is that the Sphinx represents the mysterious. She is an unfathomable, enigmatic figure with a mysterious (fatal!) attraction. In the nineteenth century people became interested in this combination of characteristics and the modern Sphinx was developed. She changed her outward appearance – no longer a fearful seductive monster, she now combined the attractive enigmatic qualities of the female with the deadly voracity of the beast of prey.

The Dutch artist Jan Toorop shows in his painting of the Sphinx the eternal duality in humankind: the constant conflict between body and spirit. His Sphinx poses her victims with the riddle of the insoluble choice between the earthly and the heavenly. In her claws she clutches an emaciated man who is recognizably an artist – he holds a lyre. He yearns for liberation from the longings of the flesh and to achieve spiritual purity, but his yearning appears in vain. He is inextricably tied to the earth, his feet enmeshed in a woman's long luxuriant hair.

THE THREE BRIDES 1892-1893

Pencil, black and coloured chalk, white highlights , 78 x 98 cm

Kröller-Müller Museum, Otterlo

(Groninger Museum only)

The Dutch artist Jan Toorop has pictured nothing but female figures in these drawings. A jumble of different types – malicious, lovable, fully clothed or quite the opposite. They are imprisoned in a kind of whirlpool of long streaming hair. There is not a man to be seen in these oppressive scenes. Rather, portrayed here are different types of women symbolizing various facets of life, both good and evil. The same figures appear in both works.

At the centre of *The Three Brides* stands an innocent bride. To her left is a nun, who is spiritually pure and has subdued the demands of the body. On the right of the bride Toorop has portrayed a depraved women with snakes surrounding her head, symbol of lechery and materialism. It's as if the bride at the centre has to choose between two ways of life, the spiritual and the material.

The setting for *Fatalism* is a cemetery. The dim central figure is fighting against the forces of fate. She tries to push away this power, but in vain. On the left three new figures of doom appear from their graves. In the background a procession of pure virgins passes by unharmed. They seem unaware of the dark struggle for power taking place in the foreground. As the artist explained, they 'stand for those who desire to make life into something beautiful and serene.'

With these pictures Toorop intended to illustrate the eternal conflict between good and evil. He thought that humankind lives in a constant tension between these two incompatible opposites. By 'good' he understood that which is spiritual and pure; by 'evil' he meant the physical, material and sensual. He tried to show how people are torn between the two opposing demands of body and spirit. The physical, the earthly, prevents people from attaining spiritual purity.

Toorop has incorporated into the drawings several image motifs that also occur in the iconography of the *femme fatale,* such as semi-nude females with luxuriant long hair or with serpents round their heads, and women figures emerging from the grave. The women in Toorop's work are fatal in the sense that they symbolize the lures of the flesh: they embody the earthly, physical life and bodily desires. But the artist also used female figures to illustrate the lofty spiritual plane. His women are not just pernicious, threatening and deadly; they may also be beautiful and serene. However, with Toorop the category of good women is restricted to those who have foresworn bodily desires – that is, nuns and virgins.

FATALISM 1893

Pencil, black and coloured chalk, white highlights, 60 x 75 cm

Kröller-Müller Museum, Otterlo

John William Waterhouse (1849-1917)

ULYSSES AND THE SIRENS 1891

Oil on canvas, 100 x 201.7 cm
National Gallery of Victoria, Melbourne, acquired 1891

Sirens are sea nymphs and you have to watch out for their wiles. With their enchanting singing they ensnare hapless sailors to their doom. According to Greek mythology they have a bird's body and the head of a woman. So enrapturing is their song that sailors have no choice but to steer towards the source of this music as if drawn by a magnet. Thus their ship is lured onto the craggy rocks where it smashes and they drown.

Ulysses knew about this danger. He told his men to plug their ears with wax so they wouldn't be seduced by the sirens' song. Then he had himself tied fast to the ship's mast and gave strict orders that he was under no circumstances to be set free, even were he to beg and beseech them to do so. In this way Ulysses and his companions escaped drowning.

The painter John William Waterhouse shows the sirens in frontal attack. No longer are they adorning a distant island chanting their ditties, here we see them coming towards their victims in menacing array. Like a flock of huge threatening birds of prey they circle the mast of Ulysses' boat. One even sits on the rim and stares into the faces of the oarsmen. In Herbert Draper's picture the same sirens are transformed into mermaids (p.123). With their bare bosoms and buttocks these mermaids are considerably more appealing than Waterhouse's Harpy-like creatures.

In the iconography of the *femme fatale* these hybrid monsters – half woman, half animal – are a common phenomenon. Painters were highly inventive in their combinations of the female upper body with the lower parts of all sorts of unappealing creatures – insects, reptiles, snakes, birds, fish and various cat-like specimens. Generally, these animals were of a repellent and predatory nature – qualities that were attributed to certain women. These beings symbolized the baser, bestial aspects of women, just as in classical art creatures such as centaurs and satyrs represented animal aspects of the male.

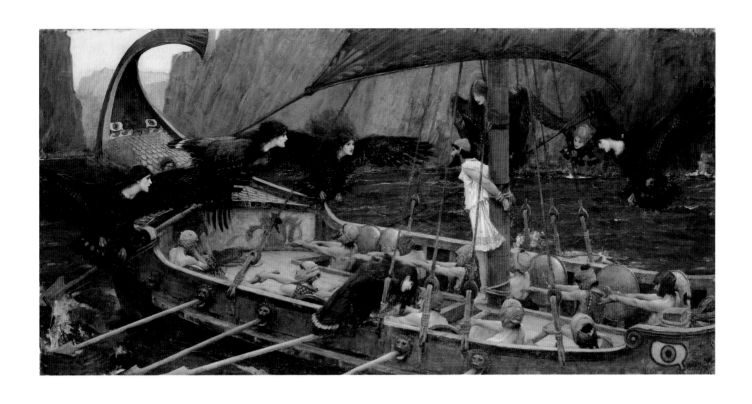

KNIGHTS & WITCHES

Christien Oele

Jenő Gyárfás (1857-1925)

THE ORDEAL OF THE BIER 1881

Oil on canvas, 192.5 x 283.5 cm
Magyar Nemzeti Galéria, Budapest

With a crazed look in her eye a young bride walks down the stairs while the bystanders gaze at her with loathing and disbelief. To the right behind her in a softly illuminated room we can detect a laid-out body. It is her dead fiancé. The young woman has just realized that she is responsible for his death.

The Hungarian painter Jenő Gyárfás based this picture on a well-known poem by his fellow-countryman János Arany. It relates how the young man Benő Bárczi was discovered lifeless in the woods with a dagger in his heart. No one could understand why he had been murdered or by whom.

At his wit's end, Benő's father decided to unmask the killer with the help of his son's corpse. The naked body was laid out and anyone who was at all suspect had to file past the bier. An old folk tradition tells that the wound will begin to bleed again as soon as the murderer approaches.

First Benő's enemies and rivals walk past, followed by his friends and family. Their innocence attested, the lovely Abigail is brought before her lover's body. Immediately, the wound begins to bleed profusely and all those present realize that she is the guilty party.

'Tis told her twice but he is still;
As if bewitched; then utters slow:
'Benő Bárczi I did not kill.
'God and his angels hear me, though
I gave the dirk that dealt the blow.'

Abigail was the kind of girl who just can't believe that her boyfriend really loves her. She kept on asking him to prove it. Benő finally got so crazy from this behaviour that he threatened to kill himself if she still wasn't convinced of his love. And instead of preventing him, Abigail handed him a dagger. 'Go on, show me how much you love me,' says she, whereupon the frantic Benő did what his true love asked of him.

Arthur Hacker (1858-1919)

THE TEMPTATION OF SIR PERCIVAL 1894

Oil on canvas 132 x 157.5 cm
Leeds Museum and Galleries (City Art Gallery), Leeds

In the Arthurian legends one of the noblest of the Knights of the Round Table was Percival. So he was chosen to go on the quest for the Holy Grail. Only a knight who excelled in courage, wisdom and virtue would be able to succeed in this undertaking. During his journeys, Percival was plagued by the Devil, who in the form of a seductive woman tried to thwart Percival's plans. At the very moment when the knight was about to yield to the charms of this lovely lady and take a sip from the enchanted drink she offered, he glanced at his sword. Its cross shape reminded him of his holy mission. Just in time, he rejected the drink and escaped the danger.

The English artist Arthur Hacker wishes us to have no doubt about the difference between good and evil. Percival is a thoroughly good guy, indeed he radiates innocence and purity. In contrast, the devilish she-cat is on the prowl, eager to entice her prey. A menacing look in her eyes, she claws through the dead crackling leaves, ready to pounce at any moment. Percival sits upright in his shining armour while the murky lady leans forward in her wide transparent dress, with a bare shoulder and half a breast bulging out. It would be impossible to present the contrast between vice and virtue in more vivid terms.

In this exhibition Percival is something of an exception. Most of the men who appear in the iconography of the *femme fatale* are either dead or nearly so, pretty much on the losing side. Percival, in contrast, is evidently a survivor. Straight-backed, he gazes with pious devotion at his sword, avoiding the sight of his temptress. He is one of the few who manages to repel the seductive blandishments of a *femme fatale*. But for this it required an iron will.

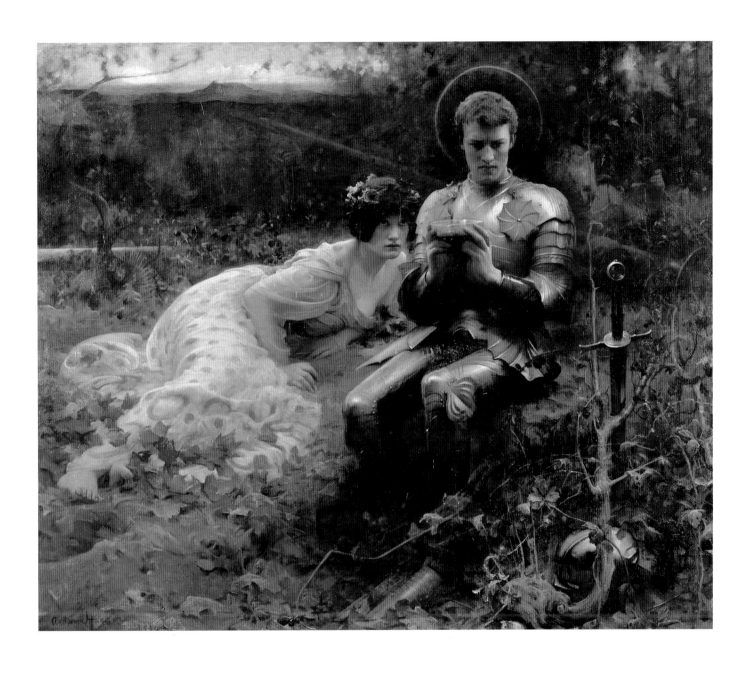

MORGAN LE FAY CA. 1862-1863

Ink and brush, with scratching out, 62 x 44 cm
Victor & Gretha Arwas Collection, London

The Arthurian legends abound with wicked women. There are devilish temptresses, malignant witches, nymphs who appear innocent and actually are nothing but, and terrifying water monsters – in fact, a whole army of female creatures that shun no means to deflect good king Arthur and his noble knights from the true path. One of these ladies was Morgan le Fay, half-sister of the legendary king and herself queen of Avalon, undoubtedly the greatest sorceress and furthermore thoroughly evil. Whenever the old magician Merlin used his powers to protect Arthur and smooth his path to fame and glory, Morgan would be there to put a spanner in the works. A combination of wicked goblin and goddess of vengeance, she engineered Arthur's downfall and the ruin of his kingdom.

The English artist Frederick Sandys has illustrated in this drawing the preparations Morgan le Fay made for an attack upon her half-brother's life. She wove him a cloak and then in her witch's cavern she tried to put a murderous spell upon the garment, using a magic lantern and chanting evil incantations. Her plan was that the moment he wrapped the garment round his shoulders, Arthur would burst into flames and be consumed. Morgan's cave is filled to the brim with the accoutrements of her magic art, with owls perched upon the weaving loom and books of magic on the ground, all indications of her evil intentions.

Although the murder plan Morgan is plotting here would in fact fail, nevertheless she sowed the seeds for her half-brother's downfall. When he was a young man not knowing Morgan was his half-sister, she seduced Arthur, who fell passionately in love with her and they lived together for a month. The result of this incestuous union was the monstrous Mordred, who was doomed to overthrow his own father.

LA BELLE DAME SANS MERCI 1893

Oil on canvas, 110.5 x 81 cm

Hessisches Landesmuseum, Darmstadt

(Groninger Museum only)

This painting is based on a poem by John Keats from 1819, titled *La Belle Dame Sans Merci*. The work tells the story of an encounter between a knight at arms, a noble, medieval figure and a woman of bewitching beauty. She takes the knight to her magic cave where she seduces him.

She took me to her elfin grot,
And there she wept and sigh'd full sore,
And there I shut her wild wild eyes -
With kisses four.

In his post-coital dream the knight sees a long procession of men, all of them pale as ghosts, and they call out to him as if in warning, that he too has fallen prey to the beautiful woman who knows no mercy.

The English painter John William Waterhouse has illustrated this danger with great imagination: the woman winds her long luxuriant hair round the knight's neck, and so pulls him towards her. She may appear innocent, but with several skeins of hair she is weaving a noose for her victim. The chilling impression this projects is underscored by the dark undergrowth in which the pair seem to lie imprisoned. In the poem by Keats,

although the fairy woman is said to have long tresses there is no mention that she binds them round her lover's neck. This is a pure addition by Waterhouse. In the second half of the nineteenth century the image of a man strangling in a woman's long hair became increasingly popular, both in the visual arts and in literature. We find Dante Gabriel Rossetti, the twenty-year older compatriot of Waterhouse, writing beside a sketch of *Lady Lilith* several lines from Goethe's *Faust*, in the English translation by the poet Shelley:

Beware of her hair, for she excels
All women in the magic of her locks
And when she twines them around a young man's neck
She will not ever set him free again.

One of the characteristics of the *femme fatale* was extremely long hair. This was the female weapon *par excellence*, symbolizing her seductive powers. Long flowing hair that attracted men but in which they might also be entrapped. Furthermore, loose free-flowing hair carried a suggestion of loose behaviour: respectable Victorian ladies naturally coiffed themselves with neat chignons.

148

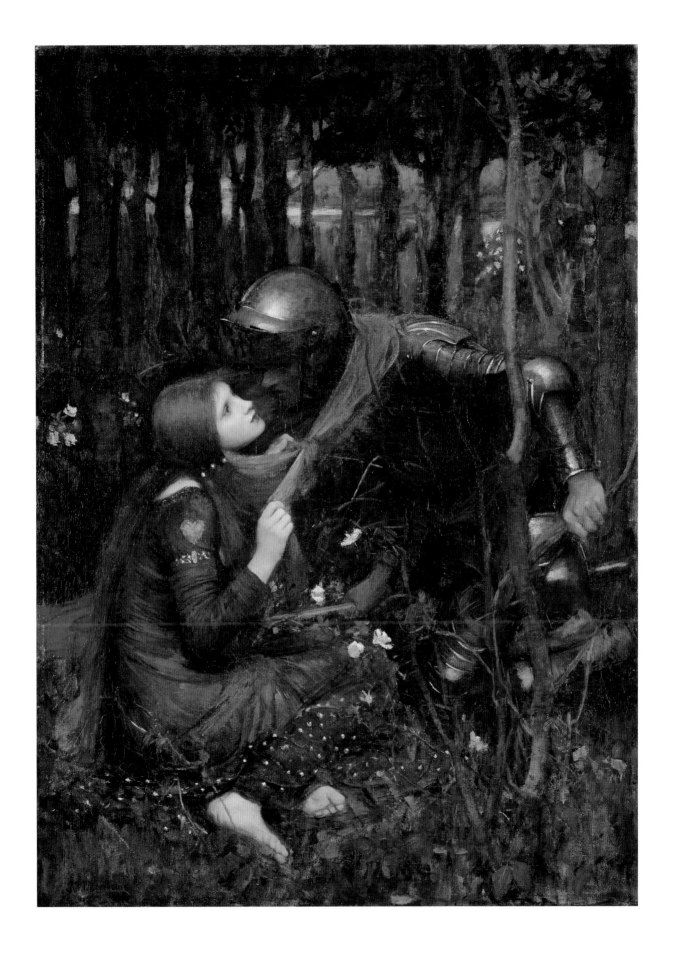

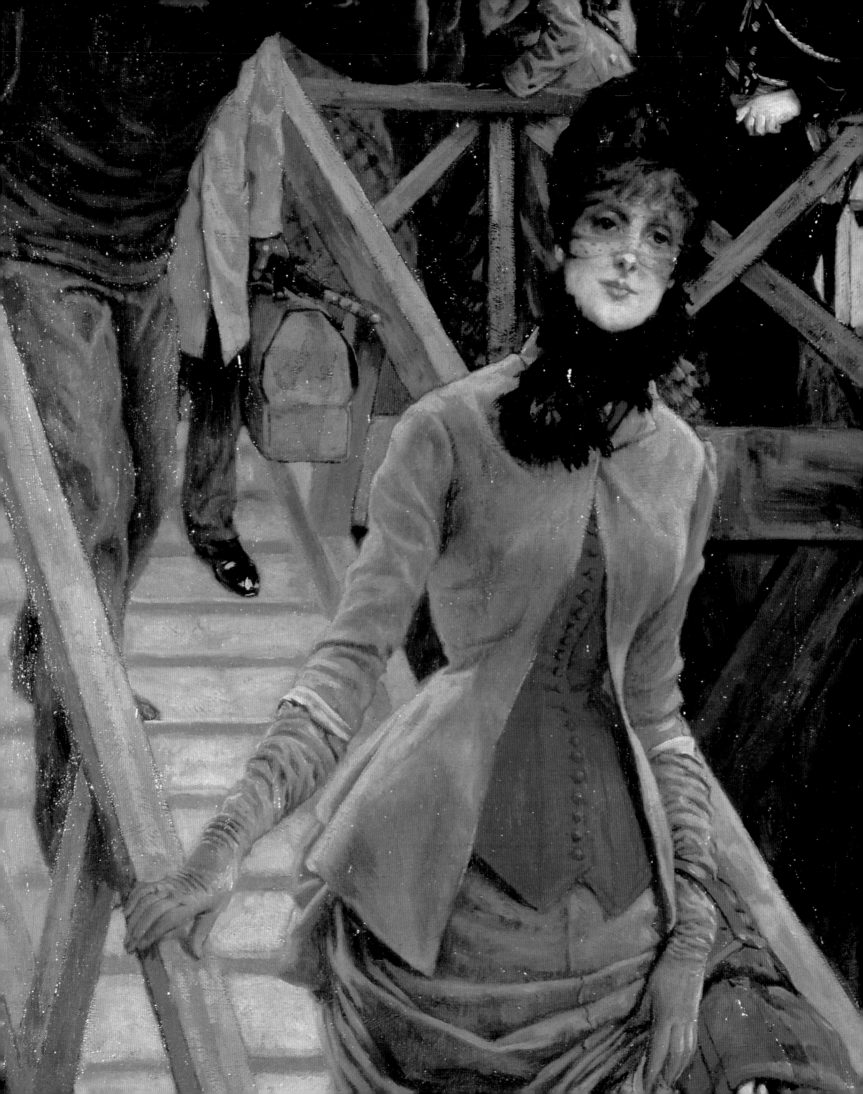

INNOCENT WOMEN?

Christien Oele

CHERRIES 1873

Oil on canvas, 79 x 129.1 cm
Koninklijk Museum voor Schone Kunsten, Antwerp

There can scarcely be a doubt what this woman is up to. Lying on a tiger skin, one hand full of ripe cherries, she regards us calmly, completely unembarrassed. The way in which she offers the juicy fruit, looking you straight in the eye, cannot be mistaken for anything but a sexual advance. The symbolism of cherries was widely known in the late nineteenth century. Indeed, from the Middle Ages onward the Dutch expression meaning 'eating cherries' was synonymous with 'making love'. Lawrence Alma-Tadema painted this picture for the Antwerp association *Cercle Artistique, Litteraire et Scientifique*. The fact that *Cherries* wasn't intended to be publicly exhibited but to hang in a private artists' club, may account for the openly erotic nature of the work. Presumably this enabled Alma-Tadema to give the painting more explicitly sexual overtones than he could when he produced for the open market and individual clients.

Not every nineteenth-century viewer would have felt at ease in the presence of this undisguised erotic invitation; the woman so charmingly reclining here has something almost aggressive in her directness. This is the very opposite of a modest Victorian maiden. It is a mature woman who takes things into her own hands and makes the first move. She is almost as much of a predator as the tiger who once inhabited the skin she lies upon. Do you dare to taste my cherries? The ball is in your court, admiring viewer. And what would happen if you did?

ÉTUDE DE FEMME CA. 1891

Red and blue chalk paper, 20.5 x 14.5 cm.
Triton Foundation Collection, the Netherlands

By the end of the nineteenth century the *femme fatale* had become so popular she was popping up all over the place. The languishing looks, the tiger-skin rugs, the arrogant pose and the endless streaming locks appear again and again. Indeed, sometimes you get the feeling that every portrait of a woman from the *fin de siècle* contains something of the *femme fatale*. Even the pictures of damsels who at first glance appear totally innocent may change into treacherous vamps under the influence of a particular setting, or perhaps because they are given a suggestive title.

The Belgian artist Fernand Khnopff is famous for his Sphinxes and Sirens but it would seem that even his portraits of ordinary women are infected with the fatal virus. Impenetrably haughty, with the deadly stare of Medusa, these women confront the viewer. Immovable and impassive they gaze at you, deeply mysterious. Is their intention to seduce you or to defy you? Silent, unmoving images, they suggest that beneath the chill inapproachability there lurks a murky secret. That at least was the conclusion of the Viennese critic Ludwig Hevesi on seeing portraits of this kind in 1898. He felt that smouldering in the sensuality of Khnopff's work lay the form of the vampire.

The two works here have the faces placed high within the picture plane, indeed so high that the frame partly cuts off the heads. This creates the impression that the woman is positioned far above you. Although she looks straight at you she is at the same time gazing down on you. From the heights of their enigmatic being these women mock and provoke the viewer's curiosity.

LA DÉFIANCE 1893

Coloured crayons on a photographic base laid down on card, 25.5 x 17 cm

Courtesy Philip Serck

Xavier Mellery (1845-1921)

PORTRAIT OF A LADY

Pencil and charcoal, 33.4 x 27.6 cm

Koninklijke Bibliotheek van België (Royal Library of Belgium), Brussels

THE SPHINX OF PARIS 1867

Oil on canvas, 72 x 53 cm
Koninklijk Museum voor Schone Kunsten, Antwerp

At first glance you wouldn't say this was a *femme fatale*. She is respectably dressed, her hair neatly coiled and there are no attributes in the picture that would seem to associate her with the genre 'vamp'. No victims, no male corpses, no deadly weapons nor any sort of suggestion that this young lady has evil intentions. However, the title of the work implies there's more to it than meets the eye. The Belgian-French artist Alfred Stevens has called the woman *The Sphinx of Paris* and has enveloped her in a cloak of mystery.

Stevens lived and worked mainly in Paris. As topic for his art he chose to portray the weal and woe of the Parisian bourgeois women. He would generally show them in their wealthy interiors, filled from floor to ceiling with knick-knacks and extravagant ornaments. This picture is remarkable for what is absent – the woman is shown in complete isolation. She is seated in a somewhat indefinite empty space and fills the whole of the picture area. This serves to increase the mystery that surrounds her. The strange cool light also helps create an alienating atmosphere. The woman doesn't look at the viewer but appears absorbed in her own thoughts. All this contributes to make the portrait far from ordinary. This young woman has something strange about her although it's hard to put your finger on exactly what.

The title adds to the enigma of this picture: why is the lady called a Sphinx? What is her riddle? Is she dangerous – beneath the charming exterior does she conceal the passions of a beast of prey – or is she no more than an innocent girl lost in her daydreams? And what are her daydreams about? Is she fantasizing about a new dress or maybe hatching some nefarious plans? By giving the picture this title Stevens has transformed an ordinary Parisian woman into an elusive apparition that will set the public busily speculating. In this way he has captured the inscrutable aspect of a woman's nature.

EMBARKATION AT CALAIS 1884

Oil on canvas, 141 x 98 cm
Koninklijk Museum voor Schone Kunsten, Antwerp

A beautiful young woman steps off a jetty and boards a boat. She is embarking for an unknown destination. People mill around her but she rises majestically above them. Indeed, she appears to tower above all the noise and chaos that surround her. We don't know where she's going to or why she's going. Is she escaping from something or going to join someone? All we can be sure of is that she is alone. And she becomes even more mysterious to the viewer because of the veil shrouding her face. She looks towards us and it's as though what she's thinking should also remain veiled behind a shadow of secrecy.

The French society artist James Tissot excelled at this kind of open-ended narrative. He painted elegant scenes whereby the viewer was free to fantasize about the precise implications of the situation. Tissot would often use the same model for very different representations and this only served to increase the confusion about the interpretation of his work. Sometimes she would appear as a weeping widow, then as a dutiful mother, or as a mysterious mistress, while here we see her as the traveller, destination unknown.

The striking thing about this painting is how the woman completely dominates the scene. Although we see plenty of men around her, carrying her cases, looking at her longingly or demonstrating various degrees of lapdog servility, they are all little grey mice scuttling about. They fade into nothing in the dazzling presence of the mysterious woman. The picture is a statement about the way in which one woman can dominate her entire surroundings.

The beautiful traveller creates a particular bond with her public. She looks you straight in the eye with a haughty stare. She approaches you with quiet confidence. The composition with the jetty and the lines of a boat suggest that this woman is coming on board – with you. Together you will sail to an unknown harbour.

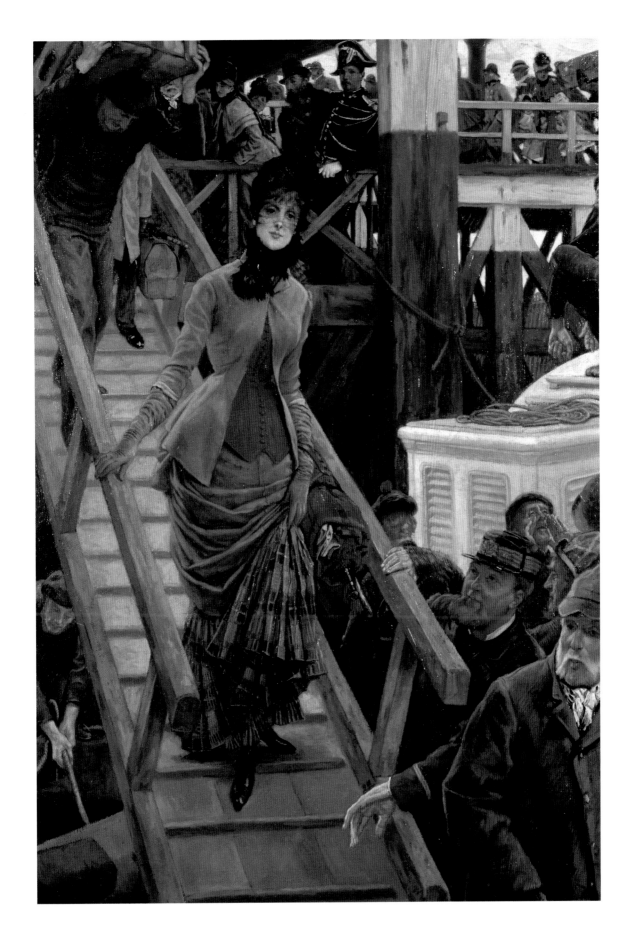

THE VICTIM

Christien Oele

SELF-PORTRAIT 1895

Lithograph, 45.7 x 31.7 cm
Munch Museum / Munch-Ellingsen Group, Oslo

The Norwegian artist Edvard Munch has long been held to be the greatest misogynistic painter of his generation. He earned this reputation because of his many paintings representing terrifying and repellent women. He was fascinated by the idea of the *femme fatale*. Not only his pictures but also his writings about women attest to this paradoxical attraction and repulsion. He speaks of the 'whore who is always intent on the downfall of every man' and tells of his first girlfriend that she robbed him forever of 'life's sweet perfume.' He has few kind words for women.

Within the iconography of the *femme fatale* Munch's works form a separate category. Although he also pictured Sphinxes, vampires, Salomes and Harpies he would lift them out of their mythological context and set them in his own world. The women he portrayed become all the more threatening because they are so unpleasantly close to home. Not Ulysses, but Munch is the prey clutched by the claws of female lust.

Like the *femmes fatales* of other artists of the period, Munch's women also have remarkably long flowing locks. He too uses the long hair to suggest ideas of bondage, to show how men are entwined and imprisoned. In *Jealousy II* a woman's hair seems to creep surreptitiously over the man's shoulder, while in *Vampire* the strands bind a man fast. In every case when Munch encounters a woman the experience soon turns into a precarious situation.

Despite all this it wouldn't be accurate to describe Munch as a misogynist. Indeed, almost all the prints discussed below come from a series titled *Love*. They formed part of Munch's magnum opus *The Frieze of Life* that he worked on for many years. This extensive series, consisting both of paintings and works on paper, was the artist's attempt to provide a comprehensive picture of life, centred on the themes of love, fear and death. Since Munch grouped the illustrations here under the heading 'Love' it seems clear that he wasn't so much out to present the woman as a devil as he was concerned to define the area where the sexes confront each other. At the interface between the male and the female Munch envisioned a vast chasm full of frustration, pain, sorrow, fear and longing.

Munch's women aren't fatal because they enjoy this role; for Munch women were fatal because he didn't know how to be with them. He shied away from commitments, from love, from being hurt and from the diminishing of self which as he saw it, every relationship with a woman inevitably involved. Thus for him women and sex were coupled with loss and destruction. Within the triangle of love, fear and death where his work unrolls, the fatal role is given to the woman. Repeatedly, the man is her victim. The woman manipulates, seduces, places her sexual wares on display and cries out for attention. The man watches and shrivels into an impotent nothing.

HARPY 1899

Lithograph, 36.3 x 32.2 cm
Munch Museum / Munch-Ellingsen Group, Oslo

Harpy and *Vampire* are two of the most violent pictures in the oeuvre of Edvard Munch. Both prints present the destructive forces of female sexuality. In classical mythology the Harpies were the goddesses who summoned up annihilating desert storms. They had the body of a bird of prey but the face of a young woman – as did the Sirens who caused such trouble to Ulysses and his companions. Munch shows the mythical female body and the cruel talons stretched out to clutch a male prey. The artist has placed breasts and claws frighten-ingly near to each other as if to emphasize all the more the danger of female sexuality. The man is so helpless he has almost ceased to exist – his emaciated body looks more dead than alive. The Harpy here is thus not so much a bird of prey as a vulture ready to strip the last shreds of flesh off the man's shrivelled form. Even in death the male cannot be rid of the predatory woman.

VAMPIRE 1895

Lithografie, 38.8 x 55.5 cm
Munch Museum / Munch-Ellingsen Group, Oslo

The *Vampire* is one of Munch's best-known works and confirmed his reputation as a misogynist. A female vampire bites into the unresisting neck of her male victim. The man's crumpled body, imprisoned in the woman's embrace, suffers and endures without resistance. His face is no longer visible. The woman's long strands of hair cascade down the sides of his head like streaming blood. Initially, the artist titled this picture *Love and Pain*. He re-named the work after his good friend the Polish poet Stanislaw Przybyszewski wrote the following description of it: 'A man broken in spirit; on his neck, the face of a biting vampire … the man spins around and around in infinite depths, without a will, powerless – and he rejoices that he can spin like that, like a stone, totally without volition. But he cannot rid himself of that vampire nor of the pain, and the woman will always sit there, will bite eternally with the tongue of a thousand vipers, with a thousand venomous teeth.'

ATTRACTION II 1896

Lithograph, 35.2 x 45.4 cm
Munch Museum / Munch-Ellingsen Group, Oslo

These two lithographs by Edvard Munch show a man and woman in an idyllic setting. But despite the peaceful scene something's not quite right. The night's darkness seems somehow to oppress this meeting between the two.

Attraction II presents a romantic scene on the waterfront. Pine trees sway gently in the wind while a full moon shines down, reflected in the smooth water. The shapes of a man and a woman can be discerned on the bank. Two mournful figures. Although they stand facing each other both stare with hollow gaze, seemingly unaware of the other. The attraction between the two is symbolized by the woman's hair which wraps itself softly round the man's head. Once again, it is the woman who takes the initiative while the man plays a purely passive role. This is further emphasized by the dark shadows falling across his face. In contrast to the woman, whose features are illuminated, the man is a mere shadow.

ASHES II 1899

Lithograph and watercolour. 35.2 x 45.4 cm

Munch Museum / Munch-Ellingsen Group, Oslo

In *Ashes II* we see a couple emerging form the woods where evidently they have just made love. The experience makes the man introspective. In contrast, the woman gestures triumphantly. She faces us, a proud erect figure dressed in white, shining and gleaming, while the dim crumpled male shape makes a stark comment in the foreground. In his diary the artist wrote the following about this picture:

'We walked out of the stifling, flower-filled woods ... into the light night – I looked at her face and I ... had committed adultery ... I bent over and sat down... I felt as if our love was lying there on those hard rocks.'

Even the sweet night and the blossoming flowers could not remove the foul taste that Munch was left with after this encounter. After such a meeting he was stricken by pain and confusion.

THE WOMAN AND THE HEART 1896

Itaglio print, 25 x 24.4 cm

Munch Museum / Munch-Ellingsen Group, Oslo

A young woman holds a huge bleeding heart in front of her. She is naked, her bare feet bathed in the blood that trickles from the organ. The scene is curiously alienating. It appears as if the woman is sitting outdoors but the horizontal row of trees in the background and the schematic positioning of the flowers create an artificial air. Also disturbing are the woman's neat coiffure and one earring which seem in conflict with her liberating nudity. Her pose is equally difficult to describe. Is she pushing the heart away, filled with aversion, or is she perhaps dispassionately considering the way in which the blood falls upon her feet?

Man's head in woman's hair is equally ambiguous. A man entangled in a woman's hair occurs more often in Munch's work, likewise a decapitated male head. Indeed, this picture has

MAN'S HEAD IN WOMAN'S HAIR 1896

Woodcut, 54.6 x 38 cm

Munch Museum / Munch-Ellingsen Group, Oslo

echoes of his Salome, in which John the Baptist's head appears enmeshed in a similar manner. But the woman pictured in this woodcut is not particularly threatening. Although she towers over the man's head, she looks down at it with tender sweetness. And her hair is not simply binding it fast, possibly it also serves to protect the head. Furthermore, the artist has represented the woman's disembodied head – thereby placing the two on a more equal footing. This is no Salome gloating over a man's hacked-off head, rather, it shows a man and woman reduced to their bare essentials. But whether you interpret it as revealing an imprisoned or a protected man, it is quite clear that the woman is the boss. She controls her man's fate. Sometimes she dallies with his heart, at other times she dominates his thoughts.

LIST OF WORKS IN EXHIBITION

Sir Lawrence Alma-Tadema (1836-1912), **Cherries**, Opus CXIV, 12 August 1873, 1873
Oil on canvas, 79 x 129.1 cm. Koninklijk Museum voor Schone Kunsten, Antwerp (see p.153)

Aubrey Beardsley (1872-1898), **The Climax** (Salomé), 1893
Lineblock reproduction, 34.3 x 27.2 cm. Alessandra and Simon Wilson Collection, London
(see p.103)

Robert Barret Browning (1846-1912), **Dryope Fascinated by Apollo in the Form of a Serpent**, 1884
Bronze, 92 cm (height). Victor & Gretha Arwas Collection, London, (see p.77)

Alexandre Cabanel (1823-1889), **Cleopatra trying out poison to the condemned**, 1887
Oil on canvas, 165 x 290 cm. Koninklijk Museum voor Schone Kunsten, Antwerp
(see p.16,79)

Hon. John Collier (1850-1934), **Clytemnestra**, 1882
Oil on canvas, 239.5 x 148 cm. Guildhall Art Gallery, Corporation of London, London
(see p.17,81)

Jean Delville (1867-1953), **Imperia**, 1892
Blue chalk and 'sanguine' on paper, 15.3 x 56.5 cm. Musée des Beaux-Arts, Tournai

Georges-Olivier Desvallières (1861-1950), **Salomé**, Gouache (varnished) on paper
59,5 x 50,5 cm. Private Collection, France (see p.105)

Herbert Draper (1864-1920), **The Golden Fleece**, 1904
Oil on canvas, 155 x 272.5 cm. Bradford Art Galleries and Museums, Bradford (see p.83)

Herbert Draper (1864-1920), **Ulysses and the Sirens**, 1910
Oil on canvas, 126.8 x 152.5 cm. Leeds Museum and Galleries (City Art Gallery), Leeds
(see p.123)

František Dritikol (1883-1961), **Sphinx (Cleopatra)**, 1913
Oil pigment print on paper, 34.8 x 46.6 cm. Museum of Decorative Arts, Prague (see p.125)

László Dunaiszky (1822-1904), **Judith en Holofernes**, c. 1862
Marble, 67 cm (height) Magyar Nemzeti Galéria, Budapest

Georges de Feure (1868-1928), **Femme Damnée**, 1897-1898
Gouache on paper, 34.5 x 25 cm. Victor & Gretha Arwas Collection, London

Sir George James Frampton (1860-1926), **Lamia**, 1899-1900
Bronze, ivory and opals, 61 x 55.3 x 25.4 cm. Royal Academy of Arts, London (see p.85)

Eugène Grasset (1841-1917), **Vitrioleuse (Jaloesie)**, 1894
Lithograph, 40 x 27.5 cm. Victor & Gretha Arwas Collection, London

Jeño Gyárfás (1857-1925), **Ordeal of the Bier**, 1881
Oil on canvas, 192.5 x 283.5 cm. Magyar Nemzeti Galéria, Budapest (see p.143)

Arthur Hacker (1858-1919), **The temptation of Sir Percival**, 1894
Oil on canvas, 132 x 157.5 cm. Leeds Museum and Galleries (City Art Gallery), Leeds
(see p.145)

Fernand Khnopff (1858-1921), **Étude de femme**, ca.1891
Red and blue chalk on paper, 20.5 x 14.5 cm. Triton Foundation, The Netherlands
(see p.155)

Fernand Khnopff (1858-1921), **Victoria. Comme des flammes ses longs cheveux....** 1892
Pastel on paper, 70.5 x 28.5 cm. Courtesy Philip Serck

Fernand Khnopff (1858-1921), **La Defiance**, 1893
Coloured crayons on a photographic base laid down on card, 25.5 x 17 cm.
Courtesy Philip Serck (see p.156)

Fernand Khnopff (1858-1921), **Medusa's blood**, 1898
Lithograph, 21.5 x 14.5 cm. Koninklijke Bibliotheek van België (Royal Library of Belgium),
Brussels (see p.87)

Fernand Khnopff (1858-1921), **Hérodiade**, 1917
Pencil and chalk drawing on paper, 20.4 x 16.4 cm. Victor & Gretha Arwas Collection, London

Max Klinger (1857-1920), **The Siren**, 1895
Oil on canvas, 100 x 185 cm. Villa Romana Florenz, Florence (see p.16,127)

Max Klinger (1857-1920), **The head of the new Salome**, 1893
Bronze, 70 cm (height). Van Gogh Museum, Amsterdam (see p.107)

Max Liebermann (1847-1935), **Simson and Delilah**, 1909
Oil on canvas, 125.6 x 175.8 cm. Städtisches Museum Gelsenkirchen (see p.109)

Sir Edgar Bertram Mackennal (1863-1931), **Circe**, 1893
Bronze, 58 cm (height). Victor & Gretha Arwas Collection, London (see p.89)

Xavier Mellery (1845-1921), **Portrait of a Lady**
Pencil and charcoal on paper, 33.4 x 27.6 cm. Koninklijke Bibliotheek van België (Royal
Library of Belgium), Brussels (see p.157)

Gustave Moreau (1826-1898), **Le Sphinx vainqueur**, ca. 1868
Watercolour on paper, 31.5 x 17.5 cm. Clemens-Sels Museum, Neuss (see p. 129, GM only)

Gustave Moreau (1826-1898), **Hélène sur les remparts de Troie**
Oil on canvas, 93 x 61 cm. Musée Gustave Moreau, Paris (see p.181)

Gustave Moreau (1826-1898), **Salomé**
Oil on canvas, 80 x 40 cm. Musée Gustave Moreau, Paris, (see p.111)

Gustave Moreau (1826-1898), **Salomé dansant**
Watercolour on traces of pencil, 72 x 34 cm. Collectie Musée Gustave Moreau, Parijs
(see p.112, GM only)

Evelyn de Morgan (1855-1919), **Medea**, 1889
Oil on canvas, 149.8 x 88.9 cm. Williamson Art Gallery and Museum, Birkenhead, Wirral
Museums Service (see p.90)

Gustav Adolf Mossa (1883-1971), **Diana**, c. 1906
Watercolour, pencil and ink on paper. Victor and Gretha Arwas Collection, London (see p.91)

Gustav Adolf Mossa (1883-1971), **Salomé**, 1907
Watercolour, pencil and ink on card. Victor and Gretha Arwas Collection, London
(see p.113)

Edvard Munch (1863-1944), **Twee mensen (De eenzamen)**, 1895
Droge naald, 15,5 x 21,4 cm. Rijksmuseum, Amsterdam

Edvard Munch (1863-1944), **Self-portrait**, 1895
Lithograph, 45.7 x 31.7 cm. Munch Museum / Munch-Ellingsen Group, Oslo (see p.165)

Edvard Munch (1863-1944), **Madonna**, 1895
Lithograph, 60 x 44 cm. Munch Museum / Munch-Ellingsen Group, Oslo (see p.19)

Edvard Munch (1863-1944), **Vampire**, 1895
Lithograph, 38.8 x 55.5 cm. Munch Museum / Munch-Ellingsen Group, Oslo (see p.167)

Edvard Munch (1863-1944), **The woman and the heart**, 1896
Intaglio print, 23.6 x 23.6 cm. Munch Museum / Munch-Ellingsen Group, Oslo (see p.170)

Edvard Munch (1863-1944), **The urn**, 1896
Lithograph, 46 x 26.5 cm. Munch Museum / Munch-Ellingsen Group, Oslo (see p.52)

Edvard Munch (1863-1944), **Jealousy II**, 1896
Lithograph, 47.5 x 57.5 cm. Munch Museum / Munch-Ellingsen Group, Oslo

Edvard Munch (1863-1944), **Sphinx**, 1896
Lithograph, 32 x 56 cm. Munch Museum / Munch-Ellingsen Group, Oslo

Edvard Munch (1863-1944), **Attraction II**, 1896
Lithograph, 39.3 x 60 cm. Munch Museum / Munch-Ellingsen Group, Oslo (see p.168)

Edvard Munch (1863-1944), **On the waves of love**, 1896
Lithograph, 30.5 x 41.5 cm. Munch Museum / Munch-Ellingsen Group, Oslo (see p.52)

Edvard Munch (1863-1944), **Head of man in woman's hair**, 1896
Woodcut, 54.7 x 38 cm. Munch Museum / Munch-Ellingsen Group, Oslo (see p.171)

Edvard Munch (1863-1944), **In the man's brain**, 1897
Woodcut, 37.3 x 56.8 cm. Munch Museum / Munch-Ellingsen Group, Oslo

Edvard Munch (1863-1944), **Harpy**, 1899
Lithograph, 36.3 x 32.2 cm. Munch Museum / Munch-Ellingsen Group, Oslo (see p.166)

Edvard Munch (1863-1944), **Ashes II**, 1899
Lithograph, 35.4 x 45.6 cm. Munch Museum / Munch-Ellingsen Group, Oslo (see p.169)

Edvard Munch (1863-1944), **The woman**, 1899
Lithograph, 46 x 59.5 cm. Munch Museum / Munch-Ellingsen Group, Oslo

Edvard Munch (1863-1944), **Head by head**, 1905
Woodcut, 39.7 x 54 cm. Munch Museum / Munch-Ellingsen Group, Oslo

Edward Poynter (1836-1919), **Helen**, 1881
Oil on canvas, 91.7 x 71.5 cm. Art Gallery of New South Wales, Sydney, acquired 1968
(see p.93)

Félicien Rops (1833-1898), **The temptation of St. Anthony**, 1878
Pencil on paper, 73.8 x 54.3 cm. Koninklijke Bibliotheek van België (Royal Library of
Belgium), Brussels (see p.115)

Félicien Rops (1833-1898), **Les Diaboliques**, Le Sphinx, 1879
Gouache, watercolour and coloured pencil on paper, 29.7 x 20.4 cm. Private collection,
Belgium. Courtesy Galerie Ronny van de Velde, Belgium (see p.131)

Félicien Rops (1833-1898), **Les sataniques**, 1882
Serie van vijf gravures au vernis mou, Particuliere collectie, Belgium (see p.130)

Félicien Rops (1833-1898), **Les Sataniques 'Le Sacrifice'**, 1882
gouache and mixed media on paper, 26 x 16 cm. Private collection, Belgium

Félicien Rops (1833-1898), **Les Sataniques 'Le Calvaire'**, 1882
gouache and mixed media on paper, 20.7 x 14.5 cm. Private collection, Belgium
(see p.4)

Félicien Rops (1833-1898), **Les Sataniques 'L'Idole**, 1882
gouache and mixed media on paper, 26.5 x 17 cm. Private collection, Belgium

Frederick Sandys (1829-1904), **Morgan le Fay**, 1862-1863
Ink and brush, with scratching out, 62 x 44 cm. Victor & Gretha Arwas Collection, London
(see p.147)

Frederick Sandys (1829-1904), **Medea**, 1866-1868
Oil on panel, 62.2 x 46.3 cm. Birmingham Museums & Art Gallery, Birmingham (see p.15,95)

Carlos Schwabe (1866-1929), **Death and the Gravedigger**, 1895-1900
Watercolour and qouache over pencil, 75 x 55.5 cm. Musée D'Orsay, Paris (kept in the
printroom, Musée du Louvre, Paris) (see p.133, GM only)

Charles van der Stappen (1843-1910), **Le Sphinx**
Bronze, cire perdue, 70 x 32 x 30 cm. Musée des Beaux-Arts, Tournai

Alfred Stevens (1823-1906), **The Sphinx of Paris**, 1867
Oil on canvas, 72 x 53 cm. Koninklijk Museum voor Schone Kunsten, Antwerp (see p.18,159)

Franz von Stuck (1863-1928), **Judith en Holofernes**, ca. 1926
Oil on cardboard, 54 x 50 cm. Courtesy Galerie Katharina Büttiker, Zürich (see p.117)

James Tissot (1836-1902) **Embarkation at Calais**, 1884
Oil on canvas, 141 x 98 cm. Koninklijk Museum voor Schone Kunsten, Antwerp
(see p.18,161)

Jan Toorop (1858-1928), **Fatalism**, 1893
Pencil, black chalk and coloured chalk, white highlights, 60 x 75 cm. Kröller Müller Museum,
Otterlo (see p.137)

Jan Toorop (1858-1928), **The three brides**, 1892-1893
Pencil, black and coloured chalk, white highlights, 78 x 98 cm. Kröller Müller Museum,
Otterlo (see p.137, GM only)

Jan Toorop (1858-1928), **De Sphinx**, 1892-1897
Black chalk, pencil and oil pastel on canvas, 126 x 135 cm. Collectie Gemeentemuseum Den
Haag (see p.135, GM only)

John William Waterhouse (1849-1917), **Circe offering the Cup to Ulysses**, 1891
Oil on canvas, 146.5 x 91 cm. Gallery Oldham, Charles Lees Collection, Lancashire
(see p.14,97)

John William Waterhouse (1849-1917), **Ulysses and the Sirens**, 1891
Oil on canvas, 100 x 201.7 cm. National Gallery of Victoria, Melbourne, acquired 1891
(see p.14,139)

John William Waterhouse (1849-1917), **Circe invidiosa**, 1892
Oil on canvas, 180.7 x 87.4 cm. Collectie Art Gallery of South Australia, Adelaide
South Australian Government Grant 1892 (see p.99)

John William Waterhouse (1849-1917), **La Belle Dame sans Merci**, 1893
Oil on canvas, 110.5 x 81 cm. Hessisches Landesmuseum, Darmstadt
(see p.17,149, GM only)

Véra Willoughby, **Salomé**, c. 1922
Gouache and watercolour on paper 30 x 25 cm. Victor & Gretha Arwas Collection, London
(see p.118)

NOTES & BIBLIOGRAPHY

Marianne Kleibrink - *The Myths of Womankind*

1 Keuls, 1985.
2 Davidson, 1998.
3 Blum and Blum 1970.
4 See on nymphs: Larson 2001.
5 See on Medea: Claus and Johnston 1997.
6 'Fatale monstrum' cp. Horace's poems, Carmina, 1, 37, 21.
7 Solomon 1978.

Sijbolt Noorda
Jaël, Judith & Salome - Femmes Fatales in the Biblical Tradition

1 Henri Regnault's *Salomé* is presently to be seen in the Metropolitan Museum of Art in New York.
2 I thank the following for this information: Bairati 1998, p. 155.
3 Kohnstamm/ Cassee 1992 (1998).
4 Zahavi 1991.
5 Judges 5:24-31, from the New Revised Standard Version of 1989.
6 See: Judges 4:1-3 and 4-24.
7 In a play by Steven Lust from 1660: *Herstelde hongers-dwang*. See: Meijer Drees 1992, p. 74.
8 I have taken this and the following examples form the excellent collection to be found in Bleyerveld 2000.
9 Judith 10:4; 12:16-20; 13:4-10. (New Revised Standard Version of the Bible, 1989).
10 Judith 13:15-17.
11 Judith 16:5-11.
12 Judith 9:10-14.
13 A comprehensive description and interpretation of Judith's cultural-historical career is to be found in: Stocker 1998.
14 Respectively *Salome, the daughter of Herodias*, orders the beheading of John the Baptist, from 1856, presently in the Boijmans-Van Beuningen Museum in Rotterdam; and *The beheading of John the Baptist*, from 1869, presently in the Barber Institute of Fine Arts in Birmingham, UK. London's National Gallery has a variation on the latter painting, from the same year. The work in London shows Salome, the executioner and John the Baptist as well as Herod and a woman in tears. The model for Salome was Marie Cantacuzène, the artist's future wife. The fact that the painting is given the exact date – unusual for Puvis – of his 45th birthday, strengthens the suspicion that the painter identified with John the Baptist.
15 Stang 1979, p. 178.
16 Flavius Josephus, *Jewish Antiquities*, 18.5.4
17 Although in most Bible translations it reads 'the daughter of Herodias', it may well be argued that it should read 'his daughter Herodias'. This would give her the same name as her mother, just as Herod had the same name as his father.
18 Mark 6:17-20, New Revised Standard Version, 1989.
19 Mark 6:21-28.
20 Heinrich Heine wrote *Atta Troll* in 1841. It appeared in 1843 in the *Zeitschrift für die elegante Welt* (Journal for the elegant world) and in 1847 a new edition was published in book form. In 1848 a French translation appeared, and was a great success. The English translation here is by Hal Draper, The Complete Poems of Heinrich Heine, Boston, 1982.
21 For a detailed discussion see: Zagona 1960.
22 Banville 1875.
23 Laforgue 1886.
24 Mallarmé 1898.
25 Flaubert 1877.
26 As in almost all cases, 'originality' is a relative term, here too. Heine's fantasy about Herodias had its roots in medieval literature. See Nivardus's *Ysengrimus* for an excellent example of this tradition.
27 The intertwined world of literature and visual art is excellently demonstrated in J.-K. Huysmans's novel *A Rebours* in which the main character Des Esseintes (see also the essay in this publication by Jacqueline Bel) is fascinated by paintings of Salome by the French artist Gustave Moreau:
'The character of Salome, a figure with a haunting fascination for artists and poets, had been an obsession with him for years. Time and again he had opened the old Bible ... and read the Gospel of St Matthew which recounts in brief, naïve phrases the beheading of the prophet ... But neither St Matthew nor St Mark nor St Luke nor any of the other sacred writers had enlarged on the maddening charm and potent depravity of the dancer. She had always remained a dim and distant figure...
In Gustave Moreau's work, which in conception went far beyond the data supplied by the New Testament, Des Esseintes saw realized at long last the weird and superhuman Salome of his dreams ... She had become, as it were, the symbolic incarnation of undying Lust, the Goddess of immortal Hysteria, the accursed Beauty ... the monstrous Beast, indifferent, irresponsible, insensible, poisoning, like the Helen of ancient myth, everything that sees her, everything that she touches.'
See: Huysmans, *Against Nature*, (English translation of *A Rebours*), Penguin 1959, pp. 65-66.

Eddy de Klerk - *The Femme Fatale and her Secrets from a Psychoanalytical Perspective*

1 I would like to thank both my colleagues K. Mispelblom Beyer-Broeshart and J. Tijsma for their suggestions and critical comments.
2 Bak, 1973.
3 See: Ladan 2000 and further Schreuder 2001.
4 Broers, J. Smit jr, R. Born, *English-Dutch Dictionary*, Groningen 1933 (edition consulted: 1963).
5 Bartok 1988.
6 In the same sort of way Oedipus solved the riddle of the Sphinx, namely by integrating different aspects in one person. 'Which creature, with only one voice, sometimes has two feet, sometimes three, sometimes four and is weakest when it has the most feet?'. The ones who could not solve the riddle were strangled and devoured on the spot (by the Sphinx). Oedipus guessed the answer: 'Man' he replied, 'because as a young child he crawls on hands and feet, in his prime he stands firmly on his two legs and in old age he leans on a stick.' The Sphinx could not bear the disgrace and threw herself off the mountain crashing to her death in the depths of the valley below. See: Graves 1999, p.360.
7 See: Wilde 1995. The Bible stories about Salomé are to be found in Mathew 14:1-11 and Mark 6:14-28.
8 See: Bade 1979.
9 Wilde 1995, p.553.
10 Vogel 1992.
11 The information summarised here is taken from various publications on Munch: Hodin 1972, Heller 1984 and Stang 1979.
12 Steinberg/Weiss 1954, p.421.

Jacqueline Bel - *The Femme Fatale in Literature: the Beautiful, Merciless Woman*

1 Lapidoth 1893, vol. 2, p. 107. Although this citation presents Goëtia as a promising Decadent heroine, she is in fact a good woman who only drives men to destruction in order to avenge her father!
2 I have used various sources containing a detailed discussion of the femme fatale. These include: Praz 1970, (The Romantic Agony), ch. 4; Polak 1955; Dirikx 1993; Koelemij 1985; Scott 1992; Hilmes 1990 and Vandevoorde 1990. See also reference works: Frenzel 1962 and Frenzel 1988.
3 Said 1979 shows how the picture Westerners have of the East is in fact a Western construction; it is more 'a set of references' than an actual geographical place. Using Flaubert as example he shows how the Orient became associated with a sexual Paradise where everything is permitted. The Eastern or oriental, woman resembles a machine: she doesn't distinguish one male from another, she has no emotions and she makes no demands. In the East sex is liberated from guilt and punishment.
4 See on this the essay 'Twee keer op weg naar het einde', in: Wesseling 1993. See also: Romein 1976; Bank/ Van Buuren 2000; Boterman/ De Rooy 1999.
5 See: Goedegebuure 1987 a, also Dresden 1980.
6 Nordau 1893, cited in Bel 1993, p. 117.
7 See: Goedegebuure 1987 a, esp. p. 30-31.
8 'Les Parisiennes, des machines à plaisirs! Ainsi, Louise n'aura pas d'enfant! Ah! Bien oui, tout est trop étroit chez elle ... ni hanches, ni bassin ... c'est le dépeuplement complet de la France, quoi.' uit: Rachilde 1888. (Cited in The Romantic Agony, ch. 4.)
9 For the inventory of writers see chapters 2 and 14 in: Huysmans 1884 (1978). Several

Notes

of the authors I mention could not have been known to Huysmans since they had yet to publish their major works when *A Rebours* appeared.

10 'L'une, la Crampton, une adorable blonde, à la voix aiguë, à la grande taille frêle, emprisonnée dans un étincelant corset de cuivre, au souple et nerveux allongement de chatte, une blonde pimpante et dorée, dont l'extraordinaire grâce épouvante lorsque, raidissant, ses muscles d'acier, activant la sueur de ses flancs tièdes, elle met en branle l'immense rosace de sa fine roue et s'élance toute vivante, en tête des rapides et des marées?

L'autre, l'Engert, une monumentale et sombre brune aux crius sourds et rauques, aux reins trapus, étranglés dans une cuirasse en fonte, une monstrueuse bête, à la crinière échevelée de fumée noire, aux six roues basses et accouplées; quelle écrasante puissance lorsque, faisant trembler la terre, elle remorque pesamment, lentement la lourde queue de ses marchandises!'

from: Huysmans 1884, A Rebours, translated into English by Robert Baldick, published by Penguin as Against Nature (1969), p.37.

11 'Elle n'était plus seulement la baladine qui arrache à un viellard, par une torsion corrompue de ses reins, un cri de désir et de rut; qui rompt l'énergie, fond la volonté d'un roi, par des remous de seins, des secousses de ventre, des frissons de cuisse; elle devenait, en quelque sorte, la déité symbolique de l'indestructible Luxure, la déesse de l'immortelle Hystérie, la Beauté maudite, élue entre toutes par la catalepsie qui lui raidit les chairs et lui durcit les muscles; la Bête monstrueuse, indifférente, irresponsable, insensible, empoisonnant, de même que l'Hélène antique, tout ce qui l'approche, tout ce qui la voit, tout ce qu'elle touche.' from: Huysmans 1884, A Rebours, (my translation, Wendie Shaffer).

12 See on this in various forms: Polak 1955, Koelemij 1985 and Dirikx 1993.

13 Lewis 1795 (1973) p. 65.

14 See: Goedegebuure 1987 a, p. 72.

15 Infâme à qui je suis lié. Comme le forcat à la chaine. English translation by Richard Howard, 1981, p.37. Baudelaire, Les fleurs du mal, Le vampire.

16 C'est une femme belle et de riche encolure,
Qui laisse dans son vin traîner sa chevelure.
Les griffes de l'amour, les poisons du tripot,
Tout glisse et tout s'émousse au granit de sa peau.
Elle rit à la Mort et nargue la Débauche,
Ces monstres dont la main, qui toujours gratte et fauche,
Dans ses jeux destructeurs a pourtant respecté
De ce corps ferme et droit la rude majesté.
Elle marche en déese et repose en sultane;
Elle a dans le plaisir la foi mahométane,
Et dans ses bras ouverts, que remplissent ses seins,
Elle appelle des yeux la race des humains.
Elle croit, elle sait, cette vierge inféconde
Et pourtant nécessaire à la marche du monde,
Que la beauté du corps est un sublime don
Qui de toute infamie arrache le pardon.
from: Baudelaire, Les fleurs du mal, 1861; English translation by Richard Howard, 1981, p.132.

17 Wilde 1893 (1918), pp. 22-23.

18 Ibid., pp. 54-55.

19 Ibid., p. 66.

20 Ibid., p.55.

21 There is a comparable theme in the life of the decadent Roman emperor and sun god, Heliogabalus. This was used by Jean Lombard in *L'agonie* from 1888, also by Stefan George in *Algabal* from 1892 and Louis Couperus in *De berg van licht* (The mountain of light) from 1905. See: Goedegebuure 1987 a, ch. 4 'Verschijningen van Heliogabalus' (Appearances of Heliogabalus).

22 De Mont 1894, p. 247. Translated from the Dutch by Wendie Shaffer.

23 Polak 1955 states that the Symbolistes thought the figure of the femme fatale was primarily embodied by Salome, Cleopatra, Medusa and the Sphinx.

24 Leonie is beautiful, sensual, egoistic and somewhat sadistic. She has perverse daydreams and fantasies, reads the decadent author Catulle Mendès and from time to time visits the city to take part in orgies. Furthermore she is, as befits a femme fatale, crazy about diamonds and can distinguish the genuine article from paste. She is not governed by her feelings and remains untouched by life until the moment when in a classic bathroom scene an unknown assailant spits at her with red betel juice. Things take a turn for the worse when Leonie's husband, the Dutch commissioner Van Oudijck, and main character in the book, fails to follow his wife's advice about how to deal with the local population. The novel also presents a male variation on the Belle Dame sans Merci, in the person of the unintelligent but extremely desirable Addy, who is always described in terms of animal metaphors. Another character from Couperus's writing, Berti in *Noodlot* (Footsteps of Fate, published in Dutch in 1891, translated 1892) can be seen as a variation of the femme fatale; indeed, he is compared with a sphinx. In 1892 Couperus published *Extaze* (Ecstasy) in which Emilie Heijdrecht plays something of the role of Fatal Woman for Quaerts. She is described as dressed in furs and with 'burning dark eyes [and] a mouth like fresh blood.' In Vienna, Quaerts thinks he sees her in a painting by Hans Makart, as a 'dancer, her body curving and twisting, naked, golden-brown, wearing nothing but jewels upon her breasts and belly' in the burning palace of Sardanalapus. Couperus also describes the fornicating mother of Heliogabalus in *De berg van licht* (The mountain of light) from 1905 as a femme fatale, as well as the character of Thaïs in *Iskander* (Iskander) his novel about Alexander the Great published in 1920, who 'wore nothing but jewels.'

In the poetry of Couperus there are also various references to femmes fatales, as for example in *Een lent van vaerzen* from 1884: En het wierd u ten minste tot vreugde,/ dat ge mij vertreden hadt (And you delighted in the fact/ that you had trampled upon me); in *Orchideeën* from 1886 he describes art in terms of a chimera, a wild and unrealistic dream or notion: Maar o, verscheur mij niet het smachtend hart/ Met speelsch klauw....daal, ik verbeid u...daal! (But oh, tear not to shreds my suffering heart / with playful claw ... descend, oh I beseech ... descend!). See: Dirikx 1993.

25 See: Musschoot 1972.

26 The poet Annie Salomons also addressed several poems to her in the collection *Nieuwe verzen* (New Verses) from 1917.

27 The Russian poet Pushkin also describes a night with Cleopatra in *Egyptian Nights*, 1835.

28 'Comment, avec la langue française, si chaste, si glacialement prude, rendrons-nous cet emportement frénétique, cette large et puissante débauche qui ne craint pas de mêler le sang et le vin, ces deux pourpres, et ces furieux élans de la volupté inassouvie [...]' from: Gautier 1839. Cited at length in: Praz 1970, p. 214.

29 'Il adorait la courtisane antique, telle qu'elle est venue au monde un jour de soleil, la femme belle et terrible [...] la créature pâle, à l'oeil de feu, la vipère du Nil, qui enlace et qui étouffe [...]' from: Flaubert 1869. Cited at length in: Praz 1970, p. 222.

30 Je trône dans l'azur comme un sphinx incompris;
J'unis un coeur de neige à la blancheur des cygnes;
Je hais le mouvement qui deplace les lignes,
Et jamais je ne pleure et jamais je ne ris.
from Baudelaire 1861, English translation by Richard Howard, 1981, p.24.

31 'Het sphinxen-gelaat kwam meer dan levensgroot uit den rechterkant der teekening te voorschijn. Het was inderdaad Hedwigs profiel [...]. Het was Hedwigs kleine rechte neus, smalle, gracelijk gebogen mond-lijn, en haar wijd-open grijze oogen onder de ietwat verwonderd hooge brauwen. Maar de oogen staarden steenig koud en wreed, en aan den even fijn-opgebogen mondhoek hing een hel-roode droppel bloed. De gelaatstint was afschuwelijk blauwig, ook de haren blauw. Het naakte bovenlijf had uitvoerig geteekende borsten en twee gele grijpvogel-klauwen, omhakend bloedend menschenlijf en schedel.' Van Eeden 1900, pp. 222-223.

32 Couperus 1987-1996, vol. 4, pp. 357-358. The Dutch author Willem Kloos writes in his *Verzen* from 1894: O, marmeren Medusa zonder ziel (Oh marble Medusa without soul).

33 For the image of women in the Netherlands, see: Kemperink 2001, ch. 5 'Tot elkaar veroordeeld. Het sterke en het zwakke geslacht', (Condemned together – the strong and the weaker sex) pp. 147-204, and Van Dijk 2001.

34 This doesn't, however, mean that the type of fatal seductress doesn't still exist. She is regularly to be encountered in film, especially thrillers and *film noir*, as well as in TV series such as *Dynasty* in which actress Joan Collins plays the man-devouring Alexis Colby. And not without reason are such stars as Marlène Dietrich and Madonna called vamps. In Dutch literature the femme fatale continued to flourish, witness an epistolary novel such as *Rolande met de bles* (1944) by Herman Teirlinck. In some cases the type was portrayed ironically, as in *De vierde man* (1981) by Gerard Reve. See on this: Goedegebuure 1987 b and Anbeek 1996.

Anbeek 1996 T. Anbeek, *Het donkere hart. Romantische obsessies in de moderne Nederlands-talige literatuur*, Amsterdam 1996.

Bade 1979 P. Bade, *Femme fatale; Images of evil and fascinating women*, London 1979.

Bairati 1998 E. Bairati, *Salomè. Immagini di un mito*, Nuore 1998.

Bak 1973 R.C. Bak, 'Being in Love and Object Loss', in: *The International Journal of Pscho-Analysis*, 54 (1973), pp.1-8.

Bank/ Van Buuren 2000 J. Bank/ M. van Buuren, *1900 Hoogtij van burgerlijke cultuur*, Amsterdam 2000.

Banville 1875 Th. de Banville, *Les Princesses*, in: *Poésies : Les Exilés et Les Princesses*, Paris 1875.

Bartok 1988 B. Bartok, *Blauwbaards burcht = A Kékszakállú Herceg Vára: Opera in één akte*, (libretto: B. Balázs; vert.: T. Duchamps e.a.) Amsterdam 1988 (wereldpremière: Boedapest 1918).

Baudelaire 1861 (1995) C. Baudelaire, *Les fleurs du mal*, Paris 1861 (geraadpleegde editie: *De bloemen van het kwaad*, (vert. P. Verstegen) Amsterdam 1995).

Bel 1993 J. Bel, *Nederlandse literatuur in het fin de siècle*, Amsterdam 1993.

Bleyerveld 2000 Y. Bleyerveld, *Hoe bedriechlijck dat die vrouwen zijn. Vrouwenlisten in de beeldende kunst in de Nederlanden circa 1350-1650*, Leiden 2000.

Blum/ Blum 1970 R. Blum/ E Blum, *The dangerous hour. The lore of crisis and mystery in rural Greece*, London 1970.

Boterman/ De Rooy 1999 F. Boterman/ P. de Rooy, *Op de grens van twee culturen. Nederland en Duitsland in het Fin de siècle*, Amsterdam 1999.

Claus / Johnston 1997 J.J. Clauss en S. I. Johnston (eds.), *Medea, Essays on Medea in Myth, Literature, Philosophy and Art*, Princeton 1997.

Couperus 1987-1996 L. Couperus, *Verzameld Werk*, Amsterdam 1987-1996.

Davidson 1998 J. Davidson, *Courtesans and Fishmongers, the Consuming Passions of Classical Athens*, London 1998.

Dirikx 1993 L. Dirikx, *Louis Couperus en het decadentisme*, Gent 1993.

Van Dijk 2001 H. van Dijk, *'In het liefdeleven ligt gansch het leven'; Het beeld van de vrouw in het Nederlands realistisch proza 1885-1930*, Assen 2001.

Dresden 1980 S. Dresden, *Symbolisme*, Amsterdam 1980.

Van Eeden 1900 F. van Eeden, *Van de koele meren des doods*, Amsterdam 1900.

Flaubert 1869. G. Flaubert, *L'Éducation sentimentale. Histoire d'un jeune homme*, Paris 1869.

Flaubert 1877 G. Flaubert, *Hérodias*, in: *Trois Contes*, Paris 1877.

Frenzel 1962 E. Frenzel, *Stoffe der Weltliteratur. Ein Lexicon Dichtungsgeschichtlicher Längs-schnitte*, Stuttgart [1962].

Frenzel 1988 E. Frenzel, *Motive der Weltliteratur*, Stuttgart 1988.

Gautier 1835 Th. Gautier, *Mademoiselle de Maupin*, Paris 1835.

Gautier 1839 Th. Gautier, *Une Nuit de Cléopâtre*, verschenen in: *Une larme du diable*, Paris 1839 (geraadpleegde editie: *Le Roman de la Momie, précédé de trois contes antiques. Une nuit de Cléopâtre, Le Roi Candaule, Arria Marcelle*, Paris [1963]).

Goedegebuure 1987 a J. Goedegebuure, *Decadentie en literatuur*, Amsterdam 1987.

Goedegebuure 1987 b J. Goedegebuure, *Romantische tradities in literatuur en literatuurweten-schap*, Amsterdam 1987.

Graves 1999 R. Graves, *Griekse mythen*, Houten 1999.

Heine 1978 H. Heine, *Sämtliche Werke*, Vol.1: *Gedichte*, München 1978.

Heller 1984 R. Heller, *Munch, his life and work*, London 1984.

Hilmes 1990 C. Hilmes, *Die Femme Fatale. Ein Weiblichkeitstypus in der nachromantischen Literatur*, Stuttgart 1990.

Hodin 1972 J. P. Hodin, *Edvard Munch*, London 1972.

Huysmans 1884 (1978) J.-K.Huysmans, *A rebours*, Paris 1884 (geraadpleegde editie: Paris 1978).

Huysmans 1980 J.-K. Huysmans, *Tegen de keer*, (vert. J. Siebelink) Amsterdam 1980.

Kemperink 2001 M.G. Kemperink, *Het Verloren paradijs; De Nederlandse literatuur en cultuur van het fin de siècle*, Amsterdam 2001.

Keuls 1985 E. Keuls, *The Reign of the Phallus*, New York 1985.

Koelemij 1985 P. Koelemij, 'De femme fatale in de 19e eeuw', in: C. Ruppert/ G. Steen (eds.), *Decadentie* (Grafiet, nr. 5), Utrecht 1985, pp. 112-137.

Kohnstam/ Cassee 1992 (1998) G.A. Kohnstamm/ H.C. Cassee (eds.), *Het cultureel woorden-boek. Encyclopedie van de algemene ontwikkeling*, Amsterdam 1992 (geraadpleegde editie: 1998).

Ladan 2000 A. Ladan, *Het wandelend hoofd; Over de geheime fantasie een uitzondering te zijn*, Amsterdam 2000.

Laforgue 1886 J. Laforgue, *Salomé*, in: *Moralités légendaires*, Paris 1886.

Lapidoth 1893 F. Lapidoth, *Goëtia*, Leiden 1893.

Larson 2001 J. Larson, *Greek Nymphs, Myth, Cult, Lore*, Oxford 2001.

Lewis 1795 (1973) M. Lewis, *The Monk. A Romance*, London 1795 (geraadpleegde editie: Oxford 1973).

Mallarmé 1898 S. Mallarmé, *Hérodiade* [1864], verschenen in: *Poésies*, Paris 1898.

Meijer Drees 1992 M. Meijer Drees, 'Vaderlandse heldinnen in belegeringstoneelstukken', in: *De nieuwe taalgids* 85 (1992), pp.71-82.

De Mont 1894 P. de Mont, *Iris*, Antwerpen 1894.

Musschoot 1972 A.M. Musschoot, *Het Judith-thema in de Nederlandse letterkunde*, Gent 1972.

Nivardus 1987 Nivardus, *Ysengrimus*. (ed. J. Mann), Leiden 1987.

Nordau 1893 M. Nordau, *Entartung*, Berlin 1893 (geraadpleegde editie: *Ontaarding*, (vert. M. Smit) Zutphen 1893)

Polak 1955 B. Polak, *Het fin de siècle in de Nederlandse schilderkunst. De symbolistische beweging 1890-1900*, 's-Gravenhage 1955.

Praz 1970 (1988) M. Praz, *The Romantic Agony*, Oxford/London/New York 1970 (geraad-pleegde editie: *Lust, dood en duivel in de literatuur van de Romantiek*, (vert. A. Haakman) Amsterdam 1988).

Rachilde 1888 Rachilde, *Madame Adonis*, Paris 1888.

Romein 1976 J. Romein, *Op het breukvlak van twee eeuwen*, Amsterdam 1976.

Said 1979 E.W. Said, *Orientalism*, New York 1979.

Schreuder 2001 B.J.N. Schreuder, 'Lichaamsgeheugen en levensverhaal bij psychotrauma', in: *ICODO-info*, 18 (2001) nr. 3-4, pp. 20-38.

Scott 1992 R. Scott, *The Fabrication of the Late Victorian Femme Fatale*, Basingstoke 1992.

Solomon 1978 J. Solomon, *The ancient world in the cinema*, South Brunswick 1978.

Stang 1979 R. Stang, *Edvard Munch: The Man and His Art*, New York 1979.

Steinberg/ Weiss 1954 S. Steinberg/ J. Weiss, 'The Art of Edvard Munch and its Function in his Mental Life', in: *Psychoanalytic Quarterly*, 23 (1954) nr. 3, pp. 409-423.

Stocker 1998 M. Stocker, *Judith. Sexual Warrior. Women and Power in Western Culture*, New Haven/ London 1998.

Vandevoorde 1990 H. Vandevoorde, 'De femme fatale. Een anti-typologische verkenning', in: *Handelingen van de Koninklijke Zuidnederlandse Maatschappij voor Taal- en letterkunde en geschiedenis*, 45 (1990), pp. 123-136.

Vogel 1992 (1998) D. Vogel, *Huwelijksleven*, (vert. en naw.: K. Meiling) Amsterdam 1992 (ge-raadpleegde editie: 1984). Oorspronkelijke titel: *Chajjee nissoe'iem*, Tel Aviv 1930.

Werk in Uitvoering 1998 *Werk in uitvoering. Eerste deeluitgave van de [Nieuwe Bijbelvertaling]*, Haarlem/ 's-Hertogenbosch 1998.

Werk in Uitvoering 2000 *Werk in uitvoering 2. Deeluitgave van de [Nieuwe Bijbelvertaling]*, Haarlem/ 's-Hertogenbosch 2000.

Wesseling 1993 H.L. Wesseling, *Oorlog lost nooit iets op. Opstellen over Europese geschiede-nis*, Amsterdam 1993.

Wilde 1893 (1918) O. Wilde, *Salomé: drame*, Paris 1893 (geraadpleegde editie: *Salome: A tragedy in one act*, (trans. Lord Alfred Douglas), London 1918).

Wilde 1995 Oscar Wilde, 'Salome', in: *The Complete Oscar Wilde*, New York 1995.

Zagona 1960 H.G. Zagona, *The Legend of Salome and the Principle of Art for Art's sake*, Ge-nève/ Paris 1960.

Zahavi 1991 H. Zahavi, *Dirty Weekend*, London 1991.

Gustave Moreau, *Hélène sur les rempants de Troie*, oil on canvas, 93 x 61 cm. Musée Gustave Moreau, Paris

Acknowledgements

The catalogue **Femmes Fatales – 1860-1910** accompanies the exhibition of the same name which runs from 19 January until 4 May 2003 in the Groninger Museum, the Netherlands and from 17 May until 17 August 2003 in the Koninklijk Museum voor Schone Kunsten, Antwerp, Belgium.

Exhibition concept and catalogue Henk van Os

Exhibition curators Patty Wageman, Groninger Museum
Leen de Jong, Koninklijk Museum voor Schone Kunsten, Antwerp

Essays by Jacqueline Bel, Kristien Hemmerechts, Marianne Kleibrink,
Eddy de Klerk, Sijbolt Noorda, Henk van Os

Catalogue entries by Christien Oele, Simon Wilson (Aubrey Beardsley)

Final editor Thijs Tromp

Translation Dutch – English Wendie Shaffer (Foreword, Jacqueline Bel, Sijbolt Noorda, Christien Oele,
Henk van Os),
Stephen Smith (Kristien Hemmerechts),
Kate Williams (Marianne Kleibrink, Eddy de Klerk)

Catalogue production Patty Wageman

Graphic design Rudo Menge, Esther Fledderman

Photography Copyright of all works in this catalogue belongs to the lenders,
unless otherwise stated.
George Frampton, Lamia, 1899-1900, Royal Academy of Arts, London 2000,
© P. Highnam (p.85)
Gustave Moreau, Hélène sur les remparts de Troie, Musée Gustave Moreau, Paris,
© RMN – R.G. Ojeda (p.181)
Gustave Moreau, Salomé, and Salomé dansant, Musée Gustave Moreau, Paris
© RMN – C. Jean (p.111,112)
Edvard Munch, Munch Museum / Munch-Ellingsen Group, Oslo, © Andersen /
de Jong, BONO / Stichting Beeldrecht 2002 (p.19,52,165-171)
Edward Poynter, Helen, 1881, Art Gallery of New South Wales, Sydney, Acquired
1968, © Brenton McGeachie for AGNSW (p.93)
Henri-Alexandre-Georges Regnault, Salomé, 1870, The Metropolitan Museum of Art,
New York, gift van George F. Baker, 1916, © 1981 The Metropolitan Museum of Art
Carlos Schwabe, Death and the Gravedigger, Musée d'Orsay, kept in the printroom
Musée du Louvre, D.A.G. (fonds Orsay), © RMN – J.G. Berizzi (p.133)
John William Waterhouse, Circe offering the Cup to Ulysses, 1891, Oldham Gallery,
Charles Lees Collection, © UK/Bridgeman Art Library (p.14,97)

Cover John William Waterhouse, Circe offering the Cup to Ulysses, 1891
Oil on canvas, 146.5 x 91 cm, Oldham Gallery, Charles Lees Collection
© UK/Bridgeman Art Library

Publisher BAI, Wommelgem, Belgium

ISBN 90-76704-21-X (ENG)
ISBN 90-76704-20-1 (NL)